DISCLOSED

falling cloudberries

A WORLD
OF FAMILY RECIPES

MY MOTHER'S NAME IS SIRPA TUULA KERTTU PEIPONEN
MY FATHER'S NAME IS GEORGE

falling cloudberries

A WORLD OF FAMILY RECIPES

Tessa Kiros

PHOTOGRAPHY BY MANOS CHATZIKONSTANTIS
STYLING BY MICHAIL TOUROS
ART DIRECTION BY LISA GREENBERG

**Andrews McMeel
Publishing, LLC**

Kansas City

This edition published in 2009 by Andrews McMeel Publishing, LLC. All rights reserved. Printed in China. No part of this book may be used or reproduced in any manner whatsoever without written permission except in the case of reprints in the context of reviews. For information, write Andrews McMeel Publishing, LLC, an Andrews McMeel Universal Company, 1130 Walnut Street, Kansas City, Missouri 64106.

First published in 2004 by Murdoch Books Pty Limited
Pier 8/9, 23 Hickson Road, Millers Point NSW 2000

09 10 11 12 13 MUB 10 9 8 7 6 5 4 3 2 1

ISBN-13: 978-0-7407-8152-0

ISBN-10: 0-7407-8152-9

Library of Congress Control Number: 2008939166

www.andrewsmcmeel.com

Chief Executive: Juliet Rogers
Publisher: Kay Scarlett
Photography: Manos Chatzikonstantis
Food Styling and Illustrations: Michail Touros
Art Direction: Lisa Greenberg
Additional Design: Jacqueline Duncan and Tracy Loughlin
Cover Design: Marylouise Brammer
Editor: Sandra Loy
Food Editor: Katy Holder
Recipe Testing: Jo Glynn
Production: Alexandra Gonzalez

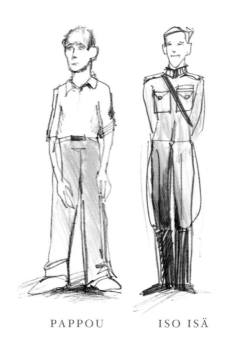

PAPPOU ISO ISÄ

This book is dedicated to my grandfathers,
Pappou and Iso Isä. And to my parents,
George and Sipi, who inherited their special souls.
Thank goodness for everywhere you took us.

Contents

food from many kitchens

These are the recipes I grew up with: the recipes that have woven their way through the neighborhoods of my mind, past indifference and into love. Those that have stayed while others might have fluttered away with a gentle spring breeze. These are the ones I choose to share; the ones that special people have taught me and that I have recorded, sometimes over a pot of coffee at my own kitchen table, and sometimes struggling to understand through the barriers of language on a journey somewhere.

I can remember the smell of those sweets my Cypriot grandmother gave us: their block shapes and bright wrappings, peppered with the eclecticism of South Africa, where we participated in Jewish Sabbath dinners at our friends' homes and sucked on butterscotch bars at Scottish fetes on days off from our Greek school.

Both my wonderful grandfathers managed to fill me with a sense of appreciation for details. My Finnish Iso Isä would amaze us with Christmas parcels of enormous rye breads and Marimekko tablecloths, and the candles that

would eventually grace the table for our Christmas Eve dinner. My Cypriot grandfather would arrive, carrying some pickled baby birds in a jar that would disgust us and have us yelping in conspiratorial glee. Who would have to sit next to the birds? Who would manage to hold in their laughter? We preferred him at his coals, turning the lamb or souvlaki, or standing in his back shed, frying potatoes and artichoke bottoms and knowing the exact moment to bash at them with his wooden spoon and make the crispy broken bits that we all fought over. At any given moment, he might calmly walk in and announce that the rice pudding was ready. Who wanted it with rose water; who preferred cinnamon?

At the same time I could imagine Iso Isä, stirring his Finnish mustard pot or poking out the freshest salmon at the fish market for gravlax, arms full of dill and weaving his way home through all those strawberry tops left on the ground.

My mother taught us a few unnecessary phrases in Finnish, so that when I arrived I was able to say, "Grandfather, this is my hand" (of course, he wasn't at all surprised at this). We did feature in the local newspaper that week for my mother having moved away and come back after so long. There were all her friends from school, serving meatballs with lingonberry jam as though she had never been away. They grew up eating cloudberry puddings and things we had never even heard of in South Africa. I remember stories of falling cloudberries, summer houses on lakes and a lot of eucalyptus.

I love tradition, and gatherings of people around traditional events, and I have had a great mixture. Born in London to a Finnish mother and a Greek-Cypriot father, when I was four we moved to South Africa. I now live in Italy, and for some years here had a housekeeper from Peru. I have always kept my favorite recipes in journals and I hope you will find a place for them among your own tablecloths. Here are the recipes that I love.

family tree

KATERINA MENCHAKOV
great-great-grandmother
(russia)

*

*** **

SOJA
great-grandmother
(finland)

JOHANNES PEIPONEN
great-grandfather
(finland)

SIRPA TUULA KERTTU PEIPONEN
mother
(finland)

ISO ISÄ
VALTTER VLADIMIR PEIPONEN
grandfather
(finland)

TERTTU SORANNE
grandmother
(finland)

GEORGE
father
(cyprus)

VANIA
aunt

PAPPOU
PAPPOU KIROS
grandfather
(cyprus)

YAYIA OLGA PETSAS
grandmother
(cyprus)

(LUDI) TANJA
sister

NICHOLAS
brother

CASSIA

ME

GIOVANNI
husband
(italy)

YASMINE

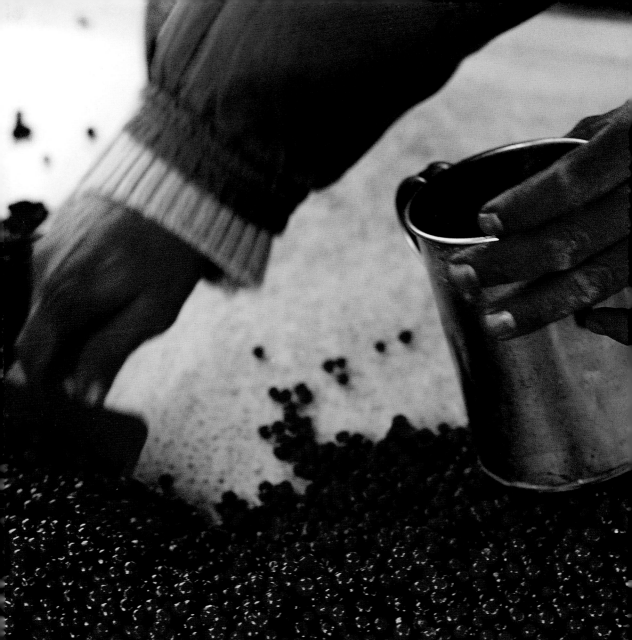

FALLING
CLOUDBERRIES

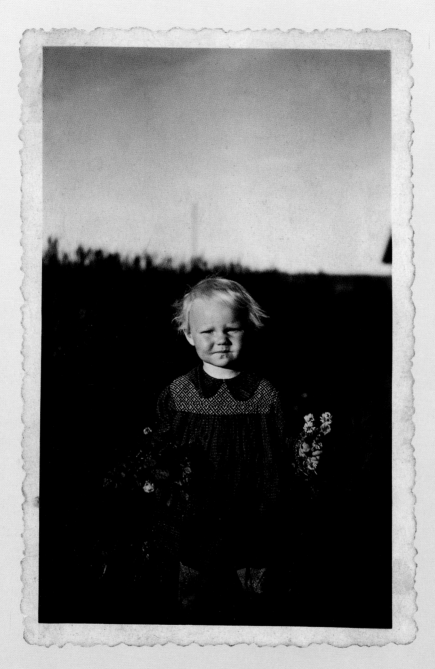

"SIPI" AS A CHILD CARRYING *chamomile*

Finland

I remember opening the long-awaited Christmas parcels from our meticulous Finnish grandfather. We would be amazed at how perfectly they were always wrapped. Those beautiful candles, and the mantelipiparkakkuja (they were the cookies). We would fall about doubled over with laughter as we tried to pronounce these names. Finland still remains a dream; a faraway land where Father Christmas lives and glides here and there with his sleigh, ducking through falling cloudberries and past my mother ice-skating to school.

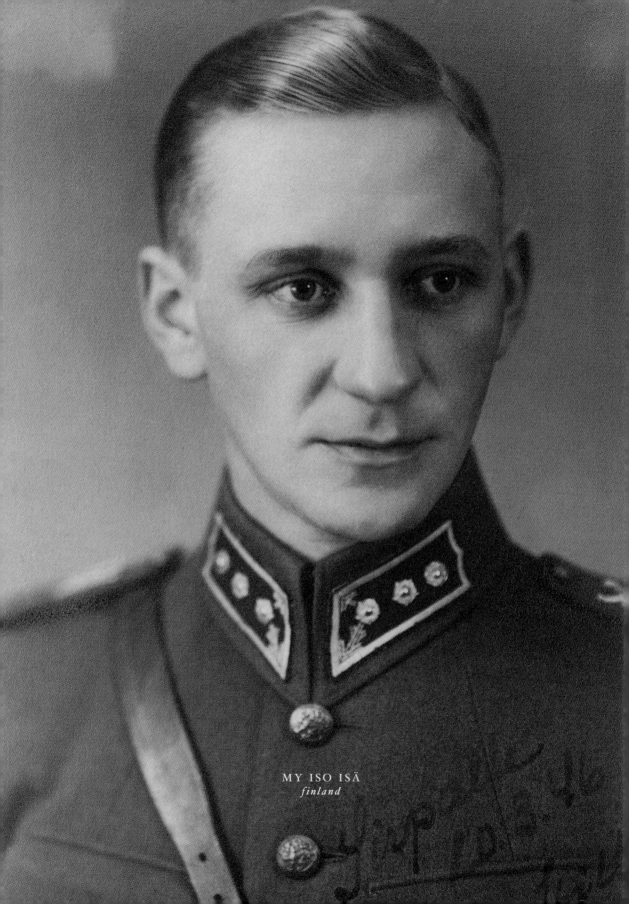

MY ISO ISÄ
finland

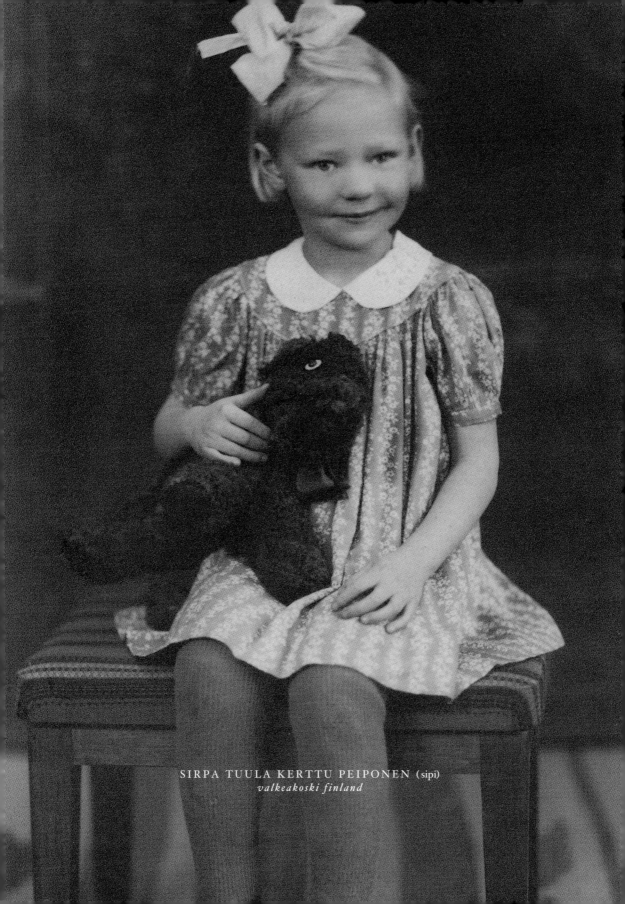

SIRPA TUULA KERTTU PEIPONEN (sipi)
valkeakoski finland

Serves 4

4 (2¼ -POUND) LIGHTLY SMOKED SALTED
 HERRINGS, *gutted*
2 CUPS LIGHT RED WINE VINEGAR
ABOUT ½ CUP SUGAR
1 TEASPOON WHOLE PEPPERCORNS
1 FLAT TEASPOON WHOLE ALLSPICE BERRIES
3 BAY LEAVES
A SMALL HANDFUL OF DILL OR WILD FENNEL
 SPRIGS, ROUGHLY CHOPPED
3 ONIONS, *cut into rings*
2 LARGE CARROTS, *sliced*

HERRINGS MARINATED
IN VINEGAR WITH DILL,
AND ALLSPICE

This is how my mother makes her herrings. There are many ways to marinate and serve herrings and these are my favorite, marinated in vinegar, some sugar, carrots, onions, dill, and allspice. I also like them done with tomato and onion. They need to stay in their marinade for about three days before you eat them. Keep the jar in the fridge and make sure that the herrings are immersed in the liquid. They will keep for about a week in the fridge and the flavor will get stronger. I use lightly smoked salted herrings and you can also use unsmoked if you prefer. You might also like to add a dried red chili to your jar. These herrings are good served with room temperature potatoes that have been boiled with salt and dill stalks, or rye bread.

Rinse the herrings and soak them overnight in cold water, changing it a couple of times.

To fillet a herring, cut off the head and tail and then open the fish out flat, skin side up. Using your thumb, press down firmly along the backbone. This will nearly release the bones from the flesh. Turn the fish over and use scissors to snip through the backbone at the head and tail. Pull away the backbone, working toward the tail end. Remove any stray bones with your fingers or tweezers. Wash the fish and pat it dry. Cut the herring fillets into 1-inch strips.

Meanwhile, boil the vinegar, sugar, peppercorns, and 1 cup water in a small pan for a few minutes, stirring to make sure the sugar has dissolved. Remove from the heat and add the allspice and bay leaves. Leave to cool down completely.

Layer the herring strips in jars with the dill, onion rings, and carrots. Pour the cooled liquid into the jars, put on the lids tightly, and keep refrigerated. Marinate for three days (or at least 24 hours if you're in a hurry) before serving. The herrings are also good drained of vinegar and served on a plate with a drizzle of olive oil.

Serves 4

1 SMALL RED ONION, *finely chopped*
1/2 TEASPOON SALT
2 LEMONS
2 HARD-BOILED EGGS
1/2 POUND SMOKED SALMON, *thinly sliced*
31/2 TABLESPOONS DRAINED BABY CAPERS
1/4 CUP CHOPPED FRESH DILL
4 HEAPED TEASPOONS SALMON ROE

SMOKED
SALMON PLATE

This is an elegant yet simple way to serve smoked salmon (or gravlax). You can add anything else you like — some cucumbers, sour cream, or crème fraîche — depending on the ingredients you have at hand. Serve this with melba toast, potato pancakes, or hapankorpuja or other rye bread. Hard-boil the eggs for 7 to 8 minutes.

Put the onion in a small bowl, cover with water, sprinkle with the salt, and let soak for 20 minutes or so. Rinse well, drain, and pat dry with paper towels before putting back in the bowl.

To make lemon fillets, slice the tops and bottoms off the lemons. Sit the lemons on a board and, with a small sharp knife, cut downward to remove the skin and pith. Holding the lemon over a bowl, remove the segments by slicing between the white pith. Remove any seeds. Squeeze out any juice left in the lemon "skeleton," then discard the skeleton.

Peel the eggs and separate the whites from the yolks. Finely chop each part and put into separate bowls.

To serve, arrange about four slices of salmon on each plate. Form small individual mounds of capers, dill, salmon roe, lemon fillets, chopped egg white, chopped egg yolk, and onion around the salmon. Drizzle lemon juice over the salmon and season with ground black pepper before serving with your favorite bread.

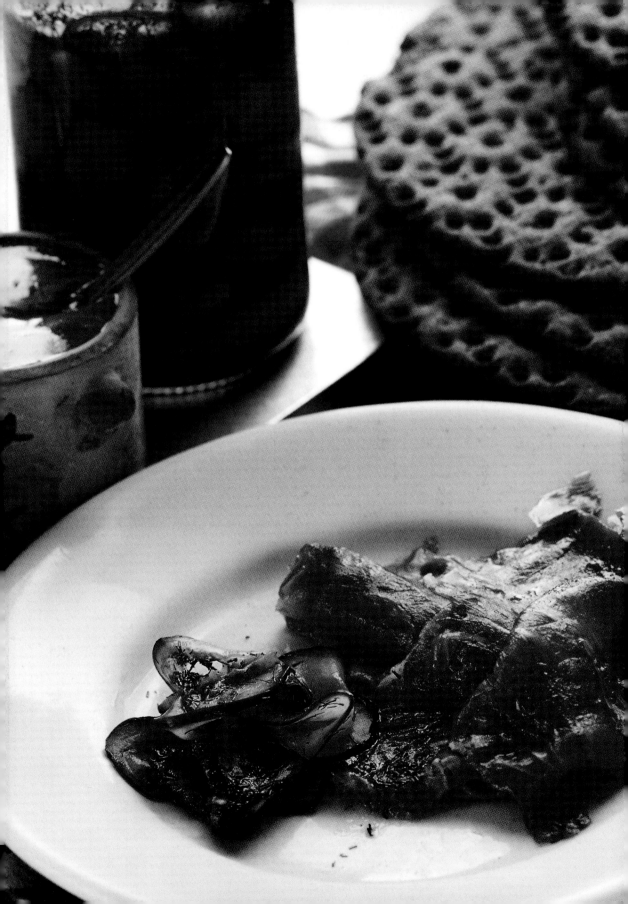

Serves 15 to 20

1/$_2$ CUP SUPERFINE SUGAR
2/$_3$ CUP COARSE SALT
2^1/$_2$ CUPS CHOPPED FRESH DILL
2 WHOLE FILLETS OF SALMON, *skin left on,
but cleaned and small bones removed*

dill cucumbers
1 CUCUMBER
1 TABLESPOON CHOPPED FRESH DILL
1/$_2$ CUP WHITE WINE VINEGAR
2 HEAPED TABLESPOONS SUPERFINE
 SUGAR
1 TEASPOON SALT

CHOPPED FRESH DILL, *to serve*
FINNISH MUSTARD (PAGE 27), *to serve*

GRAVLAX WITH DILL CUCUMBERS

Serve this with potato pancakes or rye bread, some homemade mustard and freshly chopped dill, or dill crème fraîche.

To make the gravlax, combine the sugar, salt, dill, and a few good grindings of black pepper in a bowl. Put a large piece of aluminum foil on your work surface. Onto this put about a third of the sugar mixture. Put one salmon fillet, skin side down, on top of the mixture then top this with another third of the mixture. Top with the other salmon fillet, skin side up, and cover with the remaining mixture. Pat down so it is all covered nicely and wrap the foil around to seal the salmon. Keep it in a container in the fridge for four days, turning it over every day. If you don't have a container large enough, sit it in a pan or large dish to catch any juices that may drip.

To make the dill cucumbers, cut the cucumber into very thin slices, slightly on the diagonal if you like, so that they are extra long and look good. Put them in a bowl where they will fit compactly in a few layers, sprinkling the dill between the layers. Combine the vinegar, sugar, salt, and 2 tablespoons of water, stirring to dissolve the sugar and salt. Pour this over the cucumber to cover it. Keep in the refrigerator for at least a few hours before serving. Transfer to a jar and cover with its liquid and it will keep for up to a week.

To serve the gravlax, remove the foil and scrape off as much of the sugar mixture as possible. Slice the salmon very thinly, horizontally, and scatter with more fresh dill. Serve with the dill cucumbers and some Finnish mustard.

Finland

Makes 1⅓ cups

⅓ CUP HOT ENGLISH MUSTARD POWDER
½ CUP SUPERFINE SUGAR
1 TEASPOON SALT
1 CUP HEAVY WHIPPING CREAM
1 TABLESPOON OLIVE OIL
2 TABLESPOONS APPLE CIDER (*or other*)
 VINEGAR
JUICE OF HALF A LEMON

FINNISH MUSTARD

We almost always had a jar of this in the house: my mother loves her mustard. This is wonderful — so quick to make and it will keep well for a few weeks in a glass jar in the fridge. You could find it becomes essential for cold meat sandwiches or roast ham and with smoked sausages and gravlax. I imagine it would be nice with any mustard powder you use, but this is the way my mother always makes it.

Mix the mustard powder, sugar, and salt together in a bowl, squashing out the lumps with a wooden spoon. Put in a small saucepan over low heat with the cream, oil, vinegar, and lemon juice, and bring to a boil, stirring constantly. Cook for 7 to 8 minutes, stirring often, then remove from the heat when it darkens and thickens. Stir now and then while it cools and then pour into glass jars. Store it in two shorter jars rather than a tall jar where it will be difficult to reach the last bit of mustard with a spoon. Keep in the fridge.

...there were always those stories of summer houses on lakes with eucalyptus, and hot-to-the-limit saunas...

Makes about 18

1¼ POUNDS (ABOUT 4 MEDIUM) POTATOES, *peeled and halved*
½ CUP HEAVY WHIPPING CREAM
½ CUP ALL-PURPOSE FLOUR, *sifted*
A LITTLE GRATED NUTMEG
3 EGGS, *separated*
BUTTER, *for shallow-frying*
OLIVE OIL, *for shallow-frying*

POTATO PANCAKES

These are wonderful with the richness of salmon and I like to serve them with the gravlax and dill cucumbers. But they are also good with a fried egg, onions, bacon, sausages with mustard, or just warm spread with butter. You could add some freshly chopped herbs to the batter if you like. Keep them warm in a basket covered with a cloth, until you are ready to serve.

Boil the potatoes for about 15 minutes in salted water, until they are soft. Pass them through a food mill and then stir in the cream. Add the flour, nutmeg, and some pepper, and mix well. Let it cool a little.

Lightly whisk the egg yolks and whisk into the cooled potatoes. Whip the egg whites to soft peaks and fold those into the potato batter. Add a little more salt if necessary.

Melt a little butter and olive oil to cover the bottom of a skillet over medium heat. When hot, drop in spoonfuls of the batter. Cook for 1 to 2 minutes, until golden on the underside, then flip them over swiftly. Cook until golden, then lift out and keep warm. Add more butter and olive oil to the pan when necessary and cook the rest of the pancakes. Serve warm with salmon and a dollop of mustard.

Serves 6 to 8

2¹/₄-POUND PIECE OF SALMON FILLET
ABOUT 8 WHOLE PEPPERCORNS
1 LONG STRIP OF LEMON ZEST
1 LARGE CARROT, *cut into 3 chunks*
1 CELERY STALK TOP WITH LEAVES
3 BAY LEAVES
A FEW PARSLEY STALKS
A GOOD HANDFUL OF FRESH DILL WITH STALKS
1 WHITE ONION
ABOUT 8 WHOLE ALLSPICE BERRIES
2 POUNDS (ABOUT 5 MEDIUM) POTATOES, *peeled and cut into large cubes*
1 CUP HEAVY WHIPPING CREAM
2 TABLESPOONS BUTTER

FRESH SALMON, DILL, AND POTATO SOUP

This is a rich creamy soup, sufficient as a single course with a green side salad. It is very good served with slices of white bread that have been pan-fried in butter. You could also serve it with just-toasted bread. Get your fishmonger to give you the salmon's central bone with tail if possible, so that you can make a good broth.

Skin the salmon and remove all the bones, feeling where they are by running your hand up and down the fish. Cut the salmon into chunks about 6 by 2 inches square.

To make your broth, put about 12 cups of water into a large saucepan with a bit of the salmon skin, the salmon bones, peppercorns, lemon rind, carrot, celery, bay leaves, parsley stalks, some of the dill stalks, the whole onion, and some salt. Bring to a boil and skim the surface of any scum. Decrease the heat and simmer for about half an hour before straining into a large, clean saucepan. You will need about 6 cupfuls; if you don't have enough, top up with some extra water.

Place the stock over high heat and add the allspice berries and potatoes. Simmer for about 15 minutes, until the potatoes are just soft. Add the salmon chunks, decrease the heat, and simmer for about 10 minutes, until the salmon is cooked. Add the cream, butter, and the remaining dill, chopped. Bring back to a gentle boil. Taste for salt and serve with a grinding of black pepper.

Serves 4 as an appetizer or snack

4 (2¹/4-POUND) FRESH HERRINGS, *gutted*
A PINCH OF WHITE PEPPER
¹/3 CUP CHOPPED FRESH DILL
8 VERY THIN SLICES OF LEMON, *peel and seeds removed*
1 EGG, BEATEN
1 CUP ALL-PURPOSE FLOUR
4 TABLESPOONS BUTTER
2 TABLESPOONS OLIVE OIL
LEMON WEDGES, *to serve*

FRIED STUFFED HERRINGS

This is my mother's friend Iria's recipe. She says this is autumn food in Finland, when the fishing boats anchor near the marketplaces and you can buy really fresh herrings. These are also delicious sandwiched together with the dill and then barbecued in a fish rack over hot coals. Squeeze a lemon over them just before you serve. Whole herrings are also very good barbecued, just sprinkled with salt and pepper and then served with lemon juice and olive oil.

To fillet and clean a herring, cut off the head and tail, then open the fish out flat, skin side up. Using your thumb, press down firmly along the backbone. This will nearly release the bones from the flesh. Turn the fish over and use scissors to snip through the backbone at the head and tail. Pull away the backbone, working toward the tail end. Remove any stray small bones with your fingers or tweezers. Cut the fish into two fillets down the back. Wash the fish and pat dry.

Put one piece of fish, skin side down, on a wooden board. Sprinkle with salt and white pepper and put a heap of chopped dill on it. Add two of the thin lemon slices. Put another herring fillet on top of it, skin side up, as if you were making a sandwich. Repeat with the remaining fish.

Put the egg in a dish where you can comfortably turn the herring sandwiches around to coat them completely, then pat them gently with flour.

Heat the butter and oil in a nonstick skillet. Fry the herrings, turning them over with a pair of tongs when you are sure the underneath is golden and firm. Sprinkle the done side with a little salt and pepper. Serve immediately with lemon wedges.

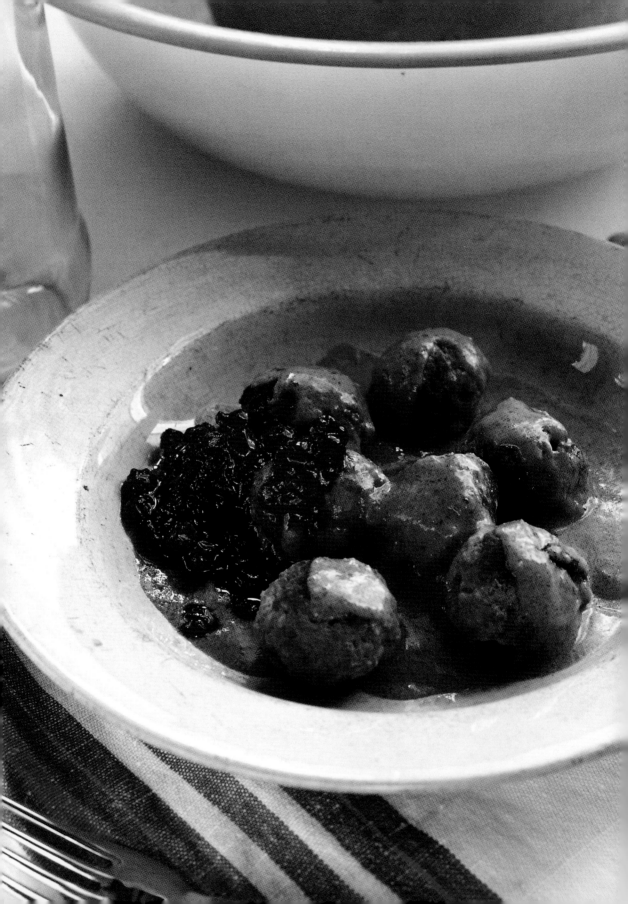

Serves 4 to 6

3 SLICES WHITE BREAD, *crusts removed*
2/3 CUP MILK
2 1/4 POUNDS MIXED GROUND PORK AND BEEF
1 LARGE EGG
1 RED ONION, *finely chopped*
2 TEASPOONS GROUND ALLSPICE
4 1/2 TABLESPOONS BUTTER
2 TABLESPOONS OLIVE OIL
1 TABLESPOON ALL-PURPOSE FLOUR
1 CUP SOUR CREAM
LINGONBERRY *or* CRANBERRY JAM (PAGE 34), *to serve*

FINNISH MEATBALLS WITH ALLSPICE, SOUR CREAM, AND LINGONBERRIES

This is so Finnish and probably one of the dishes that really remains in my mind from my childhood. Allspice is very popular in Finland; its taste is a combination of nutmeg, cinnamon, cloves, and black pepper, and it can be ground or in berry form. If you are not sure that what you have got in your spice rack is, in fact, allspice, then use less than indicated here and add a little more later (I once ended up with very liquorice-tasting ground meat). You can use ordinary cream instead of the sour cream here. You can also use a bought jam if you can find one, but this jam is really so quick and simple to make.

Soak the bread in the milk in a large bowl for about 30 minutes, or until it has absorbed all the milk and is very soft. Add the meat, egg, onion, and allspice, and season with salt and pepper. Knead together well with your hands, then form into small balls about the size of walnuts, rolling them between your palms so that they are compact and won't fall apart when cooking.

Heat 2 1/2 tablespoons of the butter with the olive oil in a nonstick skillet. Fry the meatballs in batches, turning them once during cooking. (You will have to work quite quickly and take care not to burn the butter and oil. If necessary, wipe out the skillet between batches and start again with a little less butter and oil.) Transfer the cooked meatballs to a heavy-bottomed saucepan with any onion that is on the bottom of the skillet and continue with the next batch.

Sprinkle the flour into the skillet and mix with a wooden spoon until it is smooth. Add the remaining butter and let it melt. Continue cooking, stirring almost continuously, until it is a golden color. Remove the pan from the heat and very slowly pour in 2 cups of hot water, standing back a bit. Mix in quickly, then return the pan to the heat. Stir in the sour cream and mix well, then carefully pour over the meatballs. Season lightly with salt and pepper and cook, covered, over very low heat for 10 to 15 minutes, until you have a thick, creamy sauce with soft meatballs to serve with berry jam and boiled potatoes.

Makes about 2 cups

1¹/4 POUNDS (5 CUPS) FROZEN *or* FRESH
 LINGONBERRIES *or* CRANBERRIES
1 CUP SUPERFINE SUGAR
FINELY GRATED ZEST AND JUICE OF 1 LEMON
1 SMALL APPLE, *peeled and cored*

LINGONBERRY OR CRANBERRY JAM

Lingonberries are everywhere in Finland, growing in clumps on small bushes. They make a tart, sourish jam that is delicious served with meats and game; try it with your Thanksgiving turkey or alongside a baked ham. Make it in a heavy-bottomed saucepan suitable for making jam. You might need to adjust the amount of sugar, depending on the tartness of your berries. The jam will be ready to eat once it has cooled, but you can also seal it in jars (while still hot) and store for when you need it.

Rinse the berries, if necessary, then drain well and put them in a nonreactive bowl with the sugar and lemon juice. Leave overnight, turning once or twice.

Coarsely grate the apple and put it into a jam-making pan or other heavy-bottomed saucepan with the grated lemon zest. Strain in all the juice from the berries and add 2 wooden-spoonfuls of berries, leaving the rest of the berries in the bowl for now. Add ¹/2 cup of water and simmer for 20 to 30 minutes, or until the apple is very soft and the entire mixture has thickened. Add the rest of the berries and heat through for 5 to 8 minutes. Pour into sterilized jars. Seal tightly and turn upside down. Cover with a cloth and let it cool completely, before turning upright and storing in a cool place. The jam will keep for a couple of months but, once open, keep it in the fridge and use fairly quickly.

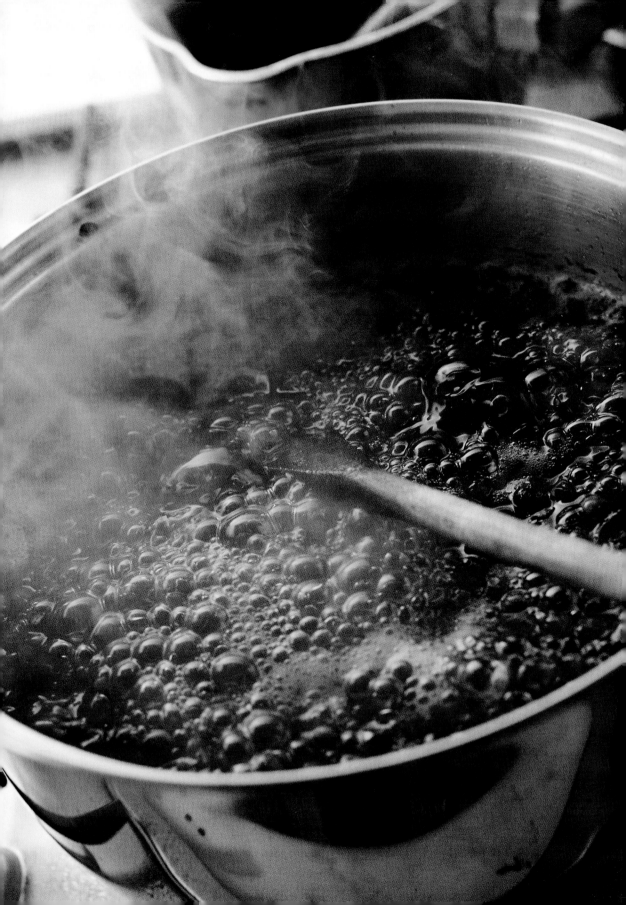

Ritva's Finnish dinner

Some afternoons in South Africa my mother would invite her Irish, Scottish, and Finnish friends around and we would eat the cakes that everyone had baked and play with their children.

When her Finnish friend, Ritva, came round, I would listen to them clucking away loudly in their native tongue. I could recognize the numbers (my mother still always counts in Finnish). I collected many recipes from Ritva and one special night we organized a Finnish dinner. It began with the caviar that a friend had flown in for her. Then we had a smoked salmon platter with various garnishes, and followed with her stroganoff of beef and pickled cucumbers, with lots of boiled potatoes and parsley. Later we ate cinnamon and cardamom buns, slightly warm, with some crème anglaise for dipping into. Ritva had thought to bring Finnish cassettes with her and all the while they were playing in the background.

I am crazy about evenings like this.

Serves 4

3 TABLESPOONS BUTTER
1 TABLESPOON OLIVE OIL
2 ONIONS, *chopped*
2 POUNDS LEAN CHUCK STEAK, *cut into chunks*
1 TEASPOON GROUND PEPPER
1 TEASPOON PAPRIKA
1 BAY LEAF
3 TABLESPOONS HONEY
3 TABLESPOONS ALL-PURPOSE FLOUR
4$\frac{1}{2}$ OUNCES CUCUMBER PICKLES, *drained and chopped*
1 CUP SOUR CREAM

STROGANOFF WITH PICKLED CUCUMBERS AND HONEY

 This is my mother's friend Ritva's recipe. It is pleasantly unusual in flavor — strong and wintery. Use the saltier variety of cucumber pickles rather than the very sweet-and-sour ones. You don't need much else with this: serve with some boiled, mashed, or sautéed potatoes, noodles, or rice.

Preheat your oven to 350°F. Heat the butter and oil in a casserole dish that can go in the oven and on the stovetop. Fry the onions for 3 to 4 minutes, until they soften a bit, then add the meat. Cook over high heat until it begins to brown, taking care that the onions don't burn. Season with salt and the pepper, then add the paprika, bay leaf, and honey, and mix thoroughly. Add 3 cups of water, cover with a lid, and cook in the oven for about 2 hours. Stir a couple of times while it is cooking, checking that there is still quite a lot of liquid.

Remove from the oven and put on the stovetop over very low heat. Put the flour in a bowl and whisk in a ladleful of the hot pan juices, whisking until smooth. Add another ladleful, whisking again before you pour it all back into the casserole dish and add the cucumbers. Stir while it comes to a boil and then cook for another couple of minutes. Add the sour cream, heat well until combined, and serve immediately.

Serves 4

2 TABLESPOONS BUTTER
2 TABLESPOONS OLIVE OIL
1³/4-POUND PIECE OF LEAN VEAL (*topside or silverside*)
3 GARLIC CLOVES, *crushed*
6 ALLSPICE BERRIES
1 BAY LEAF
2 LARGE POTATOES, *cut into chunks and kept in cold water*
2 LARGE CARROTS, *cut into wedges*
¹/4 CUP ALL-PURPOSE FLOUR
JUICE OF 1 LEMON
¹/2 CUP HEAVY WHIPPING CREAM
3 TABLESPOONS CHOPPED FRESH DILL

LONG-SIMMERED VEAL WITH CREAM AND DILL

This might be a real Finnish/Greek combination, but it's what my mother made often. It is quite delicious and just a glance through the ingredients probably makes it sound richer than it is. It is an all-in-one dish that can be taken straight to the table from the stove. You can easily add an extra carrot and potatoes to feed more people; there should be an abundance of sauce.

Melt the butter with the oil in a large, heavy-bottomed casserole dish over medium heat. Brown the veal on all sides, salting the browned part. Add the garlic and sauté for another minute. Add the allspice, bay leaf, and 4 cups of water. Decrease the heat, cover the casserole, and simmer for about 1¹/4 hours, turning the meat a couple of times. Add the drained potatoes and the carrots. Continue simmering, covered, for another 40 minutes or so, or until the vegetables are nice and soft but not falling apart. Remove from the heat.

Discard the allspice berries and bay leaf. Remove the meat, slice it fairly thickly, and set aside to keep warm on a platter. Transfer the vegetables to a warm dish.

Put the flour in a large saucepan and add a ladleful of the hot cooking liquid, stirring with a wooden spoon or whisk until smooth. Add another ladleful and stir in the lemon juice. Put the pan over low heat and add the rest or most of the liquid from the casserole. Cook until it bubbles up, then boil for 7 to 8 minutes, until thickened. Add the cream and dill, heat well, and then return all this sauce to the casserole dish along with the vegetables. Rock the casserole from side to side to make sure everything is combined. Heat through very gently for a few minutes, stirring all the time. Adjust the seasoning and serve the slices of meat and vegetables in large bowls with the sauce spooned over the top.

Finland

Serves 4 to 6

3¹/4-POUND PIECE OF LEAN SILVERSIDE
 or TOPSIDE OF BEEF
2 LARGE CARROTS, *cut into chunks*
1 LARGE RED ONION, *cut into quarters*
ABOUT 8 ALLSPICE BERRIES
1 BAY LEAF
¹/2 CUP HEAVY WHIPPING CREAM
2 TABLESPOONS CHOPPED FRESH PARSLEY

BEEF CASSEROLE WITH CARROTS, ONIONS, AND CREAM

This is adapted from a popular Finnish dish called Karelian stew, which uses a few different types of meat in the same pot, giving it a special flavor. It is a very simply cooked dish — rustic and wintery and quite undemanding. You could add a few fresh herbs or other spices if you like, or even try a variety of meats (veal, beef, and pork). This has a long, slow cooking time and is sometimes even left in the oven overnight.

Preheat your oven to 350°F. Put all the ingredients except the cream and parsley into a heavy casserole dish and add about 3 cups of water, or enough to come about three-quarters up the side of the meat.

Cover the casserole dish and bake for about 2 hours, turning the meat over a couple of times, until it is really soft. Remove from the oven. Lift out the carrots and onion with a slotted spoon and pass them through the fine disk of a food mill, or purée them. Discard the bay leaf and allspice berries from the casserole. Remove the meat from the casserole and keep warm.

Measure about 3 cups of the cooking liquid and return this with the puréed vegetables to the casserole (you can freeze the leftover cooking broth for another use). Add the cream and the parsley and heat through. Adjust the seasoning if necessary. Serve the meat thickly sliced with a lot of sauce poured over it.

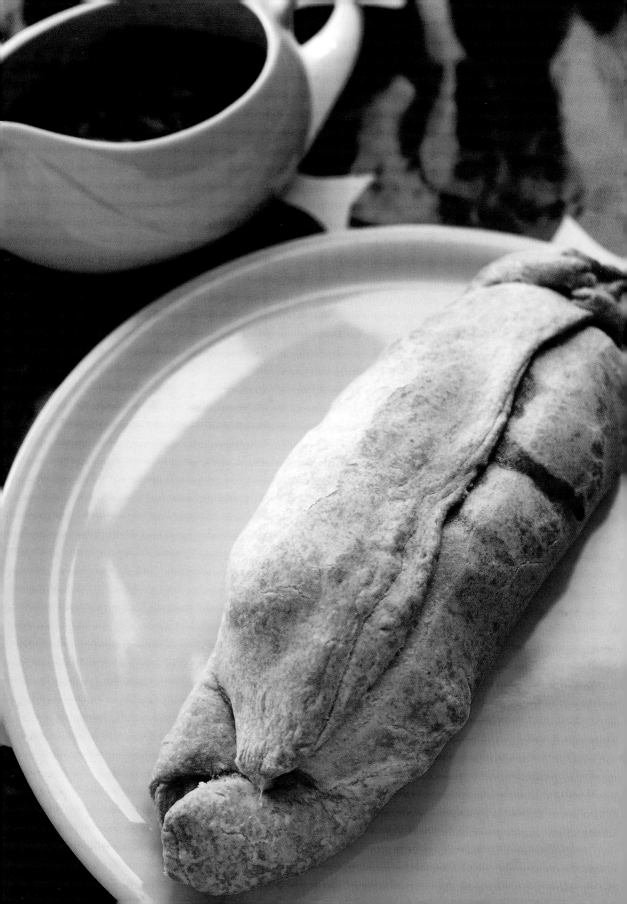

Serves 4

pastry
1³/4 CUPS ALL-PURPOSE FLOUR
2 STICKS CHILLED BUTTER, *diced*
4 TO 5 TABLESPOONS ICE WATER

3 TABLESPOONS BUTTER
2 TABLESPOONS OLIVE OIL
1¹/4-POUND PIECE OF PORK FILLET
4 GARLIC CLOVES
2 *or* 3 SAGE SPRIGS
¹/4 CUP BRANDY
2¹/3 CUPS (10¹/2 OUNCES) MIXED WILD MUSHROOMS
¹/2 CUP HEAVY WHIPPING CREAM

PORK FILLET IN PASTRY
WITH WILD MUSHROOMS
AND CREAM SAUCE

This is lovely: a whole pork fillet, cooked with mushrooms and wrapped in a jacket of pastry. If you can't get fresh wild mushrooms, buy ¹/4 ounce dried wild mushrooms and soak them in a little water, until they've plumped up. Make up the rest of the weight with ordinary mushrooms.

To make the pastry, sift the flour and a pinch of salt into a bowl. Add the butter and stir it in to coat it with flour. Add enough of the ice water to make the dough come together. Gather into a ball and transfer to a floured work surface. Flour your hands and form the dough into a rectangular block. Roll this out to make a rectangle that is about ¹/2 inch thick and has the short side closest to you. Fold up the bottom third of the rectangle and fold down the top third. Seal the edges lightly with a rolling pin. Turn the dough around by 90 degrees and roll it out again into a rectangle that is about ¹/4 inch thick. Fold as before, turn the dough, and roll out again. Do this once more, then put the dough in a plastic bag and leave in the refrigerator for 30 minutes. It can be frozen at this point if you won't be using it immediately, or the pastry can be kept in the fridge for a couple of days.

Meanwhile, preheat your oven to 400°F. Melt the butter with the oil in a casserole dish on the stovetop. Brown the pork quite quickly, seasoning the browned sides with salt and pepper. Add the garlic and sage and cook for a few seconds before adding the brandy. Either ignite the brandy and let it burn out, or just let it evaporate. Add the mushrooms around the meat, seasoning them with a little salt and pepper.

Put the dish in the oven and cook for 20 minutes, turning the pork over once or twice and tossing the mushrooms. The pork should be nicely browned and cooked through, but still

slightly pink inside (it will get more time in the oven in the pastry jacket). Transfer the pork to a plate to cool and leave the mushrooms with any juice in the dish.

Take your pastry out of the fridge and flatten it out on a lightly floured surface to make a rectangle that is about 12 by 10 inches. Lay the pork fillet along one long side, toward the bottom, and roll up the pastry around it. Pinch the ends together and fold them up over the top of the fillet. Put on a baking sheet lined with parchment paper, reduce the oven temperature to 350°F, and cook for about 30 minutes, or until the pastry is nicely golden and cooked through and the bottom is also golden and firm. Remove from the oven and let stand while you finish the sauce.

Put the casserole dish with the mushrooms on the stovetop and add about ½ cup of water, scraping up any bits from the bottom. Bring to a boil, let it thicken slightly, and then add the cream. As soon as it comes to a rolling simmer, remove from the heat and season. If the sauce seems too thin, let it simmer for a little longer.

Slice the pork and serve immediately with a little of the sauce spooned on the side. Don't spoon sauce all over the pastry or it will become soggy.

My mother always talks of how they collected wild mushrooms in the woods in thin wooden woven baskets. The pines and birches and other trees were at their most splendid and the mushrooms were fantastic that same night, sautéed in butter with onions.

Serves 3

2 EGGS
1 GARLIC CLOVE, FINELY CHOPPED
$^{1}/_{2}$ TEASPOON SWEET PAPRIKA
1 TEASPOON FINELY CHOPPED FRESH ROSEMARY
6 (2$^{1}/_{4}$-OUNCE) SLICES PORK LOIN ($^{1}/_{2}$-INCH THICK)
$^{2}/_{3}$ CUP FRESH BREAD CRUMBS
BUTTER, *for frying*
LEMON WEDGES, *to serve*

PORK SCHNITZELS

This easy dish can be made at the last moment or way beforehand. Schnitzels are great for a picnic or in sandwiches and are quite adaptable to any smorgasbord. You could add a little ginger and soy to the marinade for an oriental touch, or leave out all the garlic and herbs and make it completely plain, using any type of meat — chicken, lamb chops, veal, beef, or turkey. Serve plain, with lemon, or with a special mayonnaise such as balsamic or lemon tarragon. We always made an enormous pile of these in our house as they are great eaten cold the next day. The pile would get smaller and smaller, until eventually just the empty plate sat alone in the fridge and my mother would be left serving salad, sautéed potatoes, and bread for the next day's lunch.

Whisk the eggs in a large bowl. Season with salt and pepper, then whisk in the garlic, paprika, and rosemary. Put the slices of pork in the egg mixture, turning them over to make sure they are all well coated. Let it marinate for at least 15 minutes.

Put the bread crumbs on a plate. Take the meat out of the marinade, letting the excess drip off, and then pat into the bread crumbs on both sides, pressing down with the heel of your palm to make sure that the bread crumbs stick.

Heat enough butter in a saucepan to shallow-fry the meat. Add the pork and fry quickly, turning so that both sides are nicely golden brown and the meat is cooked through. You could add a little olive oil if you are nervous about the butter burning, but it shouldn't be a problem. If your pan is not big enough to accommodate all the slices, cook them in two batches, but you may have to wipe out the pan between batches. Serve hot, at room temperature or cold, with a squeeze of lemon juice and a little extra salt if necessary.

Finland

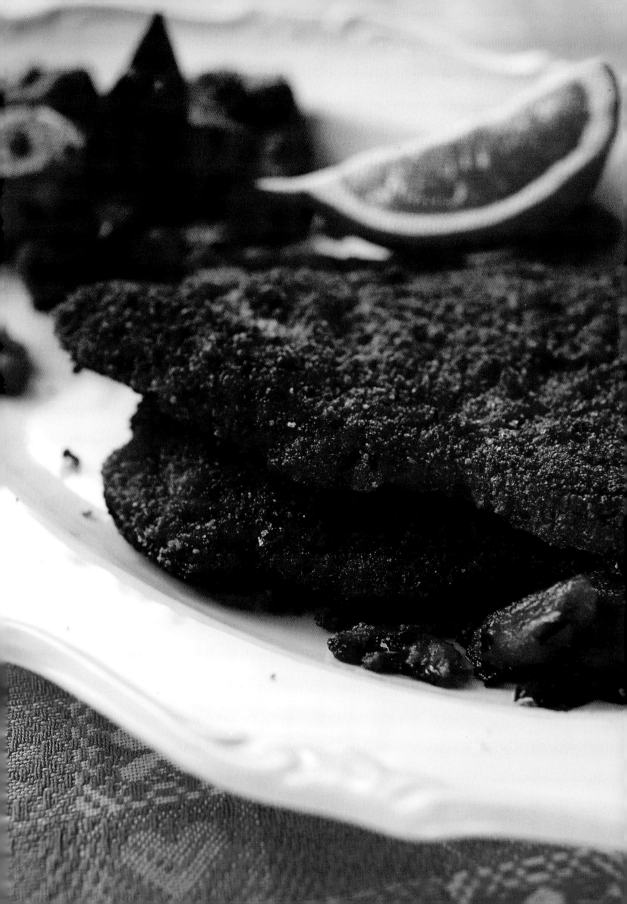

Serves 3 as a side dish

1³/4 POUNDS (4 TO 5 MEDIUM) POTATOES, *peeled and*
 cut into 1¹/4 inch chunks
2 TABLESPOONS OLIVE OIL
1 RED ONION, *chopped*
2 TABLESPOONS BUTTER
2 GARLIC CLOVES, *lightly crushed with the flat of a knife*
1 TEASPOON CHOPPED FRESH THYME
1 FRESH BAY LEAF
2 TABLESPOONS CHOPPED FRESH PARSLEY

SAUTÉED POTATOES

These are nice with sausages and mustard, schnitzels, pork chops...just about any meat.

Boil the potatoes in salted water for 10 minutes or so, until they are cooked through but not too soft. Drain well.

Heat half the oil in a nonstick skillet. Add the onion and sauté gently for about 15 minutes, until it is softened and beginning to look a bit sticky in the pan. Transfer to a plate and wipe out the pan if necessary.

Add the butter and remaining oil to the pan. Add the potatoes, garlic, and thyme, and sauté over medium heat. Once the bottoms of the potatoes begin to brown, decrease the heat slightly and let them get crusty and golden, tossing carefully from time to time. Take care not to break them up too much and try to keep them more or less in one flat layer. If the garlic looks like it is browning too much, sit it on top of the potatoes. After nearly 20 minutes, add the bay leaf and continue to sauté.

When the potatoes are quite golden and crisp in parts (like a cross between soft-boiled potatoes and fries), toss with the onion and parsley, cook for another minute or so, and then remove from the heat. Season with salt and pepper before serving.

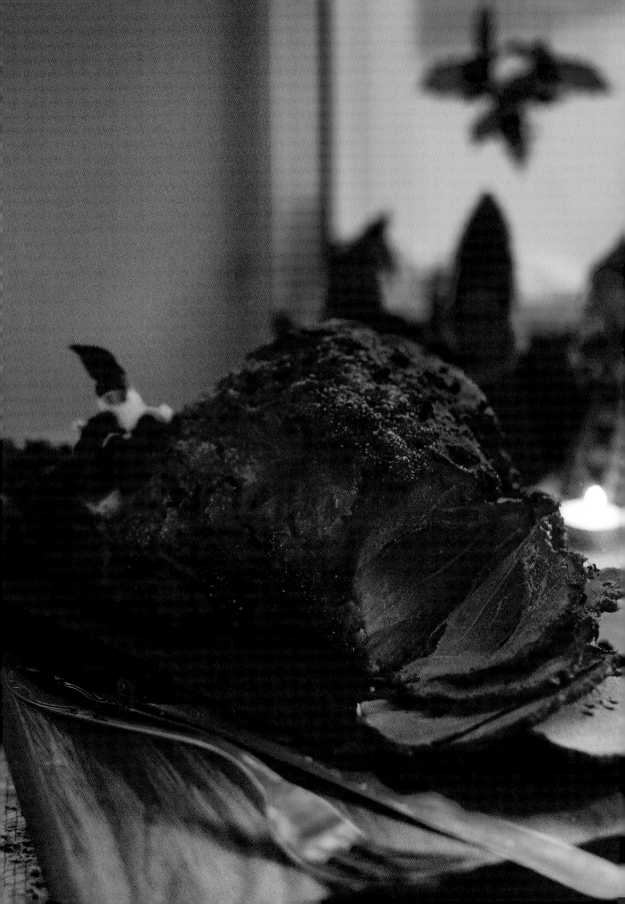

Serves 16

13-POUND HAM
1 CUP FRESH BREAD CRUMBS
$^{1}/_{2}$ CUP BROWN SUGAR, *firmly packed*
1 QUANTITY FINNISH MUSTARD (PAGE 27)
12 TO 15 WHOLE CLOVES

BAKED
HAM

 This is a classic in my family. We always had this for our "Scandinavian" Christmas Eve dinner, when the ham was often decorated with red and white ribbons tied around the bone. It is wonderful for the days that follow as well, as it is so big and people can just slice bits off whenever they feel like it. Often a pea soup is made with the leftover bone. It is easy to find a ready-salted ham in most parts of the world, although in Italy I cannot, so I often prepare it myself. Because I don't use saltpeter for the preserving, my ham is not as pink as those you will buy. If you are going to cure your ham yourself, you should be extra careful with the brining process, especially if you won't be using a preserving agent. I buy a leg of pork of about 15 pounds and I mix 4 tablespoons of salt and 2 tablespoons of sugar and rub it over the cleaned and skinned pork, then leave it for a day in a cool place. Next, I boil up a brine for a few minutes, using $1^{3}/_{4}$ pounds of salt, $10^{1}/_{2}$ quarts of water, 10 peppercorns, and a few bay leaves. When this has cooled completely, I sink the pork leg in, making sure it is completely covered in liquid, and leave it for about 8 days, turning it over from time to time. Then I rinse it with cold water, pat it dry, sprinkle it with salt and pepper, and wrap it in foil. I bake it at 425°F for 30 minutes, then turn the oven temperature down to 350°F, and bake it for another $3^{1}/_{2}$ hours. I turn it from time to time, until the ham is cooked through and hardly any liquid oozes out if I poke it with a skewer. Let it cool for a bit, before glazing it as follows.

Put the ham on an oven rack with your hands as the mustard will start melting. Sprinkle the bread crumb and sugar mixture all over the ham, throwing handfuls at the side to make it stick. Spike cloves in the top of the ham to make a rough diamond pattern. Only the very underneath of your ham should be bare.

Bake the ham for 45 minutes to 1 hour, or until the top is golden and crusty, turning the oven temperature up a bit for the end of the cooking if necessary. Let the ham cool before slicing. Serve with Finnish mustard and lingonberry jam.

Syksyn
Koriste-
Kurpitsat

1,5 €

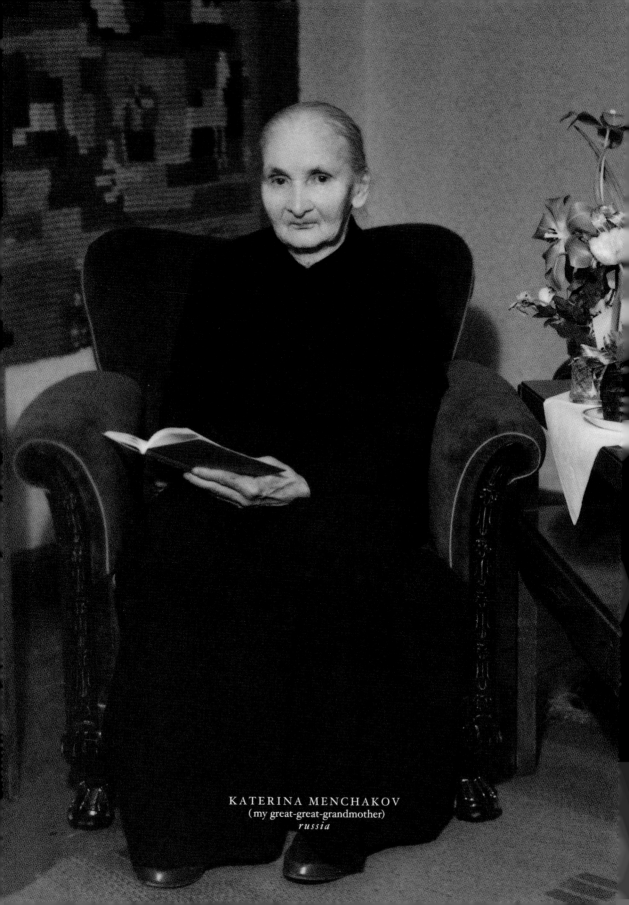

KATERINA MENCHAKOV
(my great-great-grandmother)
russia

Serves 6 as a side dish

3 POUNDS (9 TO 10 MEDIUM) POTATOES
3 RED ONIONS, *chopped*
3 CUPS HEAVY WHIPPING CREAM

OVEN-COOKED POTATOES WITH ONIONS AND CREAM

This is definitely my mother's special dish: I always remember her making it to go with the baked ham for Christmas. Serve these deliciously soft and very creamy potatoes with a simple roast meat, slices of baked ham, or a roast chicken. They are more attractive as a partner to simply cooked meats and might be too heavy with a rich dish, although this depends on your own taste. You could easily add fresh chopped herbs to the potatoes before cooking.

Preheat your oven to 375°F. Cut the potatoes into small fries, about 2 by $^1/_4$ inch. Put them in a shallow baking pan, add the onions, and season well with salt and pepper. Mix together thoroughly with your hands. Drizzle the cream over the top, making sure it covers all the potato. Cover the dish with aluminum foil and bake for about $1^1/_2$ hours. Remove the foil and bake for another 30 minutes, or until the potatoes and onions are really soft and have absorbed most of the cream. There should still be a little thickened liquid in the pan. Serve not too hot.

Serves 6 as a side dish

6 FAIRLY LARGE POTATOES
3¹/₂ TABLESPOONS BUTTER
2 TABLESPOONS OLIVE OIL
A SMALL HANDFUL OF FRESH SAGE

HASSELBACK POTATOES

Hasselbacks are gorgeous: they have style and show up a beautiful crust and texture. They look a bit like Persian shutters. Try adding a couple of tablespoons of pesto (page 306) to the cooked potatoes, spooning the pan juices over as well so that they are nicely oiled and the pesto runs into the cavities. Roast them for another 5 or 10 minutes and serve immediately. A nice, not-too-hot, grainy mustard works well, too. Choose rounded potatoes that will sit nicely on the pan once they have been halved and still have a good bulge of volume to sculpt.

Preheat your oven to 425°F. Peel the potatoes and cut them in half lengthwise. Sit them, flat side down, on a chopping board. Using a small, sharp knife, start at one end of the potato and cut down through the top, about a third of the way through. Make another tiny cut away from the first, slightly on the diagonal toward the first cut, and break away the little piece of potato to make a slit. Continue along the potato, making slits about ¹/4 inch apart.

Handling the potatoes carefully so that they don't break, arrange them in a baking pan. Add the butter and oil and season with salt and pepper. Scatter the sage leaves around and bake for 45 minutes to 1 hour, or until the potatoes are golden and crispy. Spoon a little of the buttery pan juices over the top from time to time and gently toss them so they don't stick (but don't touch them for the first 15 minutes or so, or they will simply break). Serve immediately.

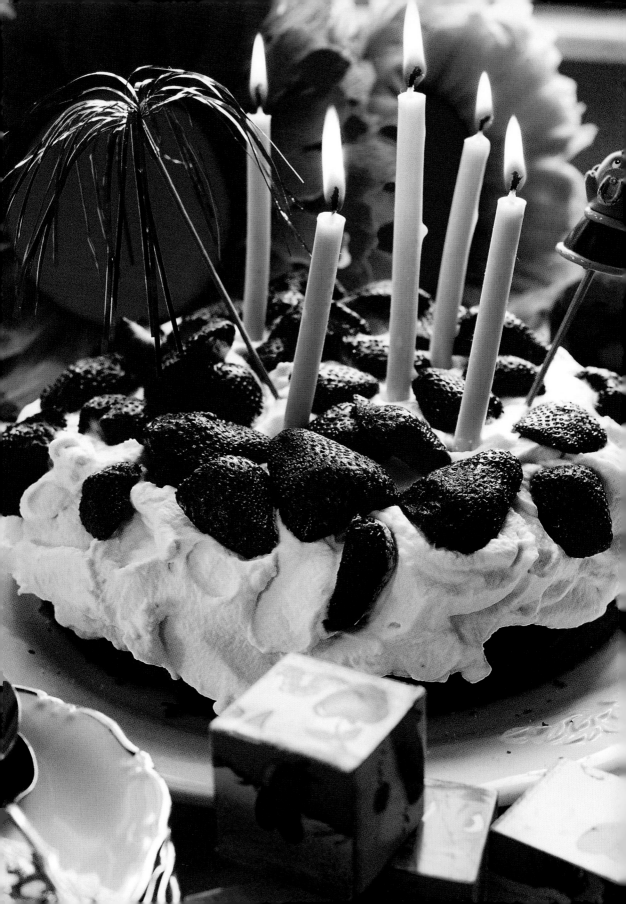

Serves 8 to 10

1¾ CUPS ALL-PURPOSE FLOUR, *plus extra for dusting*
¾ CUP SUGAR
3 TEASPOONS BAKING POWDER
1½ STICKS BUTTER, *melted*
¾ CUP WARM MILK
4 EGGS, *separated*
1 TEASPOON VANILLA EXTRACT
1¾ POUNDS (5 CUPS) WHOLE STRAWBERRIES
1 TEASPOON LEMON JUICE
4 TABLESPOONS CONFECTIONERS' SUGAR
3 CUPS HEAVY WHIPPING CREAM

SIPI'S
STRAWBERRY
CAKE

The Finns are crazy about strawberries and my mother's kitchen is always full of them. This is the cake my mother still makes for a celebration. It is so lovely; really pure and pretty, just like the Finns.

Preheat the oven to 350°F. Grease and flour an 8½-inch springform cake pan, or a Bundt pan.

Put the flour and sugar in a bowl with 1 teaspoon of the baking powder. Mix in the butter and then stir in the milk. Add the egg yolks and vanilla and beat in well. Whisk the egg whites to soft peaks, incorporating the rest of the baking powder when the eggs have started fluffing up. Fold the whites into the cake mixture.

Pour the batter into the cake pan and bake for about 1 hour, or until a skewer inserted into the center comes out clean and the top is deep golden and crisp. Remove from the oven and let cool a bit before turning out onto a rack. When cool, slice the cake in half horizontally and put the bottom half on a large serving plate.

Clean the strawberries and hull them (leave a few unhulled, if you prefer to see them that way on top of the cake). Dice about half the strawberries and sprinkle with a little lemon juice and 1 tablespoon of the confectioners' sugar. Whip the cream into stiff peaks with the remaining confectioners' sugar. Mix the diced strawberries with about a third of the whipped cream and spoon over the bottom of the cake. Put the other half of the cake on top and thickly spoon the remaining cream over the top and side, then decorate with the rest of the strawberries. This is best eaten immediately. Any leftovers will keep for a day in the refrigerator.

Finland

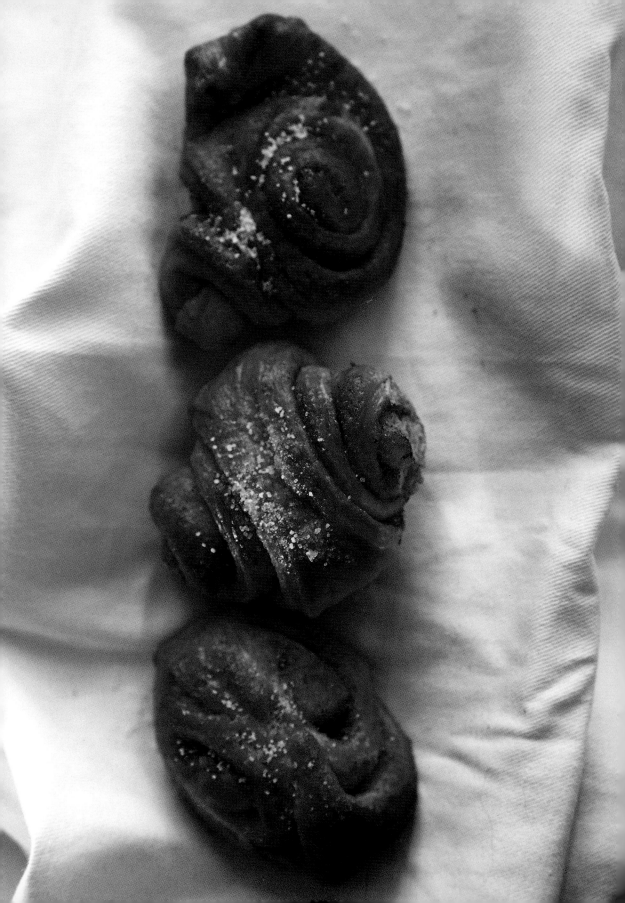

Makes about 35 buns

bun dough
1 CUP LUKEWARM MILK
$^1/_2$ CUP SUPERFINE SUGAR
1 (1-OUNCE) CAKE FRESH YEAST
1 EGG, *lightly beaten*
$^1/_4$ POUND PLUS 1 TABLESPOON BUTTER, *softened*
2 TEASPOONS GROUND CARDAMOM
1 TEASPOON SALT
$5^1/_4$ CUPS ALL-PURPOSE FLOUR

cinnamon butter
2 TEASPOONS GROUND CINNAMON
$^1/_4$ CUP SUPERFINE SUGAR, PLUS 1 TABLESPOON
 for sprinkling
$5^1/_2$ TABLESPOONS BUTTER, *softened*
1 EGG, *lightly beaten*

CINNAMON AND CARDAMOM BUNS

These gorgeous buns were always a part of my childhood. They are found everywhere in Finland — and probably all over Scandinavia — in tearooms and houses. Everyone makes their own and they freeze beautifully so you can just pull out a few when a craving sets in. Don't be put off when you see that the buns need to rise for a couple of hours. You can get the dough together really quickly and then leave it alone without even a glance. The rolling and cutting can be a little tricky the first time you do it, but the second time will be easy.

Put the milk and sugar in a bowl and crumble in the yeast. Let stand for 10 minutes, or until the yeast begins to activate. Add the egg, butter, cardamom, and salt, and mix in. Add the flour, bit by bit, mixing it in with a wooden spoon until you need to use your hands, and then turn it out onto the work surface to knead. It may seem a little too sticky initially, but will become compact and beautifully soft after about 5 minutes. Put the dough back in the bowl, cover with a clean cloth and then a heavy towel or blanket, and leave in a warm place for about 2 hours, or until it has doubled in size.

To make the cinnamon butter, mix together the cinnamon and sugar. Divide the butter into four portions and set side.

Put the dough on a floured work surface and divide it into four portions. Begin with one portion, covering the others with a cloth so they don't dry out. Using a rolling pin, roll out a rectangle, roughly about 12 by 10 inches and $1/8$ inch thick. Spread one portion of butter over the surface of the dough with a spatula or blunt knife. Sprinkle with about 3 teaspoons of the cinnamon mixture, covering the whole surface with quick shaking movements of your wrists. Roll up to make a long dough sausage. Set aside while you finish rolling out and buttering the rest of the dough, so that you can cut them all together.

Line two large baking sheets with parchment paper, or bake in two batches if you only have one sheet. Line up the dough sausages in front of you and cut them slightly on the diagonal, alternating up and down, so that the slices are fat V shapes, with the point of the V about $3/4$ inch and the base about 2 inches. Turn them so they are all the right way up, sitting on their fatter bases. Press down on the top of each one with two fingers, until you think you will almost go through to your work surface. Along the sides you will see the cinnamon stripes oozing outward. Put the buns on the baking sheet, leaving space for them to puff and rise while they bake. Brush lightly with beaten egg and sprinkle a little sugar over the top.

Let the buns rise for half an hour and preheat your oven to 350°F. Bake them for about 20 minutes, or until they are golden. Check that they are lightly golden underneath as well before you take them out of the oven. Serve hot, warm, or at room temperature and, when they are cool, keep them in an airtight container so they don't harden.

Sisi's fishing trips

My mother used to go fishing on the lakes with a rod and come home, glowing, carrying an aluminum bucket full of long bream. The fishermen had been busy with their nets and the market would later be spilling over with wooden boxes of herrings — all stacked on top of each other and shining in their silver jackets.

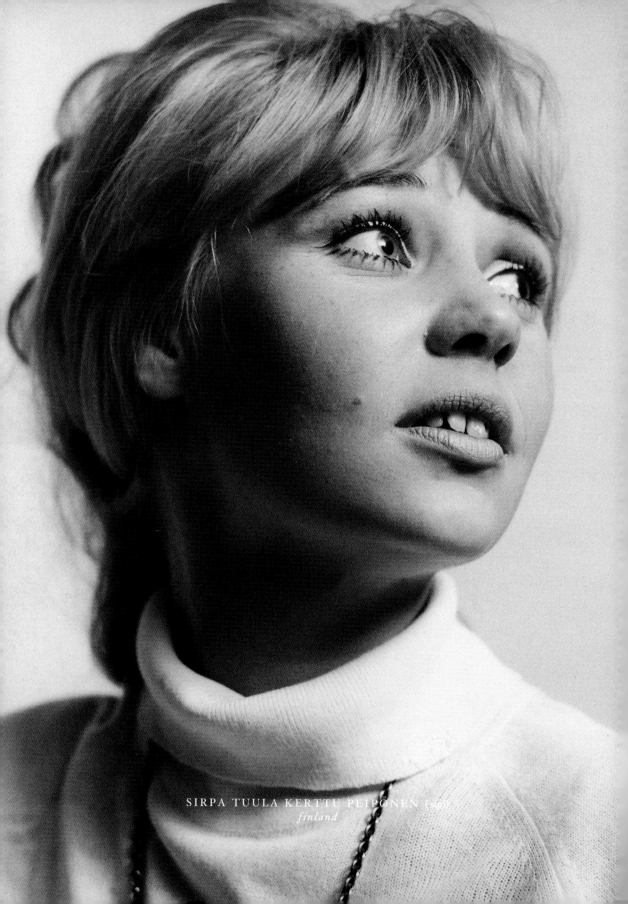

SIRPA TUULA KERTTU PEIPONEN (sip)
finland

Serves 6 to 8

5 CUPS (1¾ POUNDS) FRESH *or* FROZEN
 CRANBERRIES *or* SIMILAR BERRIES
1½ CUPS SUPERFINE SUGAR

CRANBERRY SORBET

This is stunning: refreshing, slightly tart, and such an inspiring color to bring out of your kitchen. Sometimes I like to serve it with a shot of vodka or a gentle blob of whipped cream alongside. You could also add a little liqueur to the sorbet if you like. Unfortunately, this doesn't work too well without an ice-cream machine — you can beat it by hand, but you will end up with a sort of granita instead of a sorbet.

Wash the berries. Put in a saucepan with the sugar and 3½ cups of water. Cover the pan and cook, stirring occasionally, for 10 minutes, or until the berries are soft. Purée, strain, and let it cool, before freezing in your ice-cream machine according to the manufacturer's instructions.

The berries were always collected in the summer, some one by one and others in clumps. Baskets hung over one arm, they set off. There were so many wild berries — strawberries, blueberries, blackberries, cloudberries, greenberries, raspberries, gooseberries...just berries, berries everywhere. They would eat them plain at first then, later, press them into juice or stir them until they turned into jam.

OREGANO, ORANGES, + OLIVE GROVES

Greece

I love the orange trees lining winter Athenian avenues. And the people who open their doors and their hearts to you. I love the Greek markets with baskets of gorgeous red just-flowered pistachios, piles of figs, and very wild hilltop greens sitting next to indifferent mountains of underwear. Everywhere, among the pervasive smell of fresh oregano, there is an atmosphere of people doing their own thing, each stepping in tune to their own internal guide. Greece is magnetic, they say. Once you have stepped on Greek ground it's hard to shake yourself free. Myth has it that it's because your feet become stuck in the rich honey coating this country. It's the only place where people have always wished me a good week, month, day, summer, winter, life, work...and a birthday wish to grow old with white hair.

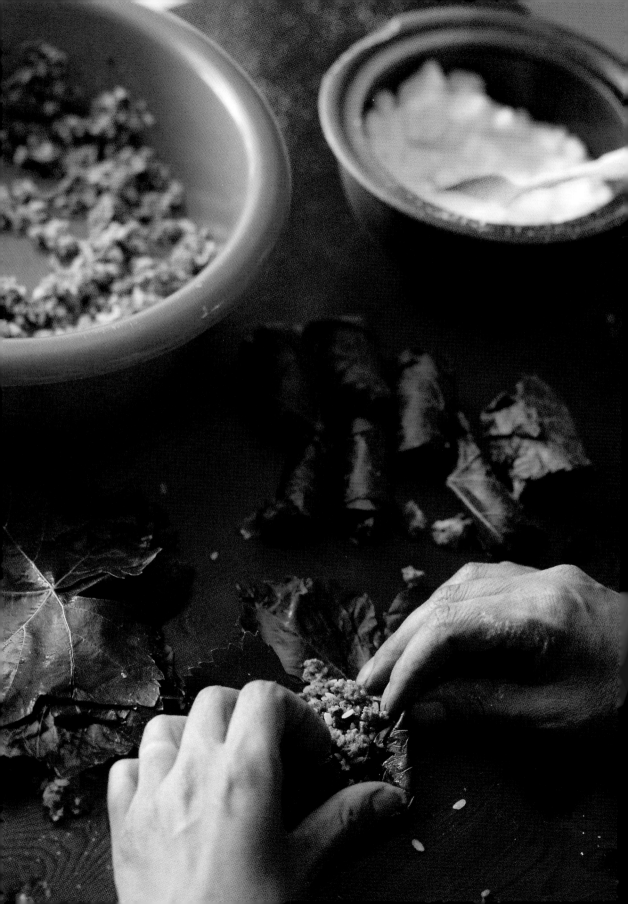

Makes about 26

5 TABLESPOONS OLIVE OIL
1¼ POUNDS MIXED GROUND PORK AND BEEF
3 SCALLIONS, *finely chopped*
3 RIPE TOMATOES, *grated or peeled and puréed*
3 TABLESPOONS ROUGHLY CHOPPED
 FRESH PARSLEY
1 TEASPOON DRIED MINT, *crumbled*
½ TEASPOON GROUND CINNAMON
½ CUP UNCOOKED LONG-GRAIN RICE
26 (8 OUNCES) VINE LEAVES (1 POUND *if bought in brine*)
2½ TABLESPOONS BUTTER
JUICE OF 1 LEMON, *plus extra, to serve*
PLAIN GREEK YOGURT, *to serve*

DOLMADES
(STUFFED VINE LEAVES)

You can use fresh vine leaves or those bought in brine, but if you use frozen you'll need to blanch them in boiling water first. Also, you can try adding pine nuts, raisins, or other fresh herbs to the filling.

To make the filling, heat 3 tablespoons of the olive oil in a nonstick saucepan. Add the meat and sauté until it is just cooked and has begun to turn golden in places. Add the scallions and sauté for a couple of minutes to soften. Season with salt and pepper. Add the tomatoes, parsley, mint, cinnamon, and rice, and mix very well, cooking for an extra minute or so to slightly soften the rice. Remove from the heat and let cool slightly.

Prepare the vine leaves. Layer five or six imperfect leaves on the bottom of a large saucepan to prevent the dolmades' sticking. Take another leaf and, holding it in your palm (shiny side down), put a tablespoon or so of filling neatly in the middle. (If your leaves are small you can use two together, slightly overlapping them.) To wrap up the leaves snugly, fold up the bottom part, then fold one side tightly over the stuffing, fold down the top part, and then fold the other side around. Then roll it up to make a compact bundle. (You can make the dolmades as small as you like; just take care not to stretch the leaves too much or they may tear.) Layer the dolmades over the vine leaves lining the pan, making two or three layers if necessary. Dot with the butter and add about 3 cups of water. Drizzle the lemon juice and remaining olive oil over the top and season with a little salt.

Turn a plate upside down and put it on top of the dolmades so that it fits tightly in the saucepan and will hold them in shape while cooking. Bring to a boil, then decrease the heat, and simmer for about 1 hour, or until the dolmades are soft and juicy. There should still be some liquid in the bottom of the pan; if not, add a bit more water toward the end. Serve the dolmades hot or cold with lemon juice and a dollop of yogurt.

Serves 6 to 8

2 GARLIC CLOVES, *very finely minced*
2 TABLESPOONS OLIVE OIL
1 TABLESPOON LEMON JUICE
1 SMALL CUCUMBER
1 TEASPOON SALT
2$\frac{1}{2}$ CUPS THICK PLAIN GREEK YOGURT
2 TEASPOONS DRIED MINT

TZATZIKI
(YOGURT, CUCUMBER,
GARLIC, AND MINT DIP)

Use as much garlic as you like: this recipe has only two cloves. You could also soak the garlic in olive oil and then just strain the oil into the dip if you are against too much garlic. This is wonderful with grilled lamb, souvlaki, souvla, or sheftalia; and it does well on a mixed meze platter with little meatballs and pita bread for dipping. It is very versatile and you could make other variations to suit whatever you're serving. For grilled salmon or tuna you could add freshly chopped cilantro or dill to the yogurt.

Put the garlic, olive oil, and lemon juice in a small bowl and set aside.

Peel the skin off the cucumber lengthwise in alternate stripes — miss one, do one. Grate the cucumber coarsely and put it in a fine sieve in the sink. Sprinkle with the salt and leave for about half an hour to let the juices drip away. Squash it with your hands or a wooden spoon to extract the liquid (this will prevent your tzatziki's being watery).

Put the yogurt in a bowl and stir in the mint, crushing it between your fingers as you add it. Add the garlic mixture and cucumber and season with some black pepper. Mix through well, and taste for salt before serving.

If you aren't serving it immediately, store in a covered container in the fridge, where the flavors will mature. It should keep for a couple of days.

Serves 8 to 10

2 SLICES BREAD, *crusts removed*
1/2 RED ONION
1 (4 1/2-ounce) TARAMA (CARP ROE) (or smoked cod roe)
1 1/3 CUPS LIGHT OLIVE OIL
JUICE OF 2 LEMONS

TARAMASALATA

This is a well-known Greek dip traditionally made from smoked gray mullet roe, but you can also use smoked cod roe. I like it a pale creamy salmon-beige color, although it is often available in a brighter pink. The actual roe, which you may have to order from your fishmonger, is a burgundy-maroon color and is strong and impossible to eat on its own. Taramasalata is served with bread or pita, and also goes nicely on a meze with some raw vegetables for dipping. You could serve it alongside other fish meze, such as a small plate of grilled octopus or some deep-fried calamari.

Soak the bread in a little water until it is soggy and then firmly squeeze out all of the water. Finely grate the onion and then squeeze the juice into a bowl (discard the onion pulp).

Put the tarama in a mixing bowl with the bread. Whisk together briefly with a handheld blender. Gradually add the olive oil slowly, whisking continuously. If it looks like curdling at any stage, add some of the lemon juice and whisk again until all of your olive oil is used up. Beat in the lemon and onion juices. You should have a lumpy-looking mayonnaise. Transfer to a blender and purée until just smooth, being careful not to overmix. This step may not be necessary if you achieve a smooth purée with the handheld blender. Transfer the taramasalata to a serving bowl. It will keep well, covered in the refrigerator, for a couple of days.

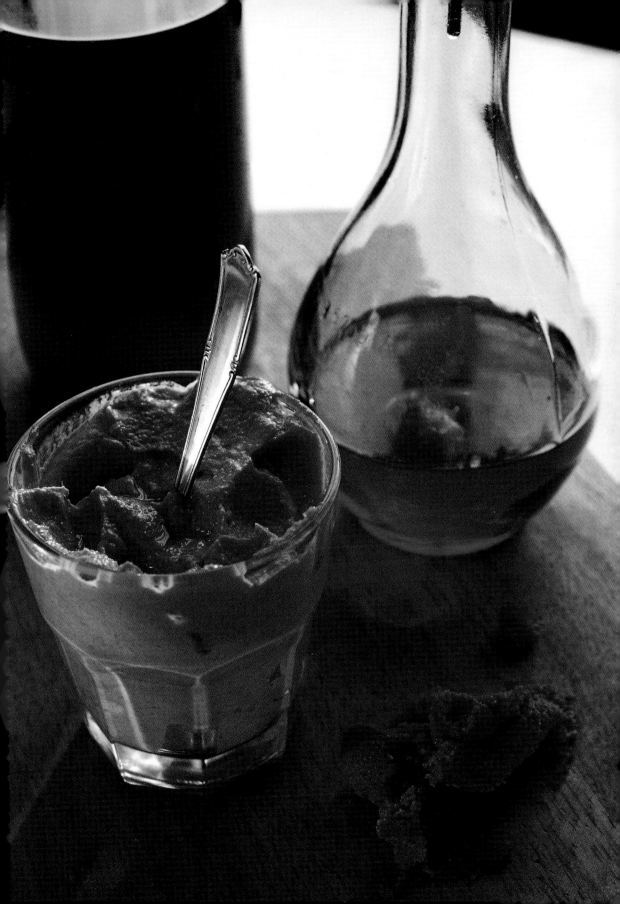

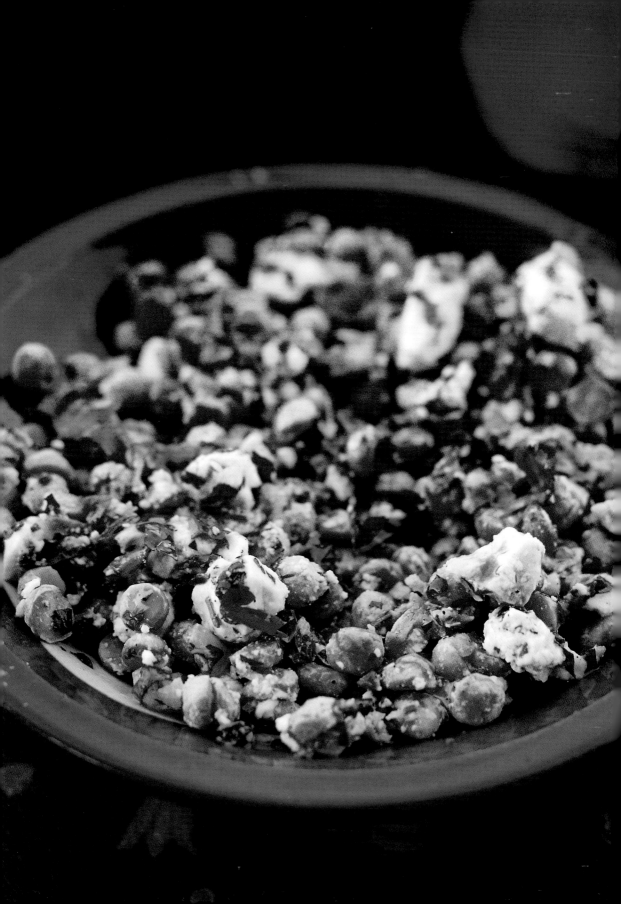

Serves 6 as a side dish

1¹/4 CUPS DRIED CHICKPEAS (*without skins if possible*),
 soaked overnight in cold water, or
1 (14-OUNCE) CAN CHICKPEAS
1 CUP OLIVE OIL
1 LARGE RED ONION, *chopped*
5 GARLIC CLOVES, *very finely chopped*
1 *or* 2 RED CHILES, *seeded and finely chopped*
1²/3 CUPS CRUMBLED FETA CHEESE
4 SCALLIONS, GREEN PART ONLY, *chopped*
¹/2 CUP CHOPPED FRESH CILANTRO
1 CUP CHOPPED FRESH ITALIAN PARSLEY
JUICE OF 1 LEMON

CHICKPEA,
FETA, AND CILANTRO
SALAD

This is my friend Stephen's way of serving chickpeas. It can be made beforehand and left to marinate for a couple of hours before being served at room temperature. Make sure that everything has cooled before you mix it all together, or else the feta will melt. I bought skinned chickpeas in Greece, which worked well and, if you need to be a little more spontaneous, you can use canned chickpeas. Serve with chicken breasts or lamb chops that have been marinated in cumin and yogurt and then grilled.

If you're using canned chickpeas, just rinse them and put them in a bowl. Otherwise, rinse the soaked chickpeas, put them in a saucepan, cover generously with water, and bring to a boil. Decrease the heat slightly and cook for 1 to 1¹/2 hours, until they are soft but not falling apart, adding salt toward the end of the cooking time. Leave them in their liquid if you will not be making the salad right away. When cooled, drain and put the chickpeas in a large bowl, picking out as many of the loose skins as you can. (You can put them in a colander and shake roughly or rub them around with your hands, then pick out the skins.)

Heat 3 tablespoons of the olive oil and fry the red onion gently, until it is cooked through and lightly golden. Add the garlic and chile and cook for a few more seconds, until you can smell the garlic. Take care not to brown the garlic. Let cool completely.

Add the feta, scallion, cilantro, parsley, and lemon juice to the chickpeas and season with pepper and a pinch more salt, if needed. Add the cooled garlic oil and the remaining olive oil and mix very well.

Serves 4

1 (3-POUND) WHOLE CHICKEN
1 WHITE ONION
1 CELERY STALK WITH LEAVES, *cut into large chunks*
1 LARGE CARROT, *cut in half*
A FEW PARSLEY STALKS
A FEW BLACK PEPPERCORNS
$^1/_2$ CUP LONG-GRAIN RICE, *rinsed*
2 EGGS
JUICE OF 2 LEMONS

AVGOLEMONO (CHICKEN SOUP WITH EGG AND LEMON)

You could easily add some thyme sprigs or other herbs to inauthentically infuse the broth of this classic Greek soup. My aunt even makes avgolemono with lamb instead of chicken, to celebrate the end of the fast for Easter. It is rich and delicious, simple and nourishing, and gives you two courses from one recipe (the soup and then the beautiful poached chicken). Egg and lemon is very popular as a finish for soups and sauces in Greek cooking.

Rinse the chicken well and put it in a large stockpot with the onion, celery, carrot, parsley stalks, peppercorns, and a good sprinkling of salt. Cover with about 14 cups of cold water and bring to a boil. Skim the surface with a slotted spoon, decrease the heat, and simmer, uncovered, for about 1$^1/_2$ hours, skimming occasionally. Lift the chicken out onto a plate with a slotted spoon. Strain the broth through a sieve, pressing down lightly on the vegetables with your wooden spoon to extract the flavor. You should have about 6 cups of broth. Return this to the saucepan, add the rice and cook over medium heat for another 15 minutes or so, until the rice is cooked.

Whisk the eggs until they are fluffy. Add the lemon juice. Add a ladleful of hot broth to the egg, whisking to stop it from scrambling. Whisk in a little more broth, then add the entire egg mixture to the pan. Return the saucepan to the lowest possible heat for a few minutes to warm the egg through. Add some salt and pepper, and serve immediately. If you like, shred one of the chicken breasts and scatter over the soup. Serve the rest of the chicken as a second course.

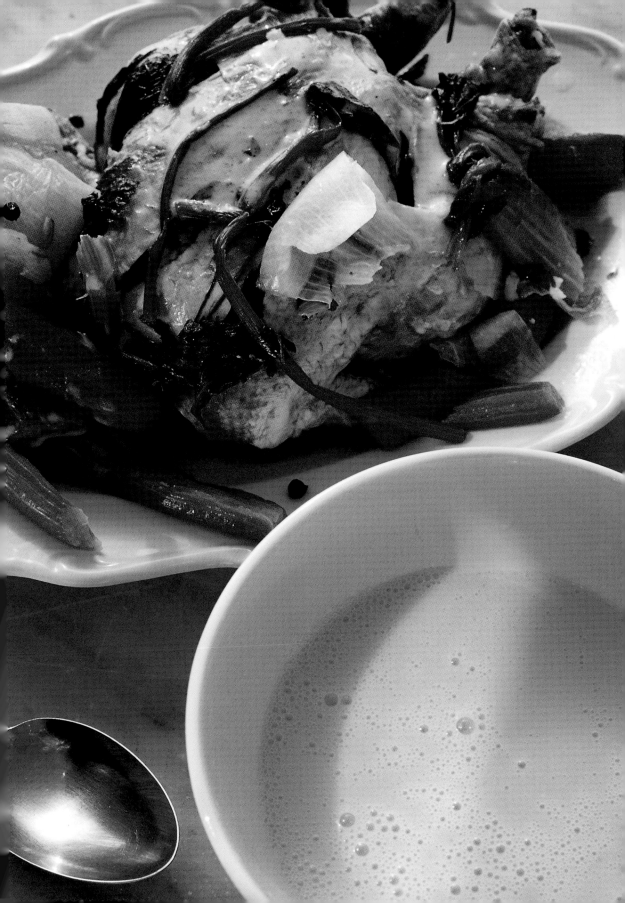

I always long for those lunches that begin anywhere between noon and five p.m. and end only when the owner decides it's time to drag the tables off the beach and back across the road. We linger now, on the sand, finishing off our frappés in glasses that we will later deposit on the taverna's doorstep.

On our way back we are twice blessed — with the haphazard washing lines of octopus silhouettes and a Greek sunset.

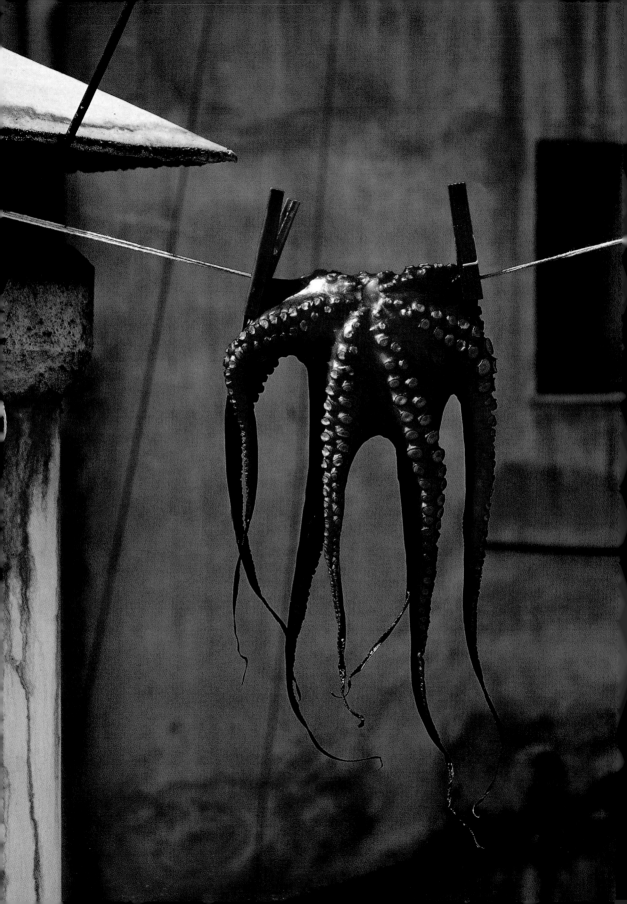

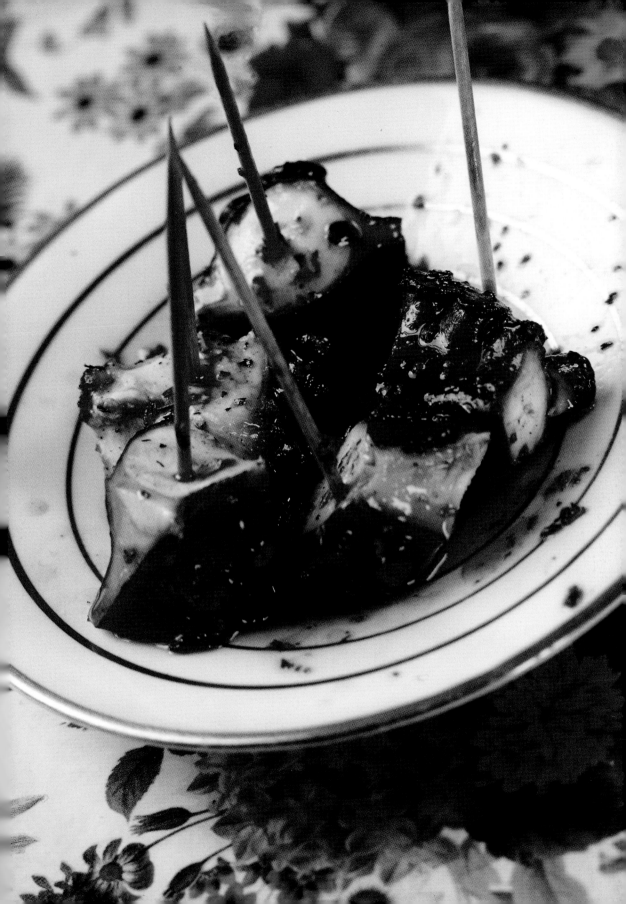

Serves 4

1 WHOLE OCTOPUS
1/2 CUP OLIVE OIL
3 TABLESPOONS RED WINE VINEGAR
1 TEASPOON DRIED OREGANO

GRILLED OCTOPUS WITH OREGANO

In Greece you will often see the whole octopus left hanging out in the sun to dry. Some cooks will also boil it for a bit before grilling on the barbecue, to ensure that it remains soft. So, if you can, hang out your octopus in the sun for a few hours beforehand, until the legs have dried and curled up a bit. I think this would go well with a fennel salad. And it is often served with a glass of ouzo on ice.

Heat the barbecue grill to hot. Cut the head off the octopus just below the eyes. Remove the beak by pushing it out through the center of the tentacles. Cut the eyes from the head by slicing off a small round. Remove the intestines by pushing them out of the head. Rinse the octopus thoroughly.

Put the octopus on the grill and turn once there are a few charred bits (otherwise it will start to taste steamed). Transfer to a serving platter and slice into chunks.

Mix together the olive oil, vinegar, and oregano, and season with salt and pepper. Drizzle the dressing over the octopus and serve immediately.

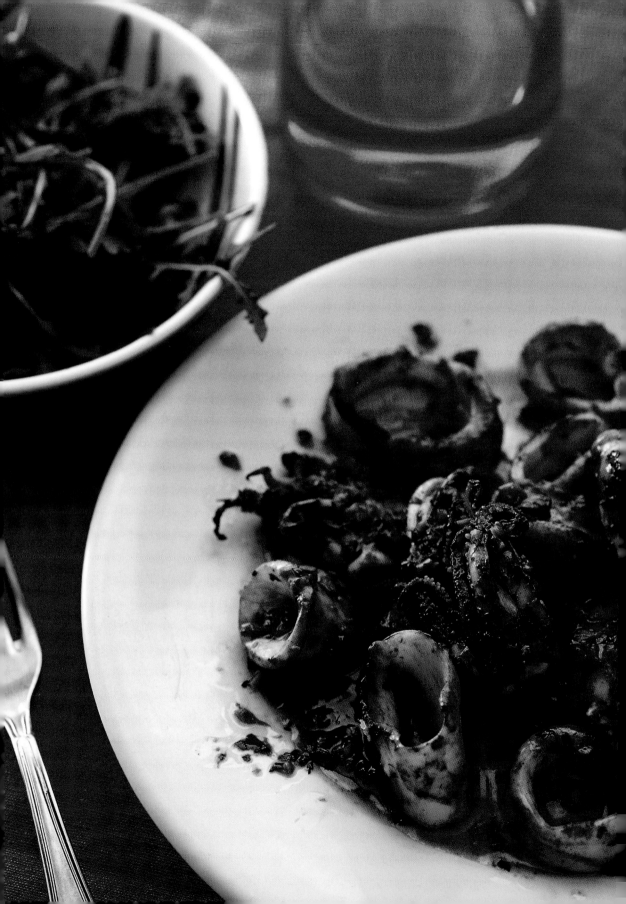

Serves 4 to 6 as an antipasto or 3 to 4 as a light meal

2¹/4 POUNDS CALAMARI (preferably baby calamari)
7 TABLESPOONS BUTTER
JUICE OF 1¹/2 LEMONS
3 GARLIC CLOVES, *finely chopped*
2 TABLESPOONS CHOPPED FRESH PARSLEY
LEMON WEDGES, *to serve*

CALAMARI WITH BUTTER, LEMON, AND GARLIC

This must be cooked in a really hot grill and then combined with the sauce to serve. You could also add a little chile here if you like. Serve with white rice or pasta, or just bread to wipe up the buttery garlic.

To clean the calamari, pull the tentacles away from the body. Remove the transparent bone from inside the body and rinse the body well under cold running water. Holding the tentacles firmly with one hand, squeeze out the little beak and cut it away, leaving the tentacles whole. Rinse the tentacles. Cut the body into rings about 1 inch thick, leaving the tentacles whole (if they seem particularly large, cut them in half). Pat dry.

Heat the butter in a saucepan and, when it sizzles, add the lemon juice. Season with salt and pepper. Add the garlic and let it sizzle for a moment to flavor the butter but not burn. Stir in the parsley and remove from the heat.

Heat a ridged stovetop grill to very hot (it should be just about smoking). Scatter with about half the calamari in a single layer (you will have to do it in two batches) and cook it over the highest possible heat. When you see that the calamari has darkened in parts on the underside, turn over with tongs and cook until the other side is darkened (take care that it doesn't burn, though, or it will taste bitter). Move it around in the grill with a wooden spoon and let it cook for a couple of minutes more, then add it to the warm butter in the saucepan while you cook the next batch. Season to taste if necessary and serve hot, directly from the pan, with lemon wedges.

Serves 2 to 3

2¹/4 POUNDS SALT COD, *soaked in cold water for 2 days*
LIGHT OLIVE *or* CORN OIL, *for deep-frying*
³/4 CUP ALL-PURPOSE FLOUR, *for dusting*
¹/2 TEASPOON DRIED OREGANO
SKORDALIA (PAGE 94), *to serve*

DEEP-FRIED
SALT COD

If you can, soak the salt cod under a dripping tap so the water is constantly changing. If you can't manage that, soak it for two days, changing the water regularly. You can taste a small piece of the fish to see how salty it still is. Serve with skordalia. (I have also seen a dressing made with olive oil, lemon juice, oregano, salt, and pepper poured over this fried fish.)

Dry the cod with paper towels and remove any bones. Cut the cod into smaller portions (about 2¹/2 inches). Half-fill a large saucepan or deep fryer with oil and heat up for frying.

Dust the fish in the flour, shaking off any excess. Lower into the hot oil and deep-fry until crispy and golden. Take care, as it becomes soft and can break. Lift out onto a plate lined with paper towels, patting on both sides to remove the excess oil. Transfer to a clean serving plate. Scatter with oregano, season with ground black pepper, and serve with skordalia on the side.

Serves 10 to 12

1 LARGE CARROT, *cut in half*
1 SMALL CELERY STALK
A FEW PARSLEY STALKS
1 SMALL ONION
A FEW BLACK PEPPERCORNS
1^{1}/4 POUNDS (4 MEDIUM) POTATOES, *peeled and cut into chunks*
5 GARLIC CLOVES
3/4 CUP OLIVE OIL
JUICE OF 1 LEMON

SKORDALIA

When you are in the mood for garlic, this is the thing. Some people make it with bread and vinegar instead of the potatoes and lemon. This is wonderful served with deep-fried salt cod.

Put the carrot, celery, parsley, and onion in a fairly large saucepan of water, add some salt and a few peppercorns, and bring to a boil. Boil for about 15 minutes before adding the potatoes and then boil for another 25 minutes or so, until the potatoes are very soft.

Meanwhile, crush the garlic completely with about 1 teaspoon of salt to make a purée. Put the garlic in a small bowl and add a couple of tablespoons of the olive oil.

Take out one-third of the potatoes with a slotted spoon and mash in a large, wide bowl with a potato masher or put through a food mill. Add the garlic, then mash another third of the potatoes with more of the olive oil and a little of the lemon juice. Continue on until you have used all the potatoes, lemon juice, and olive oil and have a smooth purée. Taste for salt. The skordalia should have a fairly soft consistency and can be eaten with fried or grilled fish, meatballs, or just on bread. Serve at room temperature.

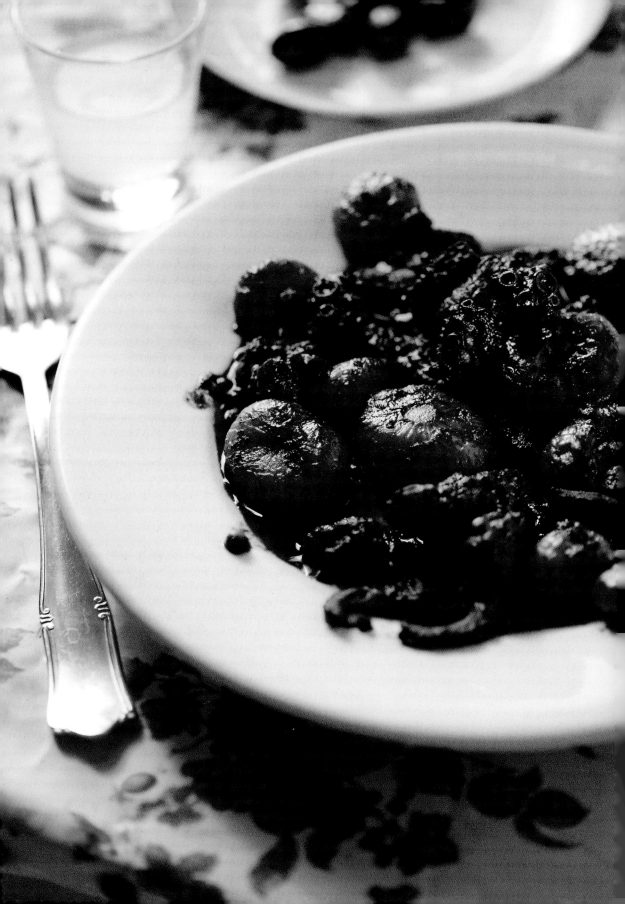

Serves 6

3¹/4 POUNDS WHOLE OCTOPUS *(preferably with thick tentacles)*
²/3 CUP OLIVE OIL
2¹/4 POUNDS (ABOUT 14) SMALL WHITE BOILING ONIONS,
 peeled and left whole
1 TABLESPOON SUGAR
3 TABLESPOONS GOOD-QUALITY RED WINE VINEGAR
3 GARLIC CLOVES, *chopped*
1 (16-OUNCE) CAN PEELED TOMATOES, *roughly chopped*
1¹/2 CUPS RED WINE
2 BAY LEAVES
1 SMALL DRIED RED CHILE, *chopped*
A PINCH OF GRATED NUTMEG
1 CINNAMON STICK
A FEW ALLSPICE BERRIES

OCTOPUS STIFADO
(OCTOPUS WITH ONIONS AND RED WINE)

This is a rich octopus and baby onion stew with red wine and spices. The same dish is also often made using rabbit or beef instead of the octopus (the cooking technique will vary slightly). It is important to let this dish sit for at least half an hour before serving, as the onions will continue to cook in the hot casserole.

Cut the head off the octopus just below the eyes. Remove the beak by pushing it out through the center of the tentacles. Cut the eyes from the head by slicing off a small round. Remove the intestines by pushing them out of the head. Rinse the head and tentacles thoroughly and cut up into chunks of about 1 inch. Put the octopus pieces in a large saucepan, cover, and cook over high heat for about 3 minutes. The octopus will create some liquid and brighten up a lot in color. Stir now and then and cook, covered, for another 10 minutes, until all the liquid has evaporated.

Meanwhile, heat a scant ¹/2 cup of the olive oil in a large saucepan. Add the onions and sauté gently until softened, stirring now and then with a wooden spoon but taking care not to break them up. When they are lightly golden, add the sugar and vinegar and continue cooking until the sauce at the bottom of the pan thickens. The onions should be quite soft now.

Add the remaining olive oil and the garlic to the octopus and sauté for a few seconds more. Add the tomato and cook for 5 minutes. Add the wine, bay leaves, chile, nutmeg, cinnamon, and allspice. Season with salt and pepper. Add 3 cups of water and bring to a boil. Decrease the heat and simmer, uncovered, for about 30 minutes.

Add the onions, mix in gently, cover the pan, and cook for another 30 minutes. Hold the pan and lid with a cloth in both hands and hula-hoop the pan around occasionally so that it doesn't stick and the onions remain whole. The octopus and onions should be barely covered with a slightly thickened sauce, but add a little more hot water if it seems necessary. Remove from the heat, cover, and let cool for about 30 minutes before serving. Serve warm, not piping hot, with your favorite bread and a salad.

Sisi's breakfasts

To this day I thank my mother for the unconventional breakfasts that she would serve as we grew up. In the mornings she would present us with leftover Greek lamb, shrimp, stuffed vegetables... the recipes are all here in this book.

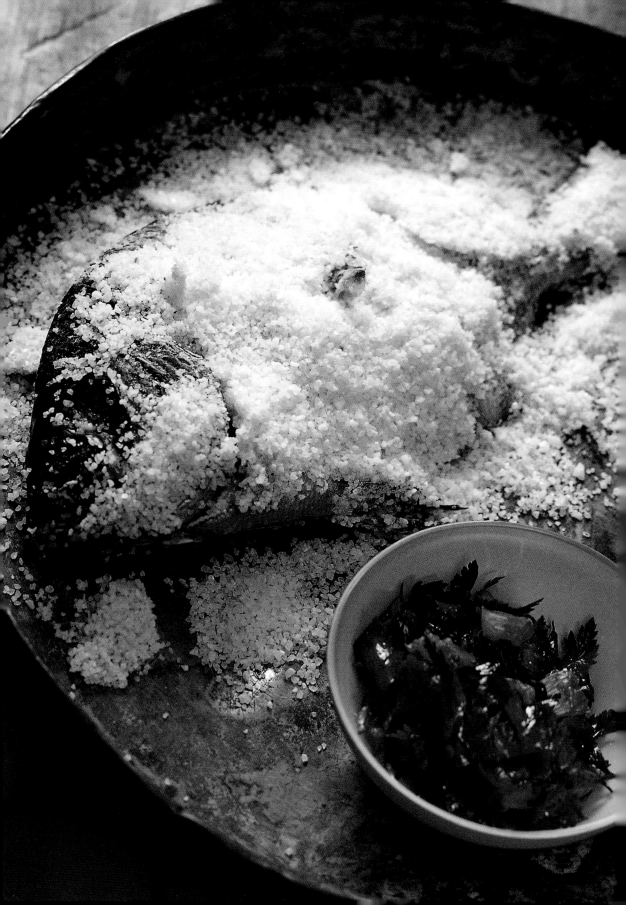

Serves 2 to 3

6½ POUNDS (ABOUT 10¾ CUPS) ROCK SALT
2¾ POUNDS WHOLE FISH, *gutted, scaled, rinsed,*
 and dried with paper towels
2 LARGE HANDFULS FRESH ITALIAN PARSLEY,
 rinsed and dried
2 LEMONS
½ TEASPOON SWEET PAPRIKA
¼ CUP EXTRA-VIRGIN OLIVE OIL

SALT-BAKED
FISH WITH LEMON AND
PARSLEY SALAD

This just seems so healthy and can serve more or less, depending on the size of the fish. Use any fish you like, estimating that about 2¼ pounds of cleaned fish will be enough for two or three people. You might like to put a few sprigs of herbs or fennel leaves, a couple of bay leaves, or lemon slices inside the cavity before cooking, although even with the fish completely plain this dish is really quite special.

Preheat your oven to 400°F. Put half of the salt in the bottom of a baking pan that is slightly larger than the fish but which still fits it quite snugly. Lay the fish on top, mounding the salt up a little over the sides of the fish. Cover the fish with the remaining salt, patting it firmly in place. Bake for about 35 to 40 minutes. To test if the fish is cooked, poke a skewer into the middle of it: the skewer should be hot when you pull it out. Transfer to a plate and crack open the salt crust. Fillet the fish into pieces that are as whole as you can manage.

While the fish is cooking, make the lemon and parsley salad. Put the whole parsley leaves in a bowl, making sure they don't have any tough stalks attached. To make lemon fillets, slice the tops and bottoms off the lemons. Sit the lemons on a board and, with a small sharp knife, cut downward to remove the skin and pith. Holding the lemon over the bowl, remove the segments by slicing between the white pith. Remove any seeds. Add the lemon fillets to the parsley and mix in the paprika and olive oil. Season with salt and pepper and squeeze out any juice from the lemon "skeletons" over the salad.

Serve the fish with a small pile of salad on top and have an extra drizzle of olive oil handy in case anyone needs more.

Serves 6 or more

4¹/₂ POUNDS LARGE RAW SHRIMP, *unpeeled*
1³/₄ STICKS BUTTER
10 GARLIC CLOVES, *finely chopped*
³/₄ CUP CHOPPED FRESH PARSLEY
LESS THAN 1 TEASPOON PERI-PERI SPICE *or*
 CHILE POWDER
JUICE OF 4 LEMONS
2²/₃ CUPS CRUMBLED FETA CHEESE

SHRIMP WITH LEMON, PERI-PERI, GARLIC, AND FETA

This is amazing. Everyone who has tasted this dish loves it and still now I use it for a special occasion dinner — it seems very "celebration". My mother still salts every single shrimp individually; once she has slit and removed the dark line of the vein she sprinkles salt along this. You can just scatter salt over each layer in the saucepan. My mother always uses peri-peri, which is a wonderfully flavored full-potency chile that we get in South Africa. Substitute your favorite chile powder or cayenne pepper, using as much as you like. I like a good balance of strong flavors but the chile should not be too overpowering. You can clean the shrimp beforehand and keep them covered in a colander in the refrigerator, then you'll only need about 20 minutes before serving. This dish needs very little else — bread, some white rice or couscous, and a large green salad.

Clean the shrimp and cut a slit through the shell down the back from the bottom of the head to the beginning of the tail. Remove the dark vein with the point of a sharp knife. Rinse the shrimp under running water and drain well.

Dot about 5 tablespoons of the butter over the base of a large cast-iron casserole dish. Arrange a single layer of shrimp in the dish and season with salt. Scatter about a third of the garlic and parsley over the top. Sprinkle with a little of the peri-peri.

Dot about half of the remaining butter over the top and arrange another layer of shrimp, scattered with garlic, parsley, and peri-peri. Repeat the layer, finishing up the ingredients. Put the lid on, turn the heat to medium–high, and cook for about 10 minutes, until the shrimp have brightened up a lot and their flesh is white. Add the lemon juice, scatter the feta over the top, and rock the dish from side to side to move the sauce about. Spoon some sauce over the shrimp. Cover the casserole, decrease the heat, and cook for another 10 minutes, or until the feta has just melted, shaking the dish again. Take the dish straight to the table and give everyone a hot finger bowl with lemon juice, to clean their hands afterward.

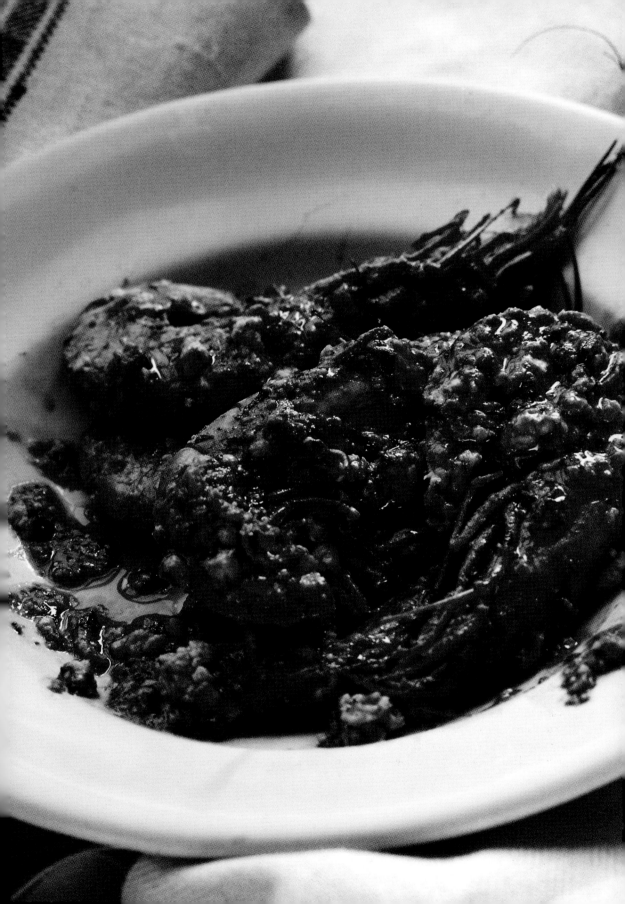

Serves 4 to 6

2¹/4 POUNDS FIRM WHITE FISH FILLETS,
 cut into 2¹/2 inch pieces
1 (14-OUNCE) CAN TOMATOES WITH JUICE, *chopped*
 or VERY RIPE TOMATOES, *peeled and chopped*
¹/4 CUP CHOPPED FRESH PARSLEY
4 LARGE GARLIC CLOVES, *finely chopped*
JUICE OF 2 LEMONS
2 CELERY STALKS, *chopped, with some leaves*
1 TEASPOON SUGAR
3 TABLESPOONS OLIVE OIL
CRUSTY BREAD, *to serve*

OVEN-BAKED FISH WITH TOMATO AND PARSLEY

This is great served either hot or cold, even straight from the refrigerator. It is wonderful with boiled potatoes that you have sprinkled with parsley and drizzled with a little olive oil. Actually, you could just put some boiled potatoes around the fish in the juice once you have removed the foil. Use any type of fresh fish fillets you like.

Preheat the oven to 350°F. Put the fish in a baking pan where they will fit in a single layer. Mix together the tomatoes, parsley, garlic, lemon juice, celery, sugar, and olive oil, and taste for seasoning. Pour over the fish to cover all the pieces, shaking the dish from side to side. Cover with foil and bake for about 30 minutes.

Remove the foil, increase the heat to 400°F, and bake for another 40 to 50 minutes, or until the liquid has thickened and the top of the fish is golden in a couple of places. Serve with crusty bread to mop up the juices.

Serves 2 to 3

1 SMALL CHICKEN
2 TABLESPOONS OLIVE OIL
3½ TABLESPOONS BUTTER
JUICE OF 2 LEMONS
1 TABLESPOON DRIED OREGANO

LEMON AND OREGANO CHICKEN

These are very familiar flavors to me and I don't ever tire of them. I love the simplicity of something that you can throw under the broiler while you put together a salad and set the table. You could cook this on a barbecue grill, varying the herbs, or you could cook it from start to finish under the broiler, leaving out the frying. But this is how my friends Corinne and Liz cook their chicken, and I think it gives it extra crispiness and flavor.

Preheat the broiler to high. Put the chicken breast side down and cut along the backbone. Turn the chicken over and push down firmly to butterfly and flatten it.

Heat the olive oil and 2 tablespoons of the butter in a large skillet. Add the chicken and half the lemon juice, season with salt, and cook until both sides are crispy and the chicken is just cooked through. Put the chicken on a baking sheet. Pour over the remaining lemon juice, dot with the remaining butter, and sprinkle with the oregano, crushing it between your fingers.

Pour ½ cup of water around the chicken and broil it on both sides until the top is crispy and deep golden. Pour a little more water around the chicken and broil for a bit longer so that you have some sauce.

Cut the chicken into pieces to serve, seasoning with a little more salt if necessary. Serve hot or at room temperature, with the sauce, bread, and a green salad.

Serves 4 to 6

3 TABLESPOONS OLIVE OIL
1¾ POUNDS LAMB MEAT (from shoulder or leg),
 trimmed and cut into 1¼-inch pieces
2 RED ONIONS, *finely chopped*
2 GARLIC CLOVES, *chopped*
1½ (14-OUNCE) CANS TOMATOES *with juice, chopped*
1 CINNAMON STICK
2 TABLESPOONS BUTTER
1 (16-OUNCE) PACKAGE ORZO
GRATED PARMESAN, PECORINO, *or* KEFALOTIRI
 CHEESE, *to serve*

YOUVETSI (LAMB AND TOMATO WITH ORZO)

 Some people like to serve this with cubes of feta or haloumi stirred in at the end so that they melt a bit. Orzo pasta is like a large grain of rice and you can use any small noodle instead, although the cooking time will probably vary. If you prefer, use one big piece of meat on the bone instead of cubes, and just break it up into portions for serving. The meat must be very soft, so cook it as long as it needs before adding the pasta to the casserole for the last 15 minutes.

Preheat the oven to 350°F. Heat the olive oil in a heavy casserole dish and fry the lamb in batches until golden on all sides. Transfer the meat to a plate and add the onions to the casserole. Sauté the onions until golden and softened, stirring continuously so they don't stick (you can add another drop of oil). Add the garlic and cook for another half a minute or so before returning the meat to the dish. Add the tomatoes, crushing them with a wooden spoon, season with salt and pepper, and add the cinnamon stick and the butter. Let it all bubble up for 5 minutes or so and then add 4 cups of hot water. Cover and bake for 1 hour, or until the lamb is tender.

Rinse the pasta in a fine sieve or colander, drain, and add to the casserole. Mix through, cover, and return it to the oven for another 15 minutes, or until the pasta is cooked and has absorbed most of the sauce. The cooking time will depend on the pasta — it takes longer to cook in the oven, so pasta that needs 7 minutes on the stovetop will take 15 minutes in the oven. You may need to add a little more hot water if it seems too dry. Serve hot, sprinkled with the grated cheese.

If you are not serving this immediately, remove the casserole dish from the oven before the pasta is completely cooked — the residual heat in the casserole dish will finish off the cooking.

Serves 6

3³/₄ POUNDS LEG OF LAMB (*on the bone*)
JUICE OF 2 LEMONS
1 TABLESPOON DRIED OREGANO
3¹/₂ TABLESPOONS BUTTER
3 TABLESPOONS OLIVE OIL
4 LARGE POTATOES

LEG OF LAMB
WITH OREGANO
AND LEMON

This is possibly one of my favorite meals. It is soft, wonderful, and meltingly lemony and we would sometimes eat the leftovers for breakfast before school. I'm not sure if this is totally the Greek way of making it — maybe the butter and cooking time are my mother's addition — but this is how it is. My mother says you could cook it overnight: I never have, but I believe her.

Preheat the oven to 425°F. Rinse and trim the lamb of excess fat and put it in a large baking pan. Rub the lamb all over with the lemon juice, season well with salt and pepper, and sprinkle with the oregano, crushing it between your fingers to cover the meat. Dot the butter over the top. Pour 1 cup of water around the lamb and drizzle the olive oil around it as well. Bake for about 15 to 30 minutes on each side, until it is browned all over.

Meanwhile, peel the potatoes and cut them into bite-size pieces. Scatter them in the baking pan around the browned lamb, add some salt, and turn them over with a wooden spoon to coat them in the juice. Add a little more water if it has evaporated. Cover the baking sheet with foil, decrease the heat to 350°F, and bake for 2¹/₂ hours or so, turning the lamb over at least once during this time and tossing the potatoes. If the lamb isn't browned enough, remove the foil for the final 30 minutes of cooking. Serve warm on a huge platter with a salad or some simply cooked greens. This is also nice with some tzatziki on the side.

Serves 6

4 TO 5 TABLESPOONS OLIVE OIL
2 ONIONS, *chopped*
2¼ POUNDS BONELESS LEG OF PORK, *cut into
 2-inch chunks*
2 GARLIC CLOVES, *lightly crushed*
1 CUP WHITE WINE
1 LARGE HEAD OF CELERY
1 TEASPOON DRIED WILD FENNEL TEA
3 EGGS
JUICE OF 2 LEMONS

PORK
WITH CELERY IN EGG AND
LEMON SAUCE

This is a dish that's good served on its own with some bread. If you don't have dried fennel flowers, add a couple of soft sprigs of wild fennel or dill.

Heat 3 tablespoons of the olive oil in a large heavy-bottomed saucepan over medium heat. Add the onions and sauté until softened. Add a little extra oil, then add the pork pieces to the pan and continue cooking until the meat browns a bit. Add the garlic and cook for another minute. Add the wine and let cook to reduce a bit. Season with salt and pepper, add 3 cups of water, and bring to a boil. Decrease the heat and simmer for 1 hour. Check the water level of the meat occasionally — it should be simmering in some liquid, so add more if necessary.

Trim the celery and separate all the stalks. Chop off the top leafy parts (you won't need them here). Strip away the stringy bits with a knife, starting at the bottom and pulling all the way to the top so that the strings come away. Cut the stalks into lengths of about 2 inches.

Add the celery and dried fennel to the pan with another 3 cups of hot water. Cover and simmer for another 45 minutes or so, again checking the water level and adding a bit more if necessary. Remove the pan from the heat and let cool for 5 minutes.

Whisk the eggs in a bowl with some salt and pepper. Whisk a ladleful of the meat juices into the eggs, whisking continuously to make sure they don't scramble. Add another ladleful of juice and then pour the eggs into the saucepan, mixing with a wooden spoon. Add the lemon juice and mix in. Put the pan back onto the lowest heat possible and cook for another minute or so, stirring continuously to just cook and thicken the eggs. Remove from the heat, taste for seasoning, and serve immediately.

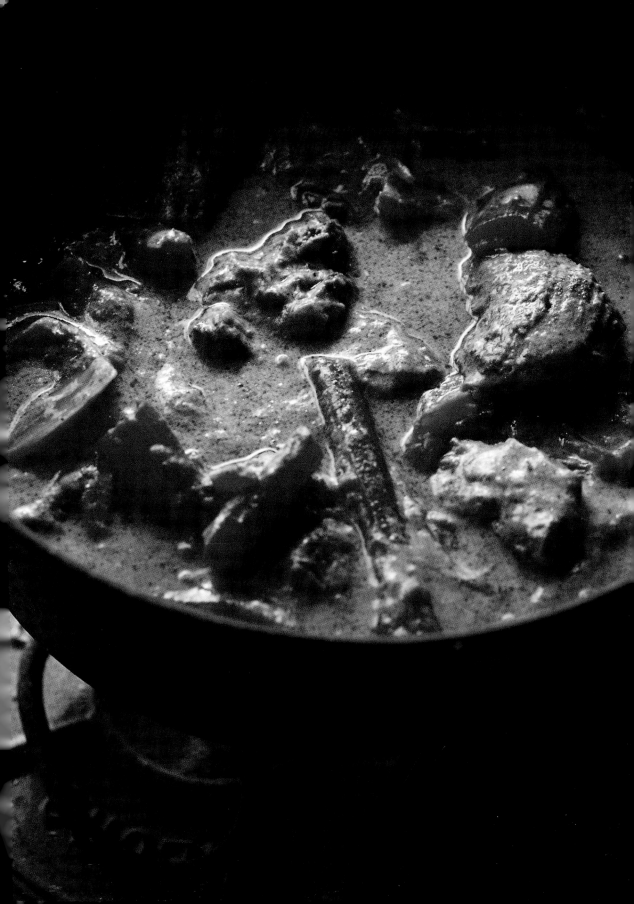

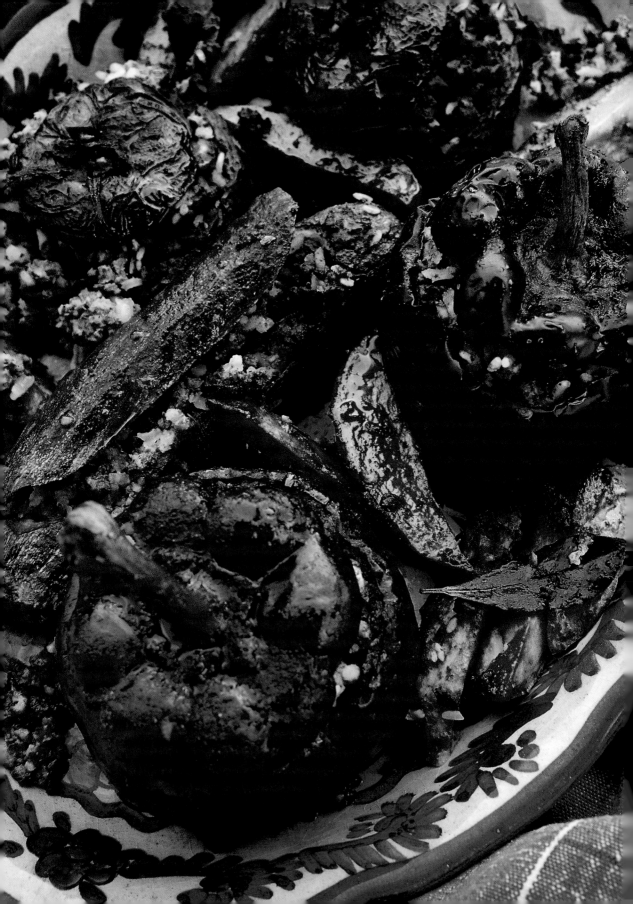

Serves 6 to 8

2 POUNDS GROUND MIXED BEEF AND PORK
2 LARGE RED ONIONS, *finely grated*
1/2 CUP CHOPPED FRESH PARSLEY
1 1/3 CUPS UNCOOKED SHORT-GRAIN RICE
4 TABLESPOONS OLIVE OIL, PLUS 1/2 CUP EXTRA
1 HEAPED TEASPOON SWEET PAPRIKA
1 TEASPOON DRIED MINT, *crumbled*
1 TEASPOON GROUND PEPPER
2 TEASPOONS SALT
6 TO 8 RIPE TOMATOES
4 PEPPERS
4 ZUCCHINI
4 POTATOES, *cut in half lengthways and then into halves or thirds*
3 TABLESPOONS BUTTER, *melted*
JUICE OF HALF A LEMON

STUFFED VEGETABLES

This is a wonderful colorful tray of mixed vegetables, which you can vary according to what's easily available and in season (you could use only tomatoes or try mixed colors of peppers). These can be made in advance and served at room temperature or warmed up before serving if you prefer. I've used a combination of tomatoes, peppers, and zucchini, which can be halved or divided, so that everyone gets a taste of each.

Preheat the oven to 400°F. Put the meat in a large bowl with the onions, parsley, rice, 4 tablespoons of oil, paprika, mint, pepper, and salt.

Slice the tops off the tomatoes and set aside. Hollow out the insides of the tomatoes with a teaspoon (a pointed one is easiest), holding them over a bowl to catch the juice. Chop up the pulp and add to the meat with half of the juice from the tomatoes. Reserve the rest of the juice. Sit the tomatoes in a large rimmed pan.

Cut away a top hat from each pepper, leaving a hinge of about 3/4 inch on one side. Scoop out and discard the seeds, but save any of the fleshy pepper bits that you can. Chop up this flesh and add it to the meat. Put the peppers in the pan — it doesn't matter if they don't sit flat, they can lie down.

Cut away a hat from each zucchini and scrape out the flesh with a pointed teaspoon. Chop this up and add it to the meat. Put the zucchini in the baking pan. (Or, cut the zucchini in half and scrape out a hollow from each side with a potato peeler or pointed spoon, so that you have the two hollowed-out halves, now upright.)

Holding the meat bowl with one hand, mix thoroughly with your other hand, turning the meat filling from the bottom of the bowl up, so that it is all well combined. Fill the hollowed-out vegetables with the meat filling, using your hands or a tablespoon, until the mixture is flush with the tops. Don't overstuff them; wait and see that they have all been filled and then you can go back and add a bit more here and there. Add the potatoes around the vegetables.

Pour the remaining $1/2$ cup of oil into the remaining tomato juice and add the butter, lemon juice, and $1^1/2$ cups of water. Mix together and pour carefully over and around the vegetables. Put the tops back on the vegetables and sprinkle with salt, especially the potatoes.

Bake for $1^1/4$ to $1^1/2$ hours, until the vegetables are golden and darkened in places and seem soft even at the bottom. (If your vegetables dry out, add a little extra water, but this shouldn't be necessary.) These should not be served really hot: turn the oven off and leave them in there for at least 15 minutes before serving (they are best if you can manage to leave them in for a couple of hours). They are good at room temperature, or even the next day.

Serves 8

8 TABLESPOONS OLIVE OIL
2 GARLIC CLOVES, *lightly crushed with the flat*
 of a knife
3 CUPS TOMATO SAUCE
4 SMALL LONG EGGPLANTS, *rinsed*
1 CELERY STALK, *finely chopped*
1 TEASPOON PAPRIKA
1 POUND GROUND BEEF
¾ CUP GRATED PARMESAN CHEESE
1 CUP DICED *or* CRUMBLED FETA CHEESE
4 TABLESPOONS CHOPPED FRESH PARSLEY

STUFFED EGGPLANTS

There are so many ways of making stuffed eggplants. Here they are boiled first, which makes the dish a bit lighter. But you could also roast or fry the eggplants before stuffing them. Serve these with a big salad, bread, and maybe some light pickles and olives. You could use a lighter-flavored cheese, such as mozzarella or cacciotta, in place of the feta here.

Heat 3 tablespoons of the oil in a saucepan with one of the garlic cloves. When you can smell the garlic, add the tomato sauce and 1 cup of water. Season with salt and pepper and bring to a boil. Decrease the heat and simmer for about 15 minutes, or until it is cooked and still rather liquid.

Preheat your oven to 350°F and bring a saucepan of lightly salted water to a boil. Cut off the stalk from each eggplant and then cut it in half lengthwise. Scoop out the flesh with a tablespoon (a pointed one is easiest), so that you have a boat-shaped, thin shell. Chop up the flesh and set aside. Boil the eggplant boats for about 10 minutes in the pan of water, testing them with a fork. They should be soft but still in shape. Drain.

Meanwhile, heat the remaining oil and garlic in a large nonstick saucepan. Add the eggplant flesh, celery, and paprika, and sauté over medium heat until it is softened and very lightly golden. Add the ground meat and continue cooking for 10 to 15 minutes, until the meat is lightly golden, seasoning lightly with salt. Break up any clusters of ground meat with a wooden spoon. Mix in 1 cup of the cooked tomato sauce, cook for 2 to 3 minutes more, and then remove from the heat to cool slightly. If your pan is big enough, mix in the Parmesan, feta, and parsley — if not, mix it all together in a larger bowl. Check the seasoning. Remove the garlic clove from the tomato sauce.

Ladle tomato sauce onto the bottom of a baking pan to a depth of ¾ inch. Use a pan that is large enough to fit all the eggplants fairly compactly in a single layer. Fill the eggplant boats with meat filling, patting it in well with your hands, but don't make it too compact. Arrange the eggplants on top of the tomato sauce and splash the tops with the rest of the tomato sauce, but don't drown them.

Bake for 30 to 45 minutes (or longer if necessary), until the sauce is bubbling up and a little bit of a golden crust has formed on the top in places. Remove from the oven and let cool slightly before serving. These are also good served at room temperature.

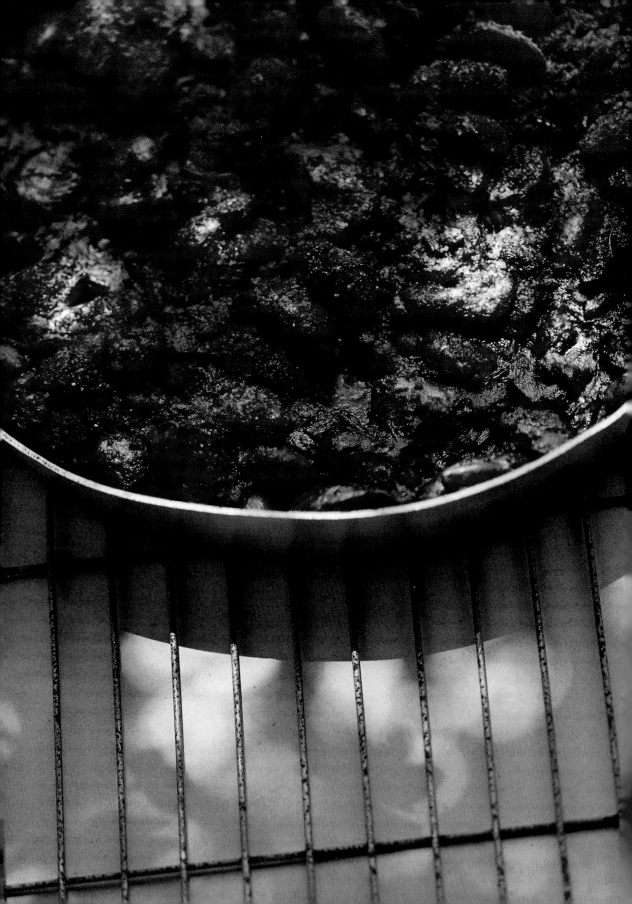

Serves 8 as a side dish

3 CUPS DRIED LIMA BEANS, *soaked overnight*
1 BAY LEAF
1/2 CUP OLIVE OIL
2 SMALL RED ONIONS, *finely chopped*
2 CELERY STALKS WITH LEAVES, *chopped*
3 GARLIC CLOVES, *finely chopped*
1^1/2 POUNDS (ABOUT 5 REGULAR) RIPE TOMATOES,
 peeled and coarsely chopped, or use 1^1/2 (14-ounce) CANS
4 TABLESPOONS CHOPPED FRESH PARSLEY
3 TABLESPOONS BREAD CRUMBS

BAKED LIMA BEANS WITH ONIONS, TOMATOES, AND PARSLEY

This is a good companion for any roasted or grilled meat dish and it can also stand alone as a vegetarian option, served with some sautéed greens and a small dish of feta. You could even stir through some freshly chopped dill before baking.

Drain the beans, put them in a saucepan with the bay leaf, cover generously with cold water, and bring to a boil. Skim off any scum that rises, decrease the heat slightly, and cook for about 1^1/2 hours, or until they are very tender. Add salt toward the end of the cooking time.

Preheat the oven to 350°F. Drain the beans, reserving about 1^1/2 cups of the cooking water, and put them in a large baking pan.

Heat about 2 tablespoons of the olive oil in a nonstick skillet. Gently sauté the onions until they are lightly golden and softened, stirring so that they don't stick. Remove from the heat and mix in a bowl with the celery, garlic, tomatoes, parsley, and remaining olive oil. Season with pepper and a little salt. Add the reserved bean water, pour all this into the beans, and mix through well. Cover with foil and bake for about 45 minutes, then remove the foil and stir the beans, adding a little extra water if they seem to be drying out. Sprinkle with bread crumbs and return to the oven, uncovered, for another 30 minutes.

The beans should be tender, golden on the top, and still with a little sauce. Serve warm, with an extra drizzling of olive oil if you like.

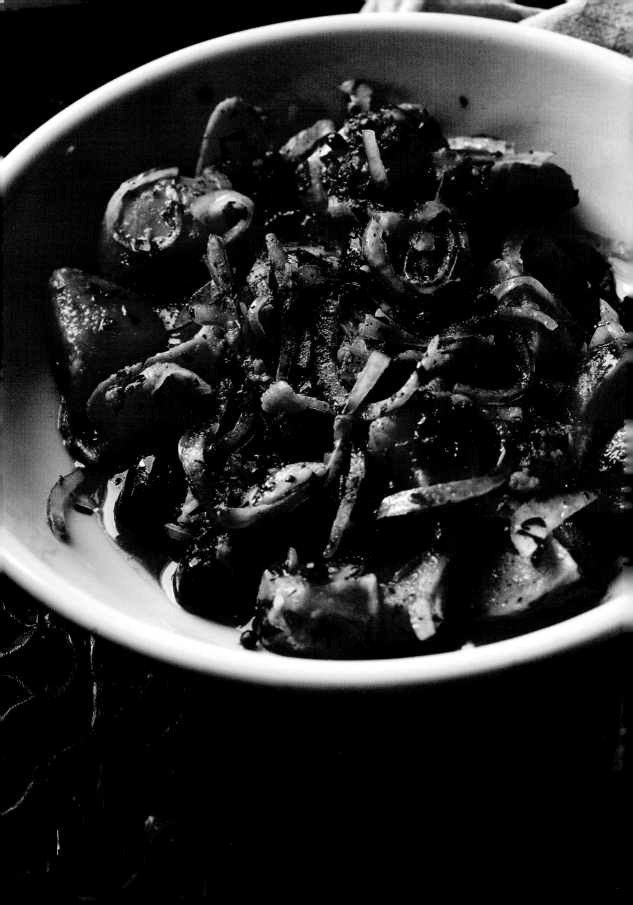

Serves 8 as a side dish

1 RED ONION, *very thinly sliced*
1 TEASPOON SALT
3¼ POUNDS (10 MEDIUM) WAXY POTATOES
3 TABLESPOONS DRAINED BABY CAPERS
½ CUP CHOPPED FRESH PARSLEY
JUICE OF 1½ LEMONS
ABOUT ½ CUP GOOD-QUALITY BLACK OLIVES
½ CUP EXTRA-VIRGIN OLIVE OIL

BOILED POTATO SALAD

This is great for an outdoor lunch that you can just do ahead and take with you wherever you are going. Use waxy potatoes if possible. You could add some mashed-up hard-boiled eggs and anchovies here, too, or any other ingredients you think would go nicely.

Put the onion in a small bowl and cover with cold water and the salt. Leave for 30 minutes or so (while you prepare the potatoes). The soaking is important and will give your onions a softer taste in the finished dish and make them more digestible.

Scrub the potatoes and boil in salted water for 20 to 25 minutes, until they are cooked but not falling apart. Drain well, then peel them when they have cooled a little — it is easier to do this if they are still warm. Cut them into chunks the size that you would like to see in your salad bowl.

Rinse the onion and drain well, patting it dry with paper towels if necessary. Add to the potato with the remaining ingredients, seasoning with pepper and probably a little extra salt. Mix gently and serve warm or at room temperature. If you make this in advance, the potatoes will soak up some of the oil as they cool, so you will have less dressing. You could save a little of the oil and add it closer to the serving time, if more is needed.

Serves 4 to 6

2 TABLESPOONS OLIVE OIL
2 TABLESPOONS BUTTER
1/2 CUP SLICED SCALLIONS
2 LARGE GARLIC CLOVES, *chopped*
2 3/4 POUNDS (ABOUT 24 CUPS FIRMLY PACKED)
 SPINACH LEAVES, *chopped*
1 1/2 CUPS UNCOOKED LONG-GRAIN RICE

SPINACH PILAF

I love the simplicity of this. You can vary the proportions to suit your personal taste. I like a lot of spinach and to eat it with a few drops of lemon juice squeezed over the top. You might also like to add a handful of freshly chopped dill toward the end. This could be served on its own as a starter, or to accompany a main course.

Heat the oil and butter in a fairly large, heavy-bottomed saucepan. Add the scallion and sauté, covered, for about 10 minutes, or until softened but not browned. Add the garlic and continue cooking for about a minute, or until you can smell it. Add the spinach and mix in thoroughly to blend the flavors.

Add the rice, mix in well, and season with salt and pepper. Pour in 3 cups of cold water, bring to a boil, decrease the heat, and cover the pan with a lid. Cook for about 15 minutes, until the rice is cooked and all the liquid has evaporated. Remove the pan from the heat, fluff up the rice, and cover the top with a clean cloth to steam the rice for a few minutes more before serving. This can also be served at room temperature.

Serves 20

8 CUPS MILK
1½ CUPS SUPERFINE SUGAR
1 VANILLA BEAN, *split in half lengthwise*
1⅓ CUPS SEMOLINA
½ POUND BUTTER
1 (16-OUNCE) PACKAGE FILO DOUGH
3 EGGS, PLUS 2 EGG YOLKS, *lightly beaten*
ABOUT 2 TABLESPOONS CONFECTIONERS'
 SUGAR
2 TEASPOONS GROUND CINNAMON

BOUGATSA

The only tricky thing here is the filo dough: getting it to the size of your baking dish and then putting it in the dish in individual layers. It is much easier with help. You won't need all of the filo, so quickly work out what is left over, wrap that up carefully and put it straight into the refrigerator before it dries out and can't be used. You could make the flavors richer by adding some chopped orange zest or rose water to the semolina but I actually love this just plain. Bougatsa is best served warm with tea or a small glass of vin santo, moscato, or port.

Put the milk, superfine sugar, and vanilla bean in a medium saucepan and bring to a boil. Pour in the semolina in a thin, steady stream, holding it up high and stirring continuously. Decrease the heat to medium and cook for 10 to 15 minutes, stirring occasionally, until the semolina thickens. Remove from the heat and let it cool a little.

Preheat the oven to 350°F and have a large ovenproof dish ready. You can use a ceramic dish or even an aluminum one, but it should measure about 14 by 10 inches and be more than 2 inches deep. Melt the butter in a small saucepan. Using a pastry brush, brush a little butter over the bottom of your dish. Lay a sheet of pastry in the dish, covering about two-thirds of the base and allowing the excess to hang over the side and up the ends. Brush the pastry with melted butter. Lay down a second sheet of pastry, covering the rest of the base, hanging over the other side of the dish and slightly overlapping the first sheet. Brush with melted butter. Repeat the layers with 12 more sheets of filo, so that you have seven layers in total, brushing each sheet with melted butter.

Remove the vanilla bean from the semolina mixture, scraping out all the seeds into the pan with a knife. Take 2 tablespoons of the melted butter and stir it into the semolina with the beaten eggs. Pour this over the filo layers in your ovenproof dish and cover with seven more layers of pastry (14 sheets), brushing each sheet with the melted butter as before.

Trim all the edges of the pastry, leaving a small overhang on all sides. Fold all the edges neatly onto the custard. Cut one more sheet of filo to exactly fit the top of the dish and hide the tucked-in edges. Brush this with melted butter.

This bit is tricky. Using a very sharp knife, score serving portions like a grid on the surface of the pastry, cutting through a couple of layers of the filo (it will be almost impossible to do this neatly after it is cooked). To prevent the pastry's moving about too much and the custard's leaking out, support it with your free hand as you cut. You should get about 20 small servings.

Bake in the middle of the oven for 15 minutes. Decrease the temperature to 300°F, and bake for another 45 minutes. Remove from the oven, dust the surface with confectioners' sugar and then cinnamon, and then return to the oven for 10 minutes. Let cool slightly before cutting into the serving portions.

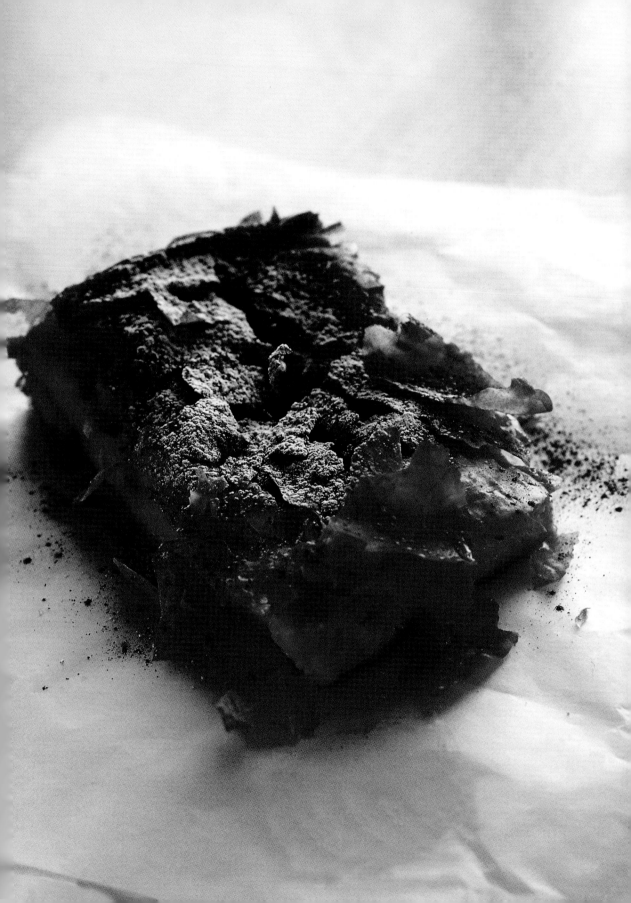

Serves 8

syrup
$^1/_3$ CUP SUPERFINE SUGAR
2 TABLESPOONS THIN HONEY
$^1/_2$ TEASPOON GROUND CINNAMON
3 CLOVES
JUICE OF HALF A SMALL LEMON

6 SHEETS FILO DOUGH
$^1/_4$ POUND PLUS 3 TABLESPOONS BUTTER, *melted*
$^2/_3$ CUP GOOD-QUALITY, SOFT DRIED APRICOTS
$^1/_3$ CUP WHOLE ALMONDS, *roughly chopped*
$^1/_3$ CUP SKINNED, UNSALTED PISTACHIO NUTS,
 roughly chopped
1 EGG WHITE
2 TABLESPOONS SUPERFINE SUGAR
A FEW DROPS OF VANILLA EXTRACT

BAKLAVA WITH NUTS AND DRIED APRICOTS

This is how Corinne and Lizzie made their baklava. I learnt a lot of their recipes as one night, when their restaurant was very full, they pulled me out of my chair and put me to work. I stayed quite a while. The quantities given here are very simple to double or adjust. Serve this warm with cinnamon or vanilla ice cream.

To make the syrup, put all the ingredients in a saucepan with $^3/_4$ cup of water, bring to a boil, and boil for 5 minutes or so, until it is clear and slightly thickened. Remove from the heat and let cool completely.

Preheat the oven to 350°F. Lay a sheet of filo on the work surface and brush generously with melted butter. Top with a second sheet of filo and brush with butter. Repeat with a third sheet of filo, brushing the top with butter. Cut the filo into four equal strips along its length. Do the same with the remaining sheets of filo, so you have eight strips in total.

Finely chop the apricots in a food processor. Mix the apricots and nuts in a bowl and taste to see if they are sweet enough — mix in some sugar if the apricots taste a bit sour. You should have a moist, coarse paste.

Whip the egg white in a bowl until soft peaks form and then whisk in the sugar and vanilla. Continue whisking until stiff and creamy.

Take a heaped tablespoon of the apricot mixture and press onto one strip of the filo about 3 inches up from the bottom edge. Put a heaped teaspoon of the egg white over the apricot mixture, and then fold the bottom of the pastry up over the filling. Turn in both the sides, pressing these down all the way up the length. Then roll up to make a neat package and seal the filling in. Brush with melted butter and put on a baking sheet lined with parchment paper. Repeat with the rest of the pastry and filling. Bake for 15 to 20 minutes, until the pastry is crisp and golden.

Arrange the baklava on a serving plate. Pour the cool syrup over the hot baklava and serve warm with a scoop of not-too-sweet vanilla ice cream, spooning any extra syrup over the baklava. These can also be eaten cold.

The villages of Greece and the islands are so beautiful around Easter, with everyone holding onto their candles in church at midnight. On the Sunday just about every soul around eats lamb, either turned on the spit or oven-roasted.

We loved the part when we would crack our red-dyed, hard-boiled eggs against each other to find out which was the strongest.

Serves 8

5 ORANGES
3 SHEETS FILO DOUGH
4¹/₂ TABLESPOONS BUTTER, *melted*
2 TABLESPOONS SUGAR
3 TABLESPOONS THIN HONEY

orange confit
GRATED ZEST AND JUICE OF 1 ORANGE
2 TABLESPOONS SUGAR

orange sauce
JUICE OF 3 ORANGES
1 TABLESPOON BUTTER
2 TABLESPOONS SUGAR
1 TABLESPOON GRAND MARNIER, PORT,
 or VIN SANTO

sabayon cream
1 TABLESPOON GRANULATED UNFLAVORED
 GELATIN
1 EGG, PLUS 2 EGG YOLKS
3¹/₂ TABLESPOONS SUGAR
1 TEASPOON ORANGE BLOSSOM WATER
1¹/₃ CUPS HEAVY WHIPPING CREAM

CONFECTIONERS' SUGAR, *to serve*

FILO
MILLEFEUILLE
WITH ORANGES

This always reminds me of Athens and the avenues lined with orange trees. I have also made this with pomegranates, juicing one or two and following the same method for the orange sauce here. Or use both and scatter pomegranate seeds and orange slices around the plate: the colors look beautiful together.

Slice the tops and bottoms off the oranges. To fillet the oranges, sit them on a board. With a small, sharp knife, cut downward to remove the skin and pith. Hold the orange over a bowl and remove the fillets by slicing between the white pith. Remove the seeds. You should be left with an orange "skeleton." Put the fillets in the bowl and squeeze out the remaining juice from the skeletons, then discard the skeletons.

To make the orange confit, put the ingredients in a small saucepan and simmer for 7 to 8 minutes, until a jam forms.

To make the sauce, put all the ingredients in a saucepan and pour in the juice from the orange fillets as well. Boil until thickened and reduced.

To make the sabayon cream, put the gelatin in a small bowl, cover with cold water, and set aside until softened completely. Put the whole egg, egg yolks, and sugar in a heatproof bowl over a saucepan of simmering water, making sure the bottom of the bowl isn't touching the water. Whisk constantly for 12 to 15 minutes, or until the mixture is thick and fluffy.

Whisk in 2 teaspoons of the confit and the orange blossom water, and take the bowl off the saucepan. (If there's any confit left you can add it to the cream or oranges at the last minute, or serve it over ice cream.)

Squeeze out all the water from the gelatin with your hands and whisk the gelatin into the sabayon cream, making sure it is well incorporated. Now whip the cream to soft peaks and fold this into the sabayon. Leave in a cool place, even in the fridge, until you are ready to use it.

Preheat the oven to 350°F. Place a sheet of filo dough on a work surface, brush with melted butter and sprinkle the surface evenly with half the sugar. Place another sheet of filo on the first, brush with butter, and sprinkle with the remaining sugar. Add the last sheet of filo, brushing with butter. Cut the filo in half horizontally and then cut each half into 12 strips, giving you a total of 24 rectangles. Put them on a baking sheet lined with parchment paper, drizzle the honey in long, thin lines all over the filo, and bake for 10 minutes, or until crisp and golden brown. Set aside to cool on a clean sheet of parchment paper so that they don't stick.

To serve, place a filo rectangle on each plate. Add a good dollop of sabayon cream, a few orange slices, another layer of filo, more sabayon and orange segments, and a final layer of filo. Scatter a few orange segments around the plate, drizzle with sauce, dust the top with confectioners' sugar, and serve.

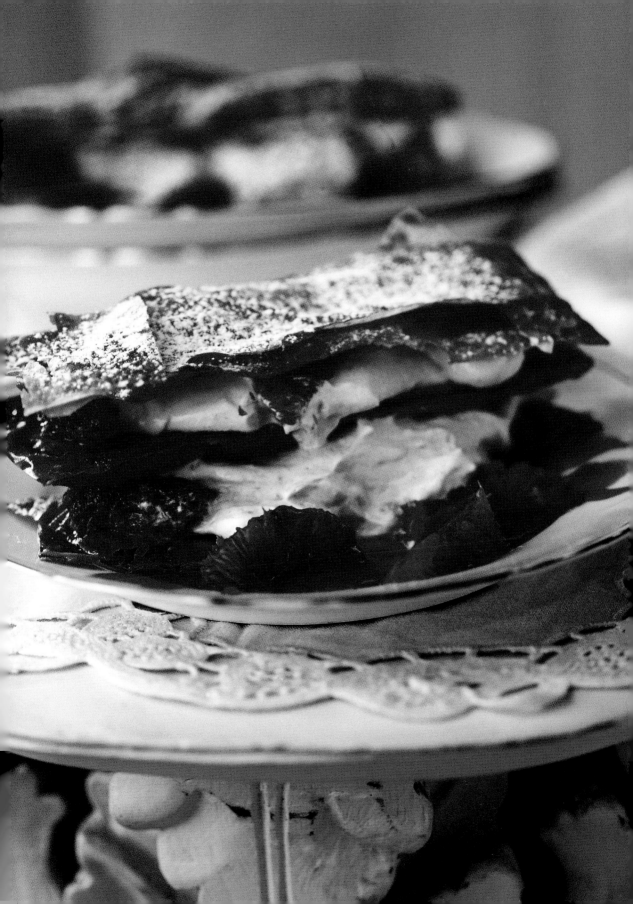

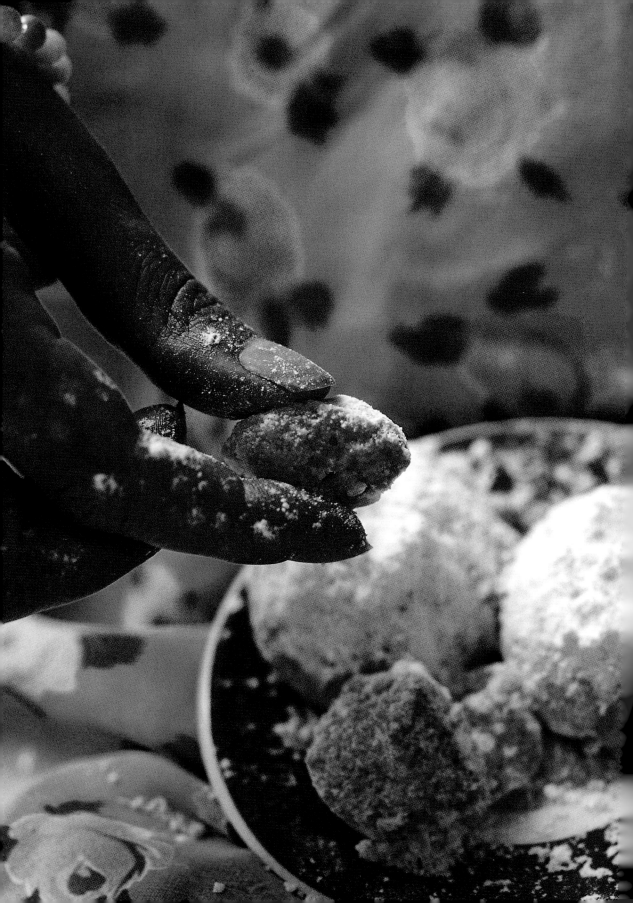

Makes 45

½ POUND PLUS 2 TABLESPOONS BUTTER
2 TABLESPOONS CONFECTIONERS' SUGAR,
 PLUS ABOUT 3 CUPS, *for dusting*
1 EGG YOLK
1 TEASPOON VANILLA EXTRACT
1 TABLESPOON BRANDY
3 CUPS ALL-PURPOSE FLOUR, *sifted*
1 TEASPOON BAKING POWDER

KOURAPIEDES

These really do melt in your mouth. You can serve them on their own with tea, coffee, a liqueur, or just a glass of iced water. Sometimes I like to make up a dessert plate: a small pile of these, little baklava and a tiny glass of preserved fruits in sugar syrup. You will find you really have to eat these over a plate or pop a whole one in your mouth at once so that the confectioners' sugar doesn't fly everywhere. You will use a lot of confectioners' sugar for dusting: you can always recycle some from the bottom, or sieve the leftover sugar of crumbs and put it back in your bin.

Preheat the oven to 350°F and line a baking sheet with a sheet of parchment paper.

Using an electric mixer, beat the butter for 8 to 10 minutes, until it is very pale and thick. Add the 2 tablespoons of confectioners' sugar, beating it in well. Add the egg yolk and vanilla, and whisk until well incorporated, then mix in the brandy. Sift in the flour and baking powder, mixing until you have a thick dough that becomes difficult to mix with the electric mixer. Scoop up softly in your hands, cover in plastic wrap, and refrigerate for about 30 minutes.

Form the dough into small balls about the size of cherry tomatoes (these are often made into crescent shapes, too) and put them on the baking sheet, leaving a little space between them.

Bake for about 20 minutes, or until they are lightly golden. Remove from the oven and let cool for 10 to 15 minutes. Meanwhile, line another baking sheet with parchment paper and sprinkle with half of the confectioners' sugar. Take the slightly cooled cookies and place them in one layer on top of the confectioners' sugar. Sprinkle the rest of the confectioners' sugar over the top (the cookies should be almost buried in the sugar). Keep these in an airtight container.

Serves 4

1 CUP SUPERFINE SUGAR
1 LONG STRIP LEMON ZEST
JUICE OF HALF A LEMON
4 QUINCES

POACHED QUINCES

I like these with pistachio ice cream. I love the color of the quinces after they have been gently stewing in their syrup for a couple of hours. You could add other flavorings with the fruit, such as half a vanilla bean, a piece of cinnamon stick, or perhaps some cloves.

Put the sugar, lemon zest, juice, and about 4 cups of water in a saucepan and bring to a boil.

Meanwhile, cut the quinces into quarters from the top down. Core and peel them (take care with the knife that it doesn't slip on the hard quince). Halve the quince pieces now into slices of about 3/4 inch each and put them in the boiling syrup. Decrease the heat to the lowest simmer possible, cover, and simmer for about 2 hours. Add another 1 cup of water after about 45 minutes and another toward the end or if the syrup looks too scant. Try not to move the quinces about at all so that they don't break up. If you do need to move them, slide a wooden spoon under to shift them. When they are a beautiful color, remove from the heat and let them cool in their syrup.

Serve the quinces with a little syrup drizzled over and a scoop of vanilla or pistachio ice cream (page 140).

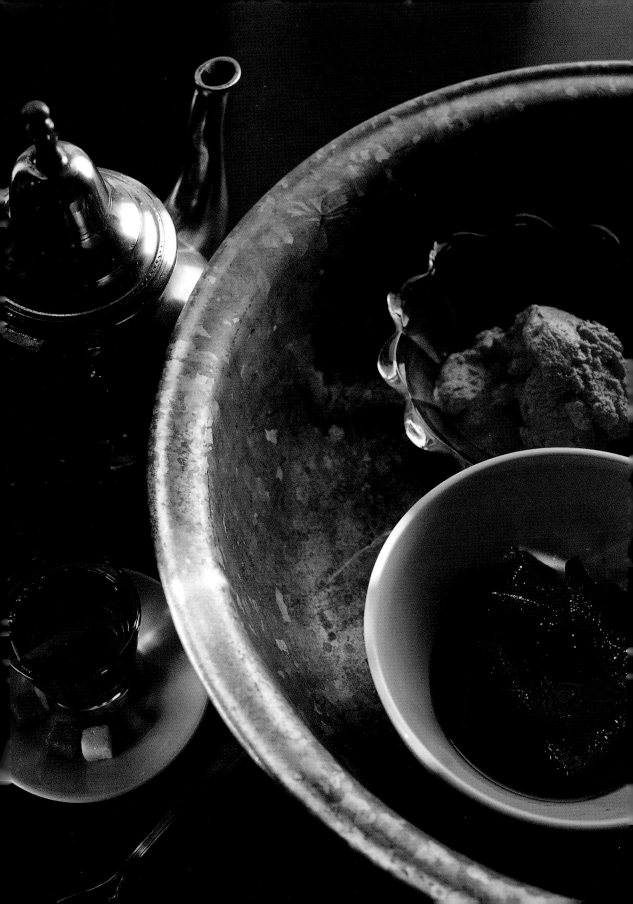

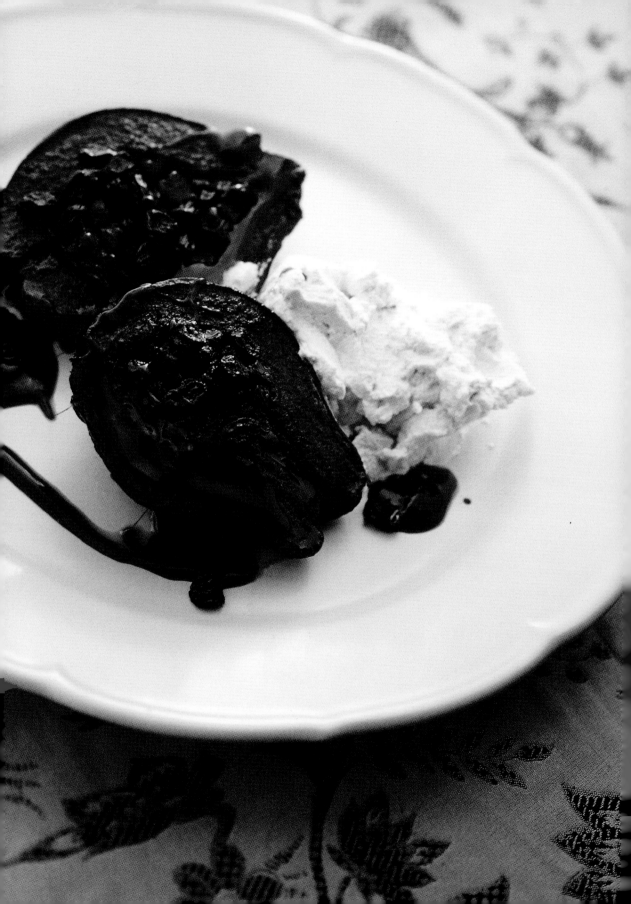

Serves 8

3 TABLESPOONS RAISINS
4 TABLESPOONS GOOD BRANDY
4 QUINCES
3 TABLESPOONS SHELLED WALNUTS, *chopped*
1 TEASPOON GROUND CINNAMON
$^1/_2$ CUP BROWN SUGAR, *firmly packed*
3 TABLESPOONS BUTTER, *cubed*

BAKED QUINCES WITH BROWN SUGAR, CINNAMON, AND WALNUTS

This is more or less the way Ketty makes her quinces. She is a special cook and has a wonderful restaurant in Plaka, Athens, called Café Avissinia. You could serve these with pistachio or vanilla ice cream or a dollop of cream or crème fraîche.

Preheat the oven to 350°F. Put the raisins in a small bowl with the brandy and let it soak for a bit.

Cut the quinces in half, leaving their skins on, and core them, making a nice nest where the core was. Put them in an ovenproof dish where they will fit compactly in a single layer. Spoon the raisins evenly into the nests and then drizzle the brandy over the top. Spoon the walnuts, cinnamon, brown sugar, and butter into the nests. Pour 1 cup of water into the dish and then cover with aluminum foil. Bake for about 2 hours, adding another 1 cup of hot water halfway through the cooking time and scraping up any bits of sugar or nuts that may be stuck to the edge of the dish. If it appears to need more water, add a little.

After about 2 hours the quinces should be really soft, but not collapsing, and beautifully golden with some thickened sauce. Serve warm, drizzled with some sauce.

Makes 3 cups

²/₃ CUP SHELLED UNSALTED PISTACHIO
 NUTS (1²/₃ CUPS UNSHELLED)
1 CUP MILK
2 CUPS HEAVY WHIPPING CREAM
1 TABLESPOON GOOD BRANDY
4 EGG YOLKS
¹/₂ CUP SUPERFINE SUGAR

PISTACHIO ICE CREAM

You could serve this with a shard or crumblings of pistachio praline scattered on top or a nice chunk of dark chocolate. I like it with beautiful red quinces, either baked or poached in syrup. Make sure your pistachios are a lovely bright green to start with. You won't need the egg whites here, so save them in your freezer for another time.

Peel the reddish-brown skins from the pistachios to reveal the bright green nuts. (If the skins won't come away easily, drop the nuts into boiling water for a minute or so and then drain and peel them.) Put the nuts in a blender and pulse into coarse bits. Transfer them to a saucepan with the milk, cream, and brandy, and bring just to a rolling boil. Remove from the heat and, with a handheld mixer, purée until fairly smooth. (It won't get completely smooth, and this will give your ice cream some texture.)

Whisk the egg yolks and sugar together for about 5 minutes, until pale and creamy. Stir in a ladleful of the hot pistachio cream to acclimatize the eggs and then gradually add the rest. Return the mixture to the saucepan over very low heat and stir constantly for 4 to 5 minutes, until it thickens. (Do not have the heat too high or the eggs will scramble.)

Remove the custard from the heat and let it cool completely, whisking every now and then to prevent the eggs from scrambling. Transfer to a bowl, cover, and put in the freezer.

After an hour, remove the bowl from the freezer, give an energetic whisk with a whisk or electric mixer, and return the bowl to the freezer. Whisk again after another couple of hours. When it is nearly firm, give one last whisk, transfer to a suitable freezing container with a lid, and let it set in the freezer until it is firm.

Alternatively, pour the mixture into your ice-cream machine and freeze, following the manufacturer's instructions.

Serves 8 to 12

2 CUPS SUGAR
1 HEAPED TEASPOON GROUND CINNAMON
ABOUT 4 CLOVES
JUICE OF HALF A LEMON
1/2 POUND PLUS 2 TABLESPOONS BUTTER
2 3/4 CUPS FINE SEMOLINA
1 CUP COARSELY GROUND WALNUTS

HALVA

There are three types of halva that I know of: one is a solid marble-looking block that is sold by the slice; the next is a semolina-type cake with nuts that is baked and then has a syrup poured over; this third kind is also with semolina, but cooked completely on the stovetop and then poured into a cake or tube pan. When cool, it is cut into slices and has a very familiar taste and texture to me. You may find it unusual — to me its taste holds such history. It is a standard dish that any Greek lady would have a recipe for.

Lightly butter a Bundt pan or 5 by 7 by 3-inch cake pan. To make the syrup, put the sugar, cinnamon, cloves, lemon juice, and 4 cups of water in a saucepan and bring slowly to a boil to dissolve the sugar. Simmer for 10 minutes, or until syrupy. Remove from the heat.

Melt the butter in a large, wide saucepan over medium heat and then cook for 3 to 4 minutes, until it starts to turn golden and smells beautifully buttery (this is important for the final taste of the halva). Add the semolina and mix in well with a wooden spoon. Continue cooking for about 10 minutes, stirring and turning the semolina almost continuously so that it turns golden brown and doesn't burn. Add the nuts and cook for about 5 minutes, until they seem to have taken on a color and the mixture smells nutty and buttery. Remove from the heat.

Return the syrup to the stove for a minute to heat through. Scoop out and discard the cloves. Carefully pour the hot syrup into the semolina (standing back a bit as it will splash up). The mixture will thicken in the pan, so stir vigorously with a wooden spoon until it comes away from the side of the pan. As it starts to look like a smooth, thick porridge, pour it into the cake pan. Let cool completely, before turning out onto a plate. Serve in slices, sprinkled with a little extra cinnamon if you like.

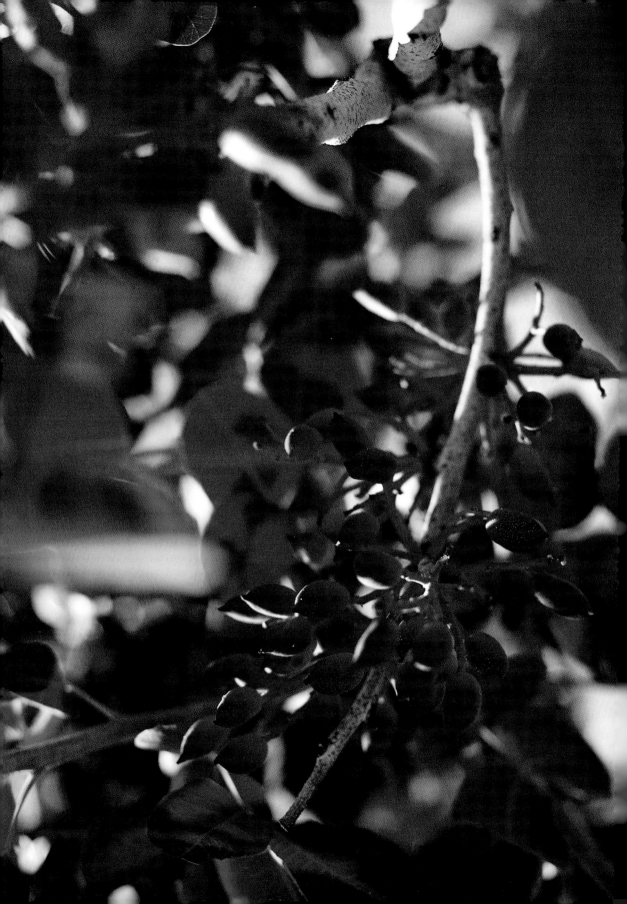

CINNAMON + ROSES

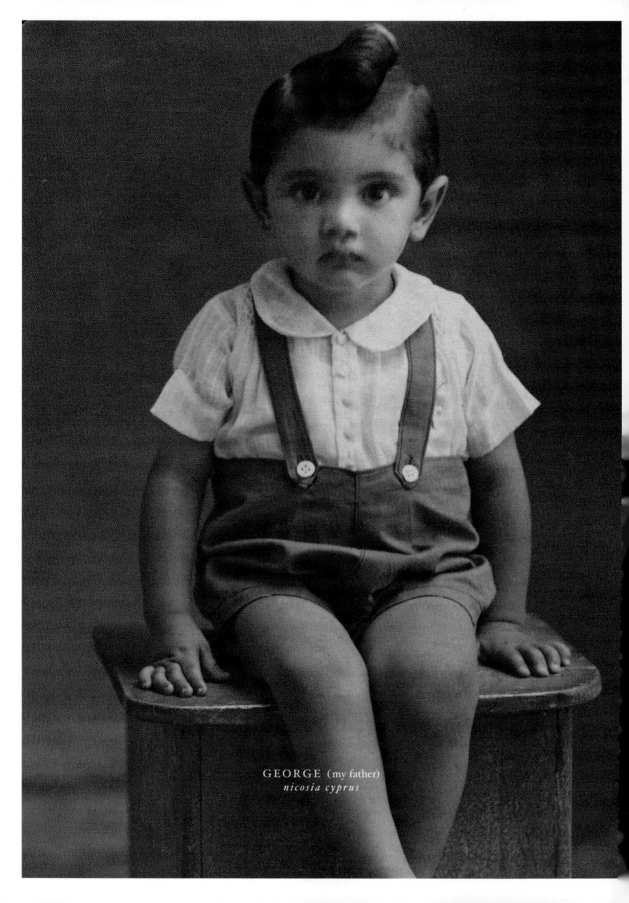

GEORGE (my father)
nicosia cyprus

Pappou, my special grandfather, was an ironmonger by trade and definitely a cook at heart. He was responsible for certain dishes in the household, which nobody interfered with. These were the souvlakia, souvla, and all barbecues, when he would sit outside for ages turning the meat around and around. The salad, too, was his section, and so were those beautiful fries that had a method to their seeming madness. Pappou gave me his recipes, with measurements such as "one flat woodenspoonful of sugar," as he stirred.

My grandfather would water his roses at any odd hour of night and had the same enthusiasm for every single thing he did, whether it was bashing his fries or driving my cousins to their music lesson in his beautiful old car. I loved the smell and the sound of that long straw broom that he used to sweep the courtyard. That strong swish-swoshing sound of straw sweeping on cement and the smell of water lullabied me to sleep some afternoons under the shade of the vines.

Serves 1

3/4 CUP NOT-TOO-THICK PLAIN YOGURT
1/2 CUP ICE-COLD WATER
1 TEASPOON DRIED MINT
ABOUT 1/2 TEASPOON SALT
CRUSHED ICE

AIRANI

In the summer, street vendors sell glasses of this in the old center of Cyprus and I am not sure that there is anything else quite so refreshing. The salt really brings out the flavors. It may be an acquired taste, but I love it every now and then on a really hot day. You could also serve something like this as a cold summer soup, perhaps adding some diced cucumber.

Mix together the yogurt, water, and mint, and season with the salt, checking for flavor and adjusting the salt to your taste. Scatter the crushed ice over the top and serve.

jasmine

The smell that hit you upon arrival in Nicosia was those jasmine bushes flanking the front door. Their syrupy delicate fragrance waltzed smoothly with the summer night heat. We would lie on the marble floors, soothing our bodies, hoping that some cooler air would arrive from somewhere. Still now, when I smell jasmine at night, I feel I could embrace the moon.

Serves 1

1^1/$_2$ TABLESPOONS BUTTER
1/$_2$ TABLESPOON OLIVE OIL
1 SLICE HALOUMI CHEESE, *about 1-inch thick*
A LITTLE ALL-PURPOSE FLOUR, *for dusting*
2 TABLESPOONS OUZO
HALF A LEMON

FRIED HALOUMI CHEESE

You can try this with any type of firm cheese. The nice thing about haloumi is that it holds its shape while just softening beautifully, instead of melting away. Make the slices as thick as you want. This can be cooked without the ouzo as part of a mixed meze, but on its own it stands beautifully with the flavor of the ouzo. Serve it simply in the pan you have cooked it in (if you have a small one), perhaps with a glass of ouzo on ice. I think it goes nicely with tzatziki, too. To serve more people, just multiply the amounts.

Heat the butter and oil in a small skillet over medium heat. Dust the haloumi with flour on both sides, shaking off the excess. Add to the hot skillet and fry until golden on both sides, taking care that the butter doesn't burn. Then add the ouzo and carefully set it alight, standing back. Serve immediately with a squeeze of lemon.

Makes 1 1/2 cups

1¼ CUPS CHICKPEAS, *soaked overnight or* 1 (16-OUNCE)
 CAN CHICKPEAS, *drained, reserving some of the liquid*
1 LARGE GARLIC CLOVE
3 TABLESPOONS TAHINI
JUICE OF 2 LEMONS
3 TABLESPOONS OLIVE OIL
½ TEASPOON SWEET PAPRIKA

HUMMUS

I love hummus. Especially heaped onto some crusty bread together with slices of juicy tomato and an extra drizzling of olive oil and some salt. Of course, it is great on toasted pita bread along with any other meat or salad filling. It is healthy — it always reminds me that I'm giving myself calcium from the sesame — and a great quick snack once you have got past the soaking and cooking of the chickpeas. I often use canned chickpeas and then it is an almost instant thing.

If you are not using canned chickpeas, drain the soaked chickpeas into a saucepan, cover generously with water, and bring to a boil. Cook over medium-high heat for about 1½ hours, until they are softened. Drain, reserving some of the cooking liquid. Pass the chickpeas through a large-holed sieve to remove their skins.

Crush the garlic with a little salt until it forms a purée. Put the chickpeas, tahini, and garlic in a blender, purée a little, and then season with salt. Add the lemon juice and continue puréeing until smooth. Scrape out into a bowl and thoroughly mix in the olive oil. If it's a bit too dry, add some of the reserved chickpea liquid. Check that there is enough salt. Sprinkle with the paprika and drizzle with a little more oil if you like. Hummus will keep in an airtight container in the refrigerator for up to a week.

Makes about 18

1¹/4 POUNDS (ABOUT 10 CUPS) FIRMLY PACKED
 SPINACH LEAVES
2¹/3 CUPS CRUMBLED FETA CHEESE
2 EGGS, *lightly beaten*
GRATED NUTMEG
3 TABLESPOONS GRATED PARMESAN CHEESE
1 (16-OUNCE) PACKAGE FILO DOUGH
¹/4 POUNDS PLUS 4 TABLESPOONS BUTTER, *melted*

SPANAKOPITA

These are to be found everywhere in Cyprus and Greece. They are good alone or as part of a meze platter. You can make them smaller: just cut more strips down the width of the filo and dollop less spinach mix onto the pastry. This will make about 18 medium-size delicious buttery, crispy pies or 30-ish smaller ones.

Blanch the spinach in boiling salted water for a few minutes and then drain well. When it has cooled slightly, chop it up finely, squeezing out as much excess water as possible. Put the spinach in a bowl, add the feta, and mash with a fork or wooden spoon. Mix in the eggs, a little nutmeg, and the Parmesan. Season with black pepper.

Preheat the oven to 350°F. Lay out one sheet of the filo dough on a work surface and brush with melted butter. (Keep the rest of the filo covered with a damp cloth so that it doesn't dry out.) Put another sheet of filo to fit exactly over the first and brush this with butter, too. Cut the filo into 4-inch strips down the length.

Put 1 tablespoon of spinach filling at the bottom middle of each strip and fold the right corner over to the left side to make a triangle. Fold the pastry upward to create another triangle and continue until you have made a neat package. Brush both sides with butter and arrange on a baking sheet so they fit quite compactly. Repeat with the rest of the pastry and filling. Bake for 15 to 20 minutes, or until the pastry is golden and crisp, and then serve immediately.

Makes about 1 pound

1¼ POUNDS (ABOUT 4 CUPS) GREEN OLIVES
 IN BRINE, *or* 1 POUND (ABOUT 3¼ CUPS) *pitted olives*
1½ LEMONS
3 TEASPOONS CORIANDER SEEDS
2 GARLIC CLOVES, *crushed*
½ CUP OLIVE OIL

GREEN OLIVES WITH CORIANDER SEEDS

I love the coriander in these olives. By all means use a little less if you feel it may be overpowering, but the flavors really do work beautifully in this typical Cypriot recipe. Sometimes it's hard to pit olives, so either leave them unpitted or, if you prefer, use pitted olives. If you find the brine too strong for your taste, rinse the olives in warm water before you marinate them.

Put the olives on their sides on a wooden cutting board. Using the flat blade of a large knife, press down on the olives with both hands — you don't want to reduce them to a pulp, but just crack them open so you can remove the pits, preferably in one clean movement. Discard the pits and put the olives in a bowl.

Cut four or five thin slices from the lemon half (removing any seeds) and add to the olives. Roughly crush the coriander seeds in a coffee or spice grinder or in a mortar and pestle, just so that the seeds are cracked and release their splendid taste and perfume. Add to the bowl.

Juice the other lemon and add to the olives with the garlic and olive oil. Season with pepper. Check before you add any salt, as the olives may be salty enough. Mix well and let the flavors mingle for at least an hour before you serve them. They will keep, covered, in the fridge for a week. The flavor actually improves and the lemon slices soften beautifully.

Makes 24 pieces

6 LARGE RED, SWEET PEPPERS
$^1\!/_2$ CUP OLIVE OIL
2 GARLIC CLOVES, *lightly crushed*
1 TABLESPOON RED WINE VINEGAR
1 SPRIG OF FRESH ROSEMARY

FRIED
RED PEPPERS

This is a bit of a job because of the frying. You can make a smaller quantity, but I find that it really is worth doing quite a lot as they can sit in the refrigerator for a few days and just improve their flavor. They are fantastic with goat's cheese on bread. I add a sprig of rosemary to the oil and, if I'm going to be serving them quite quickly, I often tear a few basil leaves or scatter some fresh chopped parsley or cilantro into the oil. These leafy fresh herbs don't do well sitting in the refrigerator (the rosemary will be fine), so mix them together just before serving. Use these as a beautiful splash of color and taste on your meze platter or as a side dish with broiled meat or fish. They are also great on pizza.

Wash the peppers, quarter them lengthwise, and scoop out all the insides. Dry them well.

Pour about half of the olive oil into a large nonstick saucepan, or enough to cover the bottom. Fry the peppers in batches over medium heat, until they are quite deeply golden on both sides. The important thing is that they surrender their firmness, so if you find that they are browning but still hard, add a new batch to the pan and stack the older ones on top of them so that they benefit from the heat for longer. This will also help you get through your pepper pile quicker.

Put the cooked peppers into a wide bowl or serving dish with the rest of the olive oil (or use some of the oil the peppers were cooked in), the garlic cloves, vinegar, and rosemary. Season with salt and pepper. Turn the peppers in the liquid and, when they are completely cool, cover the dish. Serve at room temperature.

Keep any leftover peppers covered in the refrigerator, where they will last for a few days (covered completely in olive oil, they will last even longer).

Makes about 60 small meatballs

2 SLICES OF BREAD
$^1/_2$ CUP MILK
1$^1/_2$ POUNDS MIXED GROUND PORK AND BEEF
$^1/_2$ TEASPOON DRIED MINT
2 TABLESPOONS CHOPPED FRESH ITALIAN
 PARSLEY
2 EGGS
1 SWEET APPLE, *peeled, cored, and grated*
1 RED ONION, *grated*
OLIVE OIL, *for frying*

KEFTEDES

This is a slight variation on the classic Greek fried meatballs that all households have. They are light and tasty and probably less fuss to make than you may imagine. Serve them at room temperature, alone or together with other bits and pieces on a meze platter. The Greek and Cypriot meze can really be a mix of anything you like and could be served like an Italian antipasto before a meal, or can sometimes even "become" the meal, depending on the quantities. Some mezes continue forever, it seems, and include meat, fish, and a great variety of vegetables and salads.

Break up the bread in a small bowl and add the milk. Let the bread soak and absorb the milk, squishing it up so that it dissolves.

Put the meat in a large bowl. Crumble in the mint and add the parsley, eggs, apple, onion, and the soaked bread. Season with salt and pepper. Mix very well with your hands (it will feel quite soft). Roll out small balls about the size of cherry tomatoes, using up all of the mixture. Keep these flat on a tray or board until you're ready to start frying.

Pour about $^1/_2$ inch of olive oil into a large nonstick saucepan over medium-high heat. Add a batch of meatballs in a single layer (cook in batches as they will be difficult to turn). Fry until they are golden brown all over, turning carefully with a slotted spoon. Try not to fiddle with them too much as they will be soft and may fall apart.

Remove the cooked meatballs to a plate lined with paper towels to absorb the excess oil. They can be served immediately or at room temperature with lemon juice or tzatziki (page 76).

Makes 14

1 (1-OUNCE) CAKE FRESH YEAST
1 TEASPOON SUGAR
4 CUPS BREAD FLOUR
1 TEASPOON SALT
1½ TABLESPOONS BUTTER, *melted*

topping
2 TABLESPOONS OLIVE OIL, *plus extra for drizzling*
1 RED ONION, *chopped*
1¼ POUNDS LEAN GROUND LAMB
½ TEASPOON GROUND CINNAMON
½ CUP CHOPPED FRESH ITALIAN PARSLEY
¼ (14-OUNCE) CAN TOMATOES, *chopped or puréed*
JUICE OF 1 LEMON, *to serve*
CHOPPED CHILES IN OIL (PAGE 160), *to serve*

LACHMAJOU

This is very Middle Eastern and versatile: like a small pizza, topped with a fairly dry lamb, onion, and parsley mixture, baked and then splashed with lemon juice and chile oil. You could also add a couple of chopped red chiles to the lamb sauté, although I prefer to let people add as much as they like — and my children have it without. This makes 14: you could serve two as a light lunch with a salad; one would do as an antipasto. Or serve them alongside some other Middle Eastern meze. Ask your butcher to grind the lamb for you or you can do it in the blender. Some people simply mix together the topping ingredients and put this uncooked onto the rolled-out dough that is going to be baked in the oven anyway.

Crumble the yeast into a bowl, sprinkle with the sugar, and add 1¼ cups of lukewarm water. Let it stand for 10 to 15 minutes, until it begins to activate. Mix in the flour, salt and butter and, when it all comes together, turn out onto a lightly floured work surface and knead well, until the dough is smooth and elastic. Put it back into the bowl and cover with a dish towel, then a heavier cloth. Let it stand in a warm place for about 1½ hours to rise — the dough should puff right up to the top of the bowl.

To make the topping, heat the olive oil in a saucepan and gently sauté the onion to soften it. Add the lamb, cinnamon, and most of the parsley. Season with salt and pepper. Cook until any moisture from the lamb has evaporated and the meat is lightly golden, breaking up any clusters with a wooden spoon. Remove from the heat and stir in the tomato. Preheat your oven to 425°F.

Punch down the dough by punching out all the air to bring it back to its original size. Divide the dough into 14 balls, keeping them covered so they don't dry out. On a lightly floured surface, roll out the dough balls to $^1/_{16}$ inch thick and about 5 to 6 inches in diameter. Don't worry if they're not completely round: sometimes I make them oval or even a bit triangular. Arrange on lightly floured baking sheets and scatter more than a heaped tablespoon of topping over each, leaving a thin border around the edge. Drizzle about a teaspoon of olive oil over each one and bake for a maximum of 10 minutes, or until the dough is just cooked but not dried out. Serve immediately, sprinkled with lemon juice, a little chopped chile in oil, and the rest of the chopped parsley. Cover any that you don't eat with foil. They can be heated quickly in a hot oven or eaten at room temperature.

Makes 1 large jar

ABOUT 40 FRESH RED CHILES
SALT
1$^1/_2$ CUPS OLIVE OIL

CHILES
IN OLIVE OIL

A teaspoonful of this oil (and a bit of the chile itself) can be drizzled onto pasta or over broiled meats and salads. The oil will initially be very hot, but as it is used you can top it up with more olive oil and it will eventually lose some of its potency. The flavor of the oil will depend entirely on your choice of chiles. Be sure to wear rubber gloves when handling the chiles, as just a little on your skin can prove uncomfortable even a few hours later (especially if you rub your eyes!).

Cut the chiles into thin rounds of about about $^1/_{16}$ inch. Put them in a colander in the sink and remove as many of the seeds as you can by tapping the colander sharply on the side of the sink. Sprinkle generously with salt and put a plate that fits inside your colander on top of the chiles to squash them and extract some of the juice. Set aside for about 24 hours.

Still using gloves, squeeze the chiles with your hands to drain away the excess salt and moisture and pack them into a clean, sterilized jar. Cover them completely with olive oil. The oil will be ready in a couple of days, but will be better in a couple of weeks. Add more olive oil if the chile oil is too strong. Store in a cool place. The chiles must remain covered by the oil at all times.

Serves 8 to 10

1 CUP BULGUR
1 SMALL RED ONION, *chopped*
$\frac{1}{2}$ TEASPOON SALT
2 CUPS CHOPPED FRESH ITALIAN PARSLEY
2 TABLESPOONS CHOPPED FRESH MINT LEAVES
JUICE OF 2 LEMONS
$\frac{1}{2}$ CUP OLIVE OIL
2 SMALL RIPE TOMATOES, *diced*

TABOULI

You will need to start this salad a few hours, or even a day, before you are going to serve it, as the bulgur needs soaking. You can also dress the salad beforehand as the ingredients benefit from some mingling in the bowl. It is just the tomatoes that need to be added not too long before serving, so that they don't become soggy. This is more parsley salad than anything else. I love parsley — I love the idea of eating so much iron.

Put the bulgur in a bowl and cover it with about 1 cup of cold water. Stir well, cover the bowl with plastic wrap, and refrigerate for a few hours or overnight so that the bulgur absorbs the water. Stir a couple of times.

Put the onion in a small bowl, cover with cold water, sprinkle with the salt, and set it aside for 20 minutes or so before draining away the water and rinsing again.

Drain the bulgur through a fine sieve, pushing it gently with a wooden spoon to extract any water. Pour it into a bowl and add the parsley, mint, onion, lemon juice, and oil. Season with salt and pepper, and mix together well. Keep the salad in the fridge and mix in the tomatoes just before serving.

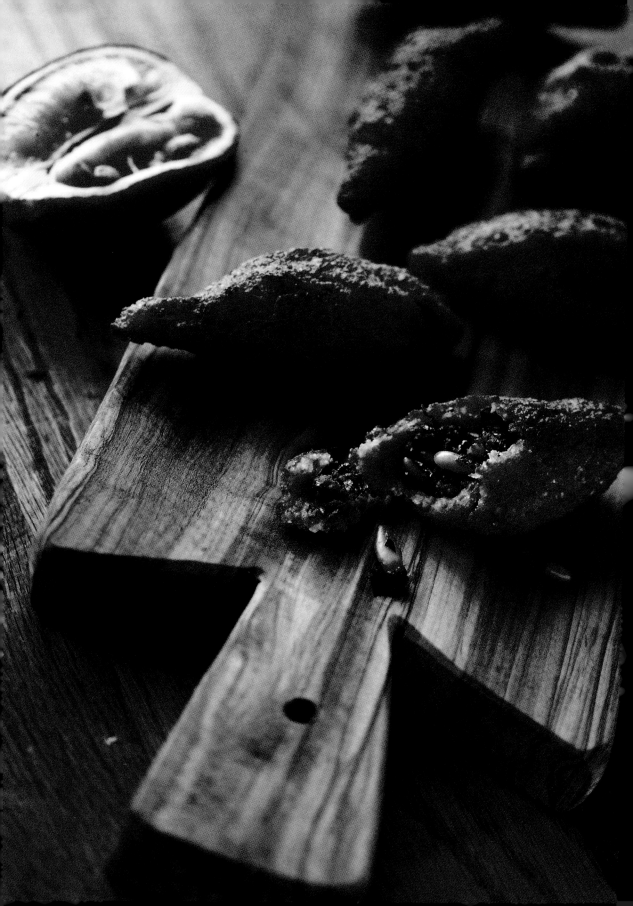

Makes 25 koupes

shells
²/₃ CUP FINE BULGUR *or*
 2¹/₂ CUPS FINE BULGUR (*and no lamb, see below*)
1¹/₄ POUNDS LEAN GROUND LAMB
2 RED ONIONS, *chopped*

filling
1 TABLESPOON OLIVE OIL
1 WHITE ONION, *finely chopped*
³/₄ POUND GROUND MIXED PORK AND BEEF
¹/₂ TEASPOON GROUND CINNAMON
2 TABLESPOONS PINE NUTS
¹/₂ CUP CHOPPED FRESH PARSLEY
OIL, *for deep-frying*
LEMONS, *to serve*

KOUPES

These are a wonderful Middle Eastern speciality. It is good to have a couple of friends helping, as they can be a little tricky, but once you have tasted koupes you will want to know how to make your own. They are shaped like long dumplings or elongated eggs with slightly pointed ends. The outer shell is made with bulgur and filled with a mixture of fried ground meat, parsley, cinnamon, and pine nuts, then deep-fried. Women who have been making these for a lifetime casually churn out these bulgur shells as though they were knitting or doing something quite natural. If you use ground lamb in the shells as well as the bulgur, you will find them a lot easier to shape, so I've included both methods.

If you are feeling brave, or have made these before, you can make the shells from just bulgur. Put 2¹/₂ cups of bulgur in a bowl, season with salt, and cover with 2¹/₂ cups of just-boiled water. Mix well and, once the wheat has cooled a little, cover the bowl and let stand for about 3 hours while you make the filling.

To make the shells by the easier method, put the ground lamb in a food processor and blend to a paste. Transfer to a bowl. Blend the onions to a paste as well, add to the meat, and season well with salt and pepper. Mix well and set aside. Rinse the bulgur in a sieve under cold running water. Drain well and squeeze out any excess water. Blend in a food processor. Add the lamb mixture and blend again. Set aside while you make the filling.

To make the filling, heat the olive oil in a nonstick pan and sauté the onion, stirring, until softened and lightly golden. Add the mince and continue to sauté until all the moisture from the meat has evaporated and it is golden and completely cooked. Break up any clusters with a wooden spoon. Season with salt and pepper and add the cinnamon, stirring constantly to prevent the meat from sticking. Add the pine nuts and cook for another minute or two. Stir in the parsley, then remove from the heat to cool.

Now you are ready to make the shells. Have a small bowl of water ready. If you are using the shell mixture with just bulgur, start kneading the bulgur in the bowl and then turn it out onto the work surface and knead it as you would a dough (although it will be much harder). It should start to feel softer after a while and then you can break off a chunk about the size of an egg and make it into a ball. If you are using the shell mixture with meat in it, take a ball of the shell mixture about the size of an egg (keep the rest of the mixture covered with a damp cloth to prevent its drying out).

Hold the ball in the cup of your left hand (if you are right-handed). Using your right thumb, flatten the ball so that it takes the shape of your palm, turning upward like a blanket, and is as thin as you can make it. Add a teaspoonful of the lamb mixture and fold the sides of the "blanket" over the filling. Now you need to seal the top, so, if there is enough shell then do so dipping by your hands lightly in the water and using it like a glue if you find it helps. Or add more shell mixture, pressing it to make uniform, and then cup your hands together, cradling the shell tightly to make it smooth and compact. Put this on a tray while you make the rest.

Fill a saucepan or deep-fryer one-third with oil and heat up for deep-frying. Add the koupes a few at a time and deep-fry for 2 to 3 minutes, until dark golden and crisp. Drain on paper towels to absorb the excess oil and then serve drizzled with lemon juice and an extra sprinkling of salt. These are also good served at room temperature.

Serves 10

4 TABLESPOONS OLIVE OIL
1 LARGE ONION, *chopped*
2 TABLESPOONS CHOPPED FRESH PARSLEY
2 GARLIC CLOVES, *chopped*
2 POUNDS GROUND MIXED PORK AND BEEF
1 BAY LEAF
1 TEASPOON GROUND CINNAMON
$^1\!/_2$ CUP WHITE WINE
1 (14-OUNCE) CAN TOMATOES, *chopped*
1 (16-OUNCE) PACKAGE PENNE (*or any short*) PASTA
ABOUT 2 TABLESPOONS BUTTER
$^1\!/_2$ TEASPOON DRIED MINT
1 TABLESPOON BREAD CRUMBS

béchamel sauce
$^1\!/_4$ POUND BUTTER
1 CUP ALL-PURPOSE FLOUR
4 CUPS WARM MILK
A LITTLE FRESHLY GRATED NUTMEG

PASTITSIO

I love pastitsio. I have a special oval-shaped glass baking dish that I like to cook it in: it is about 14 inches long, 10 inches wide, and 2$^1\!/_2$ inches deep. Make it in another shaped dish if you like, but it will need to be of similar dimensions (definitely no bigger). It might seem like a lot of fuss and bother, but if you're well organized it can be fun. Pastitsio is best served warm, or even at room temperature, with a lovely big Greek salad.

Heat the oil in a large nonstick saucepan and fry the onion until it is soft and lightly golden. Add the parsley and garlic and cook for a few seconds before adding the meat. Fry for a few minutes, until all the moisture has evaporated and the meat is starting to brown. Season with salt and pepper and add the bay leaf and cinnamon. When it begins to fry in the oil and brown, add the wine and cook until evaporated. Add the tomatoes and about a cupful of water and continue cooking over medium to low heat for 10 to 15 minutes, until the tomatoes have melted into the meat. The meat shouldn't be too dry. Remove from the heat.

Preheat your oven to 350°F. Meanwhile, cook the pasta in boiling salted water for 2 minutes less than it says on the package so that it is still quite firm. Drain and put in a bowl. Mix in the butter and crumble in the mint with your fingers. Mix well and spoon half over the base of a large ovenproof baking dish. Pour the meat mixture over the top so it evenly covers the pasta, then add the remaining pasta in another layer over the top. Press down with a wooden spoon so that it is fairly compact. Set aside while you make the béchamel sauce.

Melt the butter in a saucepan. Whisk in the flour and cook for a few minutes, stirring constantly, then begin adding the warm milk. It will be immediately absorbed, so work quickly, whisking with one hand while adding ladlefuls of milk with the other. When the sauce seems to be smooth and not too stiff, add salt, pepper, and a grating of nutmeg, and continue cooking, even after it comes to a boil, for 5 minutes or so, mixing all the time. It should be a very thick and smooth sauce. Pour this over the pasta and meat layers in the dish. It should just fit exactly in the dish. Sprinkle the bread crumbs over the top and bake for 30 to 40 minutes, until the top is nicely golden in parts. Let it cool a little before cutting into squares to serve, otherwise it will run everywhere.

My father remembers Yayia making haloumi that was then preserved in salt water with flecks of mint in large clay pots. They would keep them in the loft for the months ahead.

Serves 8

2¹/₂ POUNDS (ABOUT 2 LARGE) EGGPLANTS
ABOUT 1 CUP LIGHT OLIVE OIL
1 LARGE ONION, *finely chopped*
3 TABLESPOONS ROUGHLY CHOPPED FRESH
 ITALIAN PARSLEY
2 GARLIC CLOVES, *finely chopped*
2 POUNDS GROUND MIXED PORK AND BEEF
1 TEASPOON GROUND CINNAMON
¹/₂ TEASPOON DRIED OREGANO
1 BAY LEAF
¹/₂ CUP WHITE WINE
2 CUPS TOMATO SAUCE
1¹/₄ POUNDS (4 MEDIUM) POTATOES, *peeled*

béchamel sauce
¹/₄ POUND BUTTER
1 CUP ALL-PURPOSE FLOUR
4 CUPS WARM MILK
A LITTLE FRESHLY GRATED NUTMEG

MOUSSAKA

This is more or less how my aunt makes her moussaka. It seems like an incredible job, but you could split up your workload and make the meat sauce the day before (but bring it back to room temperature before putting the moussaka together). If you peel the potatoes in advance, keep them in a bowl of water so that they don't discolor. You could even fry your eggplant and potatoes a few hours before making the béchamel and putting the moussaka in the oven. The size of the dish is important: I use a transparent oval dish, 14 inches long, 10 inches wide, and ¹/₂ inch deep.

Trim the hats off the eggplants, then slice the eggplants lengthwise into ¹/₄-inch slices. Sprinkle salt quite generously over the slices and leave them in the sink or in a bowl for about 30 minutes to draw out any bitter juices.

Heat 3 tablespoons of the oil in a wide nonstick saucepan. Sauté the onion, mixing it with a wooden spoon until it is softened and lightly golden. Add the parsley and garlic and cook for another minute, until you can smell the garlic, then add the meat. Cook over medium-high heat, until the meat loses its water and begins to brown, shifting it around with a wooden spoon. Add the cinnamon, oregano, and bay leaf and season with salt and pepper. When the meat is golden, add the wine and scrape the bottom of the pan with your spoon to make sure no meat is stuck. Let most of the wine evaporate, then add the tomato sauce and let it simmer for

about 30 minutes, uncovered, stirring now and then. Break up any clusters with a wooden spoon. If it seems too dry, add a few more drops of water, but this shouldn't be necessary.

Meanwhile, slice the potatoes lengthwise into $1/4$-inch slices and pat them dry. Heat 4 or 5 tablespoons of olive oil in a large nonstick saucepan and fry the potatoes in batches over medium heat, until they are golden on both sides and cooked through. Transfer to a plate lined with paper towels, to absorb the oil, and sprinkle with a little salt.

Rinse the salt from the eggplant with cold water and pat dry. Fry in batches in the same pan and oil as the potatoes — they will absorb a lot more oil than the potatoes, so they need a bit of attention. When the underside is golden, turn over and prick with a fork in several places, especially in any still hard bits, so that they are almost collapsing. If you press down with a fork, they should not be hard and papery but instead should be almost like a purée. If they are darkened but not yet soft, stack them on top of the new batch so they can cook for longer. Remove the slices to a plate lined with paper towels to absorb some of the oil while you finish the next batch, adding only a tablespoon of oil if possible between batches.

Preheat the oven to 350°F. Arrange half the eggplant over the bottom of your oven dish, even slightly overlapping if necessary. Then add the potatoes in a single layer, if possible. Add half the meat, pressing it down with the back of a large spoon. Add the rest of the eggplant in a layer, and then a final layer of meat. Press it down and you should still have about 1-inch space at the top of the dish.

The béchamel needs to be made just before you bake the moussaka. Melt the butter in a saucepan. Whisk in the flour and cook for a few minutes, stirring constantly, then begin adding the warm milk. It will be immediately absorbed, so work quickly, whisking with one hand while adding ladlefuls of milk with the other. When the sauce seems to be smooth and not too stiff, add salt, pepper, and a grating of nutmeg, and continue cooking, even after it comes to a boil, for 5 minutes or so, mixing all the time. It should be a very thick and smooth sauce. Taste for seasoning and spoon over the meat. It should come just about flush with the top of the dish.

Bake for 45 minutes to 1 hour with a baking sheet underneath to catch any spills, until the moussaka begins to bubble up and the top is golden in parts. Let it cool slightly in the oven before serving. It could even be served at room temperature. Cut into traditional square servings.

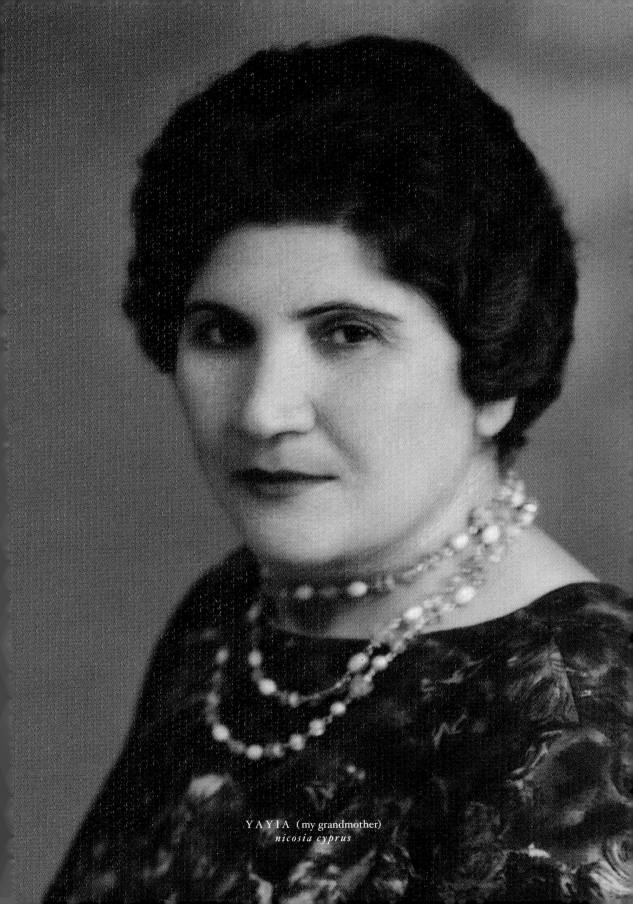

YAYIA (my grandmother)
nicosia cyprus

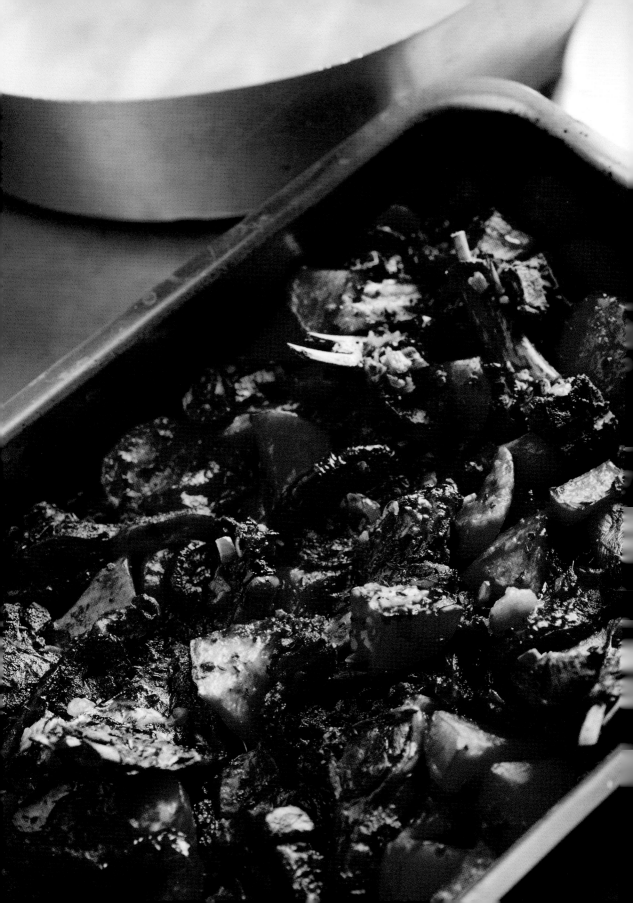

Serves 6

2 RED ONIONS, *roughly chopped*
2³/4 POUNDS (ABOUT 9 MEDIUM) POTATOES, *cut into large chunks*
2¹/4 POUNDS LAMB, *cut into chunks*
4 TABLESPOONS CHOPPED FRESH ITALIAN PARSLEY
3 HEAPED TEASPOONS CUMIN SEEDS
¹/2 CUP OLIVE OIL
4 *or* 5 RIPE TOMATOES, *cut into thick slices*
3¹/2 TABLESPOONS BUTTER

TAVA
(CYPRIOT BAKED LAMB AND POTATOES WITH CUMIN AND TOMATOES)

This is so simple. It's a very typical Cypriot all-in-one meal — you just need the time to prepare the lamb and vegetables, then you can fling it in the oven, go out for a (Greek) coffee, and come home to a ready meal. You could use lamb chops and leave them whole instead of cutting them into chunks, which makes it even simpler. And it doesn't need much by way of accompaniments — perhaps a salad or some simply sautéed vegetables.

Preheat your oven to 350°F. Put the onion, potato, and lamb in a 20-cup (5-quart) casserole dish or a deep baking dish. Season with salt and pepper. Add the parsley, cumin, and olive oil and mix very well with your hands. Put the tomato slices on top in a single layer and season lightly with salt. Dot the butter over the top and pour about ¹/2 cup of water around the sides of the dish. Cover with foil and bake for 2 hours, tilting the dish from side to side a couple of times and spooning some of the pan juices over the top. The lamb should be very tender and the potatoes soft.

Remove the foil, increase the oven temperature to 400°F, and cook for another 45 minutes or so, turning the lamb halfway through, or until the meat and potatoes are a little browned and the liquid has reduced. Serve hot or at room temperature.

— Cyprus —

Serves 4

2 POUNDS TARO OR OTHER ROOT VEGETABLES
1/2 CUP OLIVE OIL
1 (3-POUND) WHOLE CHICKEN, *skinned and cut into*
 8 serving pieces
2 RED ONIONS, *chopped*
1 TABLESPOON BUTTER
1/2 CUP CHOPPED CELERY LEAVES
2 HEAPING TABLESPOONS TOMATO PASTE
JUICE OF 2 LEMONS

KOLOKASSI

This is a Cypriot dish that we had often during my childhood. It is the taro that gives kolokassi its special flavor, although you could probably make it with another root vegetable such as celeriac or even sweet potatoes. This is often made with chunks of pork instead of the chicken — you could use either.

Peel the taro. Don't rinse it, but rub it clean with a damp cloth or paper towels. Cut the taro into chunks by just chipping into it with a sharp knife and then breaking off pieces of about 1 inch. Leave the taro pieces in a bowl with a little splash of lemon juice over them and a sprinkling of salt.

Heat the oil in a wide casserole dish and fry the chicken on both sides until it is lightly golden. Remove the chicken and add the onions to the dish, stirring constantly. When they look like they could start sticking, add the butter and stir for a few minutes more. Return the chicken to the dish, season with salt and pepper, and add the celery leaves and taro.

Dissolve the tomato paste in about 3½ cups of hot water and add to the casserole. When it comes back to a boil, cover, decrease the heat to a simmer and cook for 45 minutes to 1 hour, without stirring the chicken around too much but checking that it doesn't stick. Halfway through this time, add the lemon juice and taste for seasoning.

The chicken and taro should be very tender, but not falling apart, with a good quantity of pan juice. Let it stand for a bit before serving, so that it's not too hot.

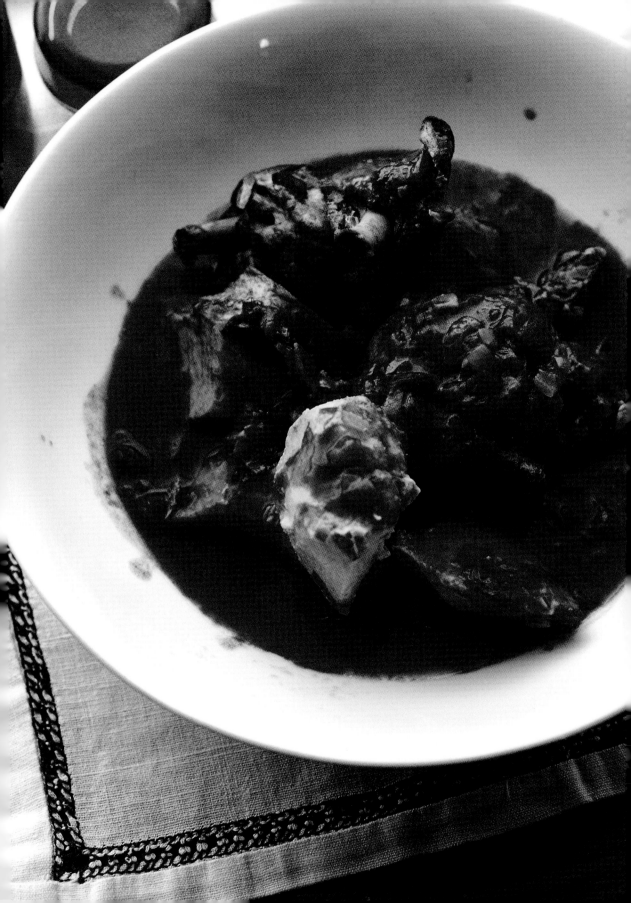

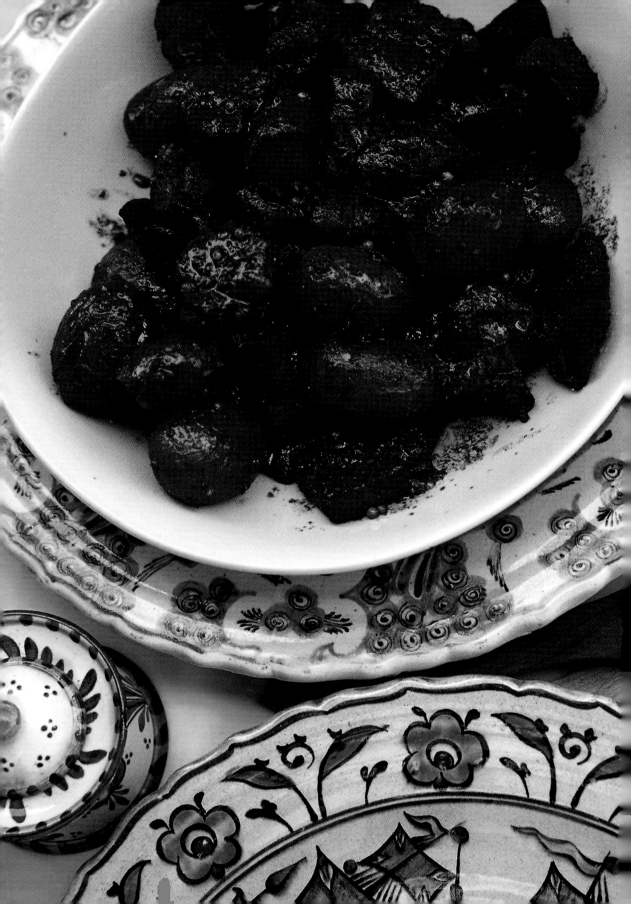

Serves 4

3 POUNDS BONED SHOULDER OF PORK WITH SOME
FAT, *cut into slices about 3/4 inch thick*
2 CUPS GOOD RED WINE
5 TABLESPOONS OLIVE OIL
2 GARLIC CLOVES, *peeled and crushed a bit*
5 HEAPED TEASPOONS CORIANDER SEEDS, *lightly crushed*
1 *or* 2 BAY LEAVES

AFELIA
(PORK IN RED WINE WITH DRIED
CORIANDER SEEDS)

This is a traditional Cypriot dish, so simple and rather wintery with the wonderful, pronounced flavors of coriander and good red wine. The pork needs to be marinated ahead of time (24 hours is best, but even a few hours is fine, too). Don't crush the coriander seeds too much — they should be almost whole, but pounded just enough to release the magnificently unforgettable flavor. Serve with deep-fried whole new potatoes, cracked wheat (see page 178), mashed potatoes, or a simple white pilaf.

If there is rind on the pork, remove this and any excess fat. Cut the pork into chunks of about 2 inches. Put in a bowl with the wine and let it marinate overnight, or for a few hours in the refrigerator. Lift out the pork pieces with a slotted spoon (reserving the marinade) and pat dry with paper towels.

Heat the oil in a casserole dish and fry the pork until it is dark golden on all sides. Season with salt and pepper, then add the garlic and coriander. Continue cooking until you can smell the garlic and then add the marinade with the bay leaves and about 1 cup of water. When it begins to boil, decrease the heat to a minimum, cover, and simmer for about $1^{1}/_{2}$ hours, or until the pork is very tender and there is a fair amount of sauce in the pan. If necessary, add a little more water during cooking. Serve warm.

Serves 4 to 6 as a side dish

4 TABLESPOONS OLIVE OIL
1 RED ONION, *finely chopped*
2 GARLIC CLOVES, *chopped*
$^1/_2$ (14-OUNCE) CAN TOMATOES, *chopped*
1$^1/_2$ CUPS BULGUR
1 TEASPOON PAPRIKA
1$^1/_4$ CUPS PLAIN GREEK YOGURT, *to serve*

PURKOURI (CRACKED WHEAT)

This is good as part of a vegetarian meal, or instead of rice or potatoes with something like a simple broiled chicken breast. You might like to serve it with a splash of chile oil.

Heat the oil in a heavy-bottomed saucepan. Sauté the onion until soft and lightly golden, then add the garlic. Cook until you can smell it before adding the tomatoes. Cook for a few minutes, until it is bubbling nicely. Add the wheat, season with salt and pepper, and mix well. Add the paprika and 3 cups of hot water and, when it starts to boil, put the lid half on, decrease the heat to low, and cook for 10 minutes. Take the saucepan off the heat, cover with a clean cloth, put the lid back on, and let it stand for 10 minutes longer to steam off the heat. Take care not to overcook it or it will become mushy at the bottom and stick together. Fluff up the wheat with a fork and serve warm or at room temperature with a generous dollop of yogurt.

Serves 6

JUICE OF 1 SMALL LEMON
3/4 POUND CAUL FAT *(available from good butchers)*
2 RED ONIONS, *one sliced and one finely chopped*
1 TEASPOON SALT
2 3/4 POUNDS GROUND MIXED PORK AND BEEF
1 CUP CHOPPED FRESH ITALIAN PARSLEY

to serve
AT LEAST 12 PITA BREADS (PAGE 183)
3/4 CUP PLAIN GREEK YOGURT
 or TZATZIKI (PAGE 76)
3 REGULAR TOMATOES, *diced*
LEMON WEDGES

SHEFTALIA
(GROUND MEAT PARCELS)

These are incredible. They are sold all over Cyprus, ready barbecued and smelling wonderful, and can be tucked into pita bread or eaten alone with a salad or tzatziki and some lemon wedges to squeeze over the top. It may seem daunting to attempt this task of wrapping caul fat around the meat, but it really is quite simple. It gives a softness and wonderful flavor to the meat and holds it all together well as a wrapper. These can be cooked in a hot oven or under the broiler as well as on the barbecue. You may have to order the caul fat from your butcher (pork is best). You can easily adjust these quantities and make some to freeze (before cooking).

Fill a bowl with warm water and add the lemon juice. Soak the layers of caul fat for about 30 minutes (hot water will break it and cold water make it stiffen). Using a pair of scissors, cut the caul fat into 4-inch squares (they don't all have to be exactly the same).

Meanwhile, put the sliced onion in a small bowl, cover with cold water, and sprinkle with the salt. Let soak for 20 minutes or so. Rinse and drain well in a fine sieve and then put the onion in a serving bowl.

Prepare the meat mixture in another bowl. Mix together the meat, parsley, and chopped onion. Season with salt and pepper and then knead well with your hands. Form into small ovals, about the size of eggs.

Place a meat oval onto the center of each square of caul fat, wrap over from one side, then fold in the edges, and roll over on the other side to make a parcel. The caul fat will hold the mixture. Thread onto flat metal skewers (double skewers are a good idea for turning).

Preheat a barbecue grill or grill pan to medium hot and barbecue the sheftalia, until they are deep golden on all sides, soft inside, and completely cooked through. Arrange them on a serving platter and serve with warmed pita bread and separate bowls of tzatziki, diced tomato, the sliced onion, and some lemon wedges.

Pappou would make sausages with coriander seeds and chiles that they would then soak in red wine and put into sausage casings. These were hung up over an outdoor washing line to dry for a few days; he would bring them in at night and take them out again the next morning. They lasted for ages and were eaten grilled over the coals and sliced up on a meze plate. They were also very good fried with eggs for breakfast.

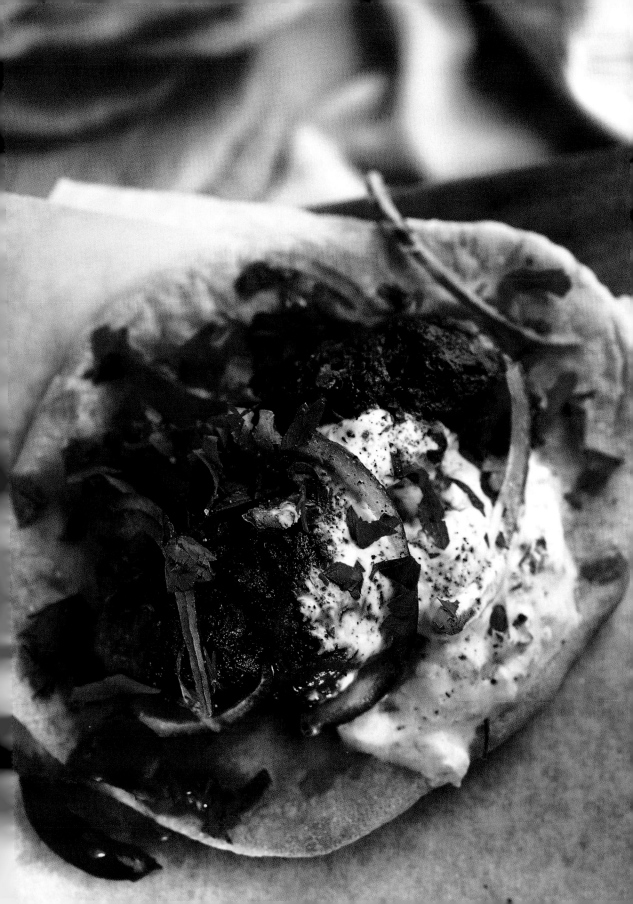

Serves 4 to 6

2 POUNDS PORK FILLET OR LOIN
1 RED ONION, *chopped*
1 TEASPOON SALT
1 TEASPOON DRIED OREGANO
JUICE OF 1 LEMON
3 TABLESPOONS OLIVE OIL
12 PITA BREADS (PAGE 183), *to serve*
TZATZIKI (PAGE 76), *to serve*
LEMON HALVES, *to serve*
2 TOMATOES, *diced, to serve*
$^1/_2$ CUP CHOPPED FRESH ITALIAN PARSLEY

SOUVLAKI

This is quite easy (once you've made it the first time) and, when you've got all your little salad bits and pieces organized, you can just sit back and advise everyone on how to fill their pita. You could also just make these under the broiler and serve them with a side salad and some chips. I always leave a little fat on the meat for the flavor and so that it doesn't dry out. Once the meat is cooked, splash it with the lemon and oregano and eat it straight from the barbecue — it doesn't like waiting around. Don't forget, bamboo skewers will need to be soaked in water for about 30 minutes before you thread the meat on, so that they don't scorch over the heat.

Cut the meat into small cubes, trimming away any excess fat. Thread onto 12 bamboo or metal skewers, not too tightly packed (about six or seven pieces per skewer, depending on how many cubes of meat you have). Preheat the barbecue grill to medium-high.

Put the onion in a small bowl, cover with cold water, and sprinkle with the salt. Let soak for 20 minutes or so, then rinse, drain well in a fine sieve and put in a serving bowl.

Combine the oregano, lemon juice and oil, season with salt and pepper to make a marinade, and brush over the meat, reserving some separately to use later as a sauce. Grill the skewers about 2 inches away from the coals, until they are nicely golden on both sides (the cooking time will depend on the heat of your grill). The meat should be cooked through with some dark brown bits, but not overcooked and dried out. Arrange on a serving platter and drizzle with the remaining oregano marinade (you can remove the meat from the skewers if you prefer). Sprinkle with a little extra salt and serve immediately with the just warmed pita breads (either on the grill or in the oven, covered in foil), and the tzatziki, onion, lemon halves, tomatoes, and parsley all in separate bowls for people to help themselves.

Makes 12

1 (¹/4-ounce) CAKE FRESH YEAST
2 TABLESPOONS OLIVE OIL
A PINCH OF SUGAR
4 CUPS PLAIN ALL-PURPOSE FLOUR
1 TEASPOON SALT

PITA BREAD

You need a really hot oven to make these and it's best to cook them in shifts so that there is only a single tray in your oven at any one time. It is a good idea to make a few extra — they freeze well and come in handy when you feel like souvlaki or hummus in pita.

Crumble the yeast into a bowl and add the olive oil, sugar, and scant ¹/2 cup of lukewarm water. Mix thoroughly and let stand for 10 to 15 minutes, until it starts activating and looks frothy.

Sift the flour and salt into a large bowl. Make a well in the center and add the yeast mixture. Gradually mix the flour into the yeast mixture, adding sufficient extra water to form a soft dough. Turn out onto a lightly floured work surface and knead for 10 minutes, or until the dough is really soft and pliable.

Put the dough back in the bowl and cover with a dish towel, then a heavier cloth on top. Leave in a warm, draft-free place for 1 to 1¹/2 hours, until it has risen. Punch the dough down by punching it to knock out all the air and bring it back to its original size. Knead it quickly and divide into 12 portions. Roll them a little and sit them a fair distance apart on a floured surface. Dust lightly with flour, then cover with another cloth. Leave for another 30 minutes or so and they will swell up again.

Meanwhile, preheat the oven to 425°F. Put two baking sheets in the hot oven for 20 minutes to get them really hot.

One by one, roll out each ball with a floured rolling pin to make a slightly elongated round of about 6¹/4 inches in diameter. Carefully put them onto the hot baking sheets, sprinkle lightly with water, and put in the hot oven, not too close to the top. Cook for about 8 minutes, or until the breads puff up in the middle and are very lightly golden. Turn over and bake them for another 2 minutes. It will probably be necessary to bake in batches.

Keep the pitas in a basket wrapped with a clean dish cloth. If you won't be eating them immediately, store them in a plastic bag to prevent their hardening. Reheat them for a minute or so in a hot oven or on a barbecue grill.

Serves 6 as a side dish

8 LARGE ARTICHOKES (ABOUT 7 OUNCES EACH)
2¼ POUNDS (5 MEDIUM) POTATOES, *peeled*
CORN OIL *or* LIGHT OLIVE, *for deep-frying*
16 FRESH SAGE LEAVES, *rinsed and dried*
LEMON WEDGES, *to serve*

FRIED POTATOES AND ARTICHOKE BOTTOMS

This was something special my grandfather made. I added the sage leaves because I am sure that, had he known about their wonderfulness, he would certainly have thrown in a handful at the last moment. Pappou liked to serve his fries in a wide stainless-steel bowl. I remember the way the salt clung to the crispy bits on the side of the bowl that we all fought over. Today I always serve my grandfather's fries in a wide metal bowl.

To prepare the artichokes, rinse them under cold running water and discard the tough outer leaves. Slice off the stem. Slice off the leaves where they meet the base of the artichoke. (You can slice the leaves thinly, being careful to remove the hairy choke first, then dress with lemon and olive oil and eat as a side salad or scatter over your pizza. They should be kept in lemon water until you dress them.)

Halve the potatoes lengthwise. Put them, flat side down, on a cutting board and cut them into fries about ¼-inch thick. Pat the artichoke bottoms dry with paper towel and cut into three thick slices, like fat fries. (Do this at the last minute, once the potatoes are ready.)

Half-fill a large, wide saucepan or deep fryer with oil and heat up for deep-frying. Add the potatoes and give them a stir with a wooden spoon. Leave them for 5 minutes, until they look like they are settling and starting to turn golden and soft, then toss them around with your wooden spoon so that they actually get a bit mashed up. (These are the bits that will crisp up wonderfully at the end.) Add the artichokes and give a gentle stir, moving the potatoes from the bottom, and then don't touch them again until they are firm and golden. Now toss them again (this should all take about 20 minutes, depending on the heat of your oil). About a minute before you take out the potatoes, throw in the sage leaves to crisp them up. Lift them all out with a slotted spoon onto a plate lined with paper towels and then remove the paper after a couple of minutes. Sprinkle with salt and serve immediately with lemon wedges.

Serves 4 to 6

1 SMALL ONION, *diced*
1 TEASPOON FINE SALT
2 SMALL TOMATOES, *diced*
A HANDFUL OF CHOPPED FRESH PARSLEY
A COUPLE OF LEMONS, *cut into quarters*
1$\frac{1}{2}$ CUPS BLACK-EYED PEAS, *soaked overnight*
6 CUPS FIRMLY PACKED SPINACH LEAVES
EXTRA-VIRGIN OLIVE OIL, *to serve*

BLACK-EYED PEAS WITH SPINACH

This is probably a cross between a soup and a salad and I like it best when the beans and spinach are still warm. The tomatoes, onion, and dressing must all be at room temperature.

Put the onion in a small bowl, cover with cold water, and sprinkle with the salt. Let stand for about 30 minutes or so. Rinse and drain well, squeezing out the excess water with your hands, and put the onion in a small serving dish. Put the tomatoes, parsley, and lemons in separate dishes.

Meanwhile, rinse the peas and put them in a large saucepan. Cover generously with cold water and bring to a boil. Skim any scum from the surface with a slotted spoon. Drain the peas, return to the pan, and add fresh water. Bring to a boil again, decrease the heat slightly, and cook, uncovered, for about 1–1$\frac{1}{2}$ hours, or until the peas are soft but not mushy. If the water evaporates too quickly, add extra hot water while the peas are cooking — the water level should be just above the peas. Season with salt toward the end of the cooking time. Tear the spinach into bite-size pieces and add it to the pan. Cook for another 3 to 5 minutes, until the spinach is cooked.

Spoon the peas and spinach into individual bowls with a slotted spoon, adding a trickle of the cooking liquid, too. Everyone can dress their own dish with a scattering of parsley, some tomato and onion, salt and pepper, an extra big splash of lemon juice, and olive oil.

Serves 4

1 CUCUMBER
2 RIPE TOMATOES, *cut into chunks*
2 INNER CELERY STALKS WITH LEAVES, *chopped*
1 (6-OUNCE) JAR (ABOUT 3½ CUPS) GREEK OLIVES
 IN BRINE OR OIL, *drained*
1 SMALL RED ONION, *finely sliced*
1 CUP FIRMLY PACKED LAMB'S LETTUCE LEAVES
A HANDFUL OF FRESH CILANTRO
1 LARGE GARLIC CLOVE
2 TABLESPOONS GOOD-QUALITY RED WINE
 VINEGAR
½ CUP OLIVE OIL
1 CUP CRUMBLED FETA CHEESE
1 TEASPOON DRIED OREGANO

GREEK-CYPRIOT SALAD

 This is more or less how my grandfather would make a salad and serve it, in a big bowl, ready dressed for everyone to help themselves. Use lemon juice instead of vinegar if you like, and you could add other ingredients to these.

Peel away the skin of the cucumber in alternate stripes lengthwise. Halve lengthwise and then cut into slices and put in your serving bowl.

Add the tomatoes, celery, olives, onion, lettuce, and cilantro to the bowl. Season with salt and pepper and mix well.

Mix the garlic and vinegar with a pinch of salt in a blender until completely smooth. Stir in the oil. Pour over the salad and mix gently, adding more salt (but remembering that the feta may be quite salty) or pepper if necessary. Scatter the feta and oregano over the top before serving.

Makes about 35 puffs

1 (3/4-OUNCE) CAKE FRESH YEAST
1²/₃ CUPS ALL-PURPOSE FLOUR
¹/₂ TEASPOON SUGAR
A PINCH OF SALT
1 POUND (3 MEDIUM) POTATOES
¹/₂ CUP THIN HONEY
JUICE OF HALF A LEMON
¹/₂ TEASPOON GROUND CINNAMON
LIGHT OIL, *for deep-frying*

LOUKOUMADES (DEEP-FRIED HONEY AND CINNAMON SYRUP PUFFS)

I remember eating these in the summer cool of the Cyprus mountains. They are quite rich and probably just two per person is the best quantity — served with a glass of iced water or a coffee as an afternoon treat, rather than a dessert. You might not need to make so many at once, but you can easily halve the amounts. There are places in Greece and Cyprus (and probably elsewhere) that specialize in these. I imagine they keep their batter in the refrigerator to slow down the yeast process and fry a few at a time as needed, then shower them from a large pot of communal syrup.

Crumble the yeast into a large bowl. Add 1¹/₂ cups of warm water with a handful of the flour, the sugar, and salt, and stir thoroughly. Cover and leave for about 30 minutes in a warm place, until the yeast begins to activate. Meanwhile, peel and rinse the potatoes, then boil until soft. Mash them well.

Add the rest of the flour to the yeast bowl, along with the potatoes. Whisk well until you have a smooth, loose batter. Cover the bowl and leave again for 1¹/₂ to 2 hours in a warm place, or until the batter looks a bit frothy on the surface and has puffed up and is quite thick (otherwise the puffs will collapse when you fry them).

To make the syrup, put the honey, lemon juice, and cinnamon in a saucepan with about 3 tablespoons of water and boil for 10 minutes until thickened. Remove from the heat.

Put enough oil in a wide saucepan to come about 1¹/₂ inches up the side and heat for deep-frying. Take teaspoonfuls of the batter and push gently into the hot oil with a second teaspoon. Fry for a minute or so, just until they have puffed up, are lightly golden on all sides and cooked through. Reduce the temperature if it seems the outsides are browning too quickly and the insides remaining uncooked. Drain on paper towels and then transfer to a serving bowl. Pour the warm syrup over the fried puffs and serve hot.

Serves 10

1¹/4 CUPS LONG, *or* MEDIUM-GRAIN RICE
8 CUPS MILK
3 TABLESPOONS SUGAR
GROUND CINNAMON (*or a little rose water*), *to serve*

RICE PUDDING

This is my grandfather through and through. When I asked for recipes, he would give me vague measures: "Add one flat woodenspoonful of sugar and cook it until it is ready." I remember him always in his work shed, stirring away at this on the gas stove. He liked to sometimes splash in some rose water, but more often just scattered a little ground cinnamon over the crust-formed top. We always liked to eat one just-made warm and have another cold from the fridge for breakfast the next morning. You can add a little more sugar if you prefer your rice pudding sweeter.

Put the rice in a heavy-bottomed saucepan, cover generously with water and bring to a boil. Boil for 20 minutes, then thoroughly drain the rice. Rinse out the pan and pour in the milk. When it comes to a rolling boil, add the rice and bring it back to a boil. Decrease the heat and simmer for 20 minutes, stirring often with a wooden spoon to make sure it doesn't stick. Stir in the sugar and simmer for 10 minutes more before removing from the heat. Let cool for about 15 minutes in the pan, then spoon out, making sure you get some of the thickened liquid and rice in each portion. Sprinkle with ground cinnamon before serving. This can be eaten immediately or put in the fridge for a few hours.

Pappou was quiet; he had integrity and no flashness about him. He always wore a perfectly ironed shirt, gilet vest in winter, polished shoes, and had his hair slicked back with the special cream he ordered from Italy. He never demanded acknowledgment, but dashed around quietly with the energy of milk just at that rolling boil.

— *Cyprus* —

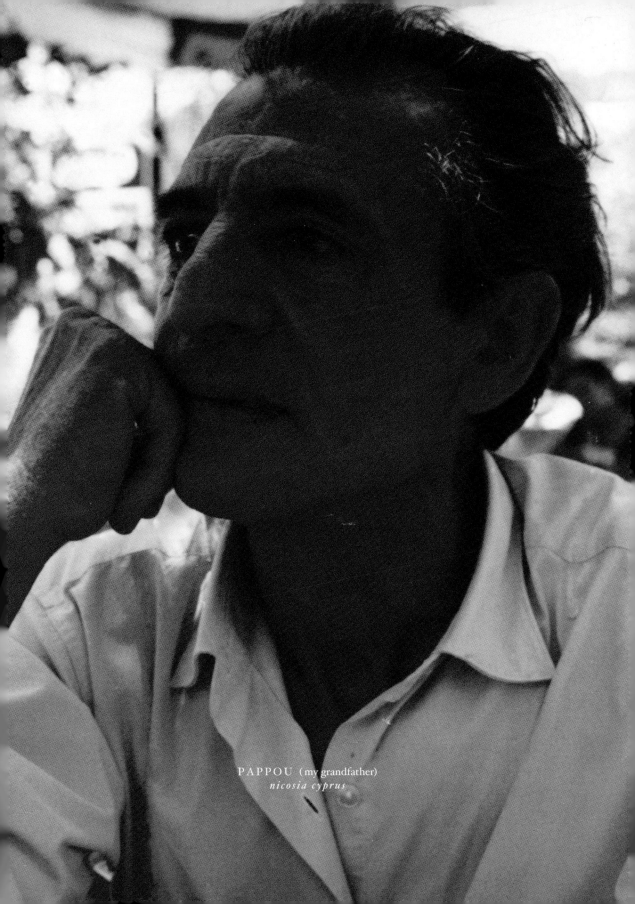

PAPPOU (my grandfather)
nicosia cyprus

Serves 4

poached pears
2/3 CUP SUPERFINE SUGAR
4-INCH PIECE LEMON ZEST, *pith removed*
1 CINNAMON STICK
4 SMALL RIPE BUT FIRM PEARS, *peeled, halved, and cored*
2 BEAUTIFUL UNSPRAYED ROSES, *petals removed
and rinsed*

filo pastry
3 SHEETS (20 by 15 inch) FILO DOUGH
3 1/2 TABLESPOONS BUTTER, *melted*
2 TABLESPOONS SUPERFINE SUGAR
3 TABLESPOONS MILD-FLAVORED THIN HONEY

praline
3 TABLESPOONS SUPERFINE SUGAR
1/4 CUP UNSALTED SHELLED PISTACHIO NUTS
4 SCOOPS VANILLA ICE CREAM
CONFECTIONERS' SUGAR, *to serve*

FILO WITH POACHED PEARS AND ROSE PETALS, PISTACHIO PRALINE, AND VANILLA ICE CREAM

This is my personal variation on a baklava; I love the way it looks. You can change or adapt the recipe — leave out the praline, serve pistachio or cinnamon ice cream instead, or biscuits instead of the filo if you want to simplify it. You could also poach plums or peaches instead of the pears. The filo can be baked beforehand (if it loses its crispness, just put it back in a hot oven for a couple of minutes). You'll probably serve just one pear half per person, so keep the rest in the fridge in their syrup for the next day.

To make the poached pears, put the sugar, lemon zest, cinnamon stick, and about 2 cups of water in a fairly wide saucepan and bring to a boil. Boil for 5 minutes, then add the pears. Decrease the heat to a minimum so that it doesn't bubble up. Lay a piece of parchment paper directly onto the pears and liquid to prevent the exposed part of the pears from discoloring. Simmer for 10 to 15 minutes, until the pears look slightly transparent and are soft but not falling apart (the cooking time will depend on their size and ripeness). Add the rose petals, keeping back a small handful, and simmer for another couple of minutes. Remove the pan from the heat and let cool.

Preheat your oven to 350°F, and either grease a baking sheet or line it with parchment paper. Put one sheet of filo dough on the work surface and brush liberally with the melted butter. Scatter half the sugar over the pastry with gentle flicking wrist movements and then cover with a second sheet of filo. Repeat the butter and sugar technique and then add the last sheet of filo, brushing the top with butter. You will have to work quite quickly and, if it is the first time you are using filo dough, you might like to have an assistant. Halve the filo lengthwise and then, using a ruler and a sharp knife, cut 9 lines down at 2-inch intervals so that you have 20 strips. Put the strips on the baking sheet. Drizzle each one with a little honey and bake for 10 to 15 minutes, or until golden and crisp. Transfer them to a sheet lined with clean parchment paper (or else they will stick), let cool and then store open, covered with a layer of parchment paper. Handle gently as they are delicate.

Butter or oil a flat baking sheet. To make the praline, put the sugar in a small saucepan over medium heat. Let it melt for about 4 minutes, until it turns to caramel — don't stir, but you can swirl the pan around a couple of times. Remove the caramel from the heat, taking care that it doesn't burn, and stir in the nuts. Pour it onto the baking sheet and then let stand until cold and set. Break up the pieces, then pound with a heavy mallet or pulse in a food processor until the praline is in coarse crumbs.

To serve, put one or two pear halves with the rose petals and a little syrup in a bowl. Add a scoop of ice cream, then two or three filo strips. Scatter with some praline, sprinkle with confectioners' sugar and your extra rose petals, and serve immediately.

Always, always upon arrival in Cyprus I would find a box of my favorite baklava, beribboned and waiting for me. Pure chance, his expression seemed to say when I looked at him questioningly. Pappou never said much, but I could tell he loved our all sitting under the lemon tree, late into the summer night, while the crickets carried on and on with their chanting.

Serves 20

1/4 POUND PLUS 1 TABLESPOON BUTTER, *softened*
1 CUP SUPERFINE SUGAR
1 CUP PLAIN YOGURT (*not too thick or thin*)
1 TABLESPOON ROSE WATER
3 EGGS, *separated*
1/2 TEASPOON GRATED LIME ZEST
1 CUP ALL-PURPOSE FLOUR
1 CUP FINE SEMOLINA
2 TEASPOONS BAKING POWDER
1/2 CUP GROUND ALMONDS

rose water syrup
1 CUP SUPERFINE SUGAR
1 TEASPOON ROSE WATER

YOGURT AND SEMOLINA SYRUP CAKE WITH ROSE WATER

This is a very typical, and very sweet, Cypriot cake. You can leave out the rose water and make a plain syrup-drenched cake, or add lemon juice, vanilla extract, or orange blossom water to the syrup.

Preheat your oven to 350°F. Grease and flour a 9-inch square cake pan. Cream the butter and sugar together in a large bowl with an electric mixer. Whisk in the yogurt, rose water, egg yolks, and lime zest. Sift in the flour, semolina, and baking powder, and mix well to incorporate. Mix in the ground almonds. In a separate bowl, whisk the egg whites until they are white, fluffy, and just making soft peaks. Carefully fold these into the mixture so that they are well incorporated. Pour the batter into the pan and bake for about 45 minutes, or until the cake is deep golden and cooked through. Let cool while making the syrup.

To make the syrup, put the sugar, rose water, and 1 cup of water in a small saucepan and boil for about 5 minutes. Pour the hot syrup over the cake and let it cool completely. To serve, cut the cake into small pieces and serve with a not-too-sweet ice cream (such as the mastika ice cream on page 200).

Serves 8

1 FLAT TEASPOON MASTIC GRANULES
(available at Middle Eastern markets or online suppliers)
1 CUP SUPERFINE SUGAR
2 CUPS MILK
2 CUPS HEAVY WHIPPING CREAM

MASTIKA
ICE CREAM

This has such a definite flavor (you might recognize it from Turkish delight). I love it on its own, or served alongside a sweet dessert such as the yogurt cake with rose water. I have a friend in Cyprus who always chews mastic, which she buys in small flat squares, instead of chewing gum. It is unscented and unsweetened; if you are serving it on its own you could add some other flavorings such as a few drops of rose water or a liqueur. Mastic is sold in crystals and I use a small coffee or spice-grinder to make it into a powder. It gives the ice cream a wonderful, almost chewy, texture and is good when you want a slightly less sweet accompaniment.

Put the mastic with a teaspoon or so of the sugar into a small grinder and grind to a fine powder. Heat the milk with the remaining sugar and ground mastic, stirring (or whisking) until it comes to a boil, so that it has completely dissolved. Remove from the heat. Let it cool a bit, whisking now and then, and then mix in the cream. Transfer to a bowl, cover, and put in the freezer.

After an hour, remove the bowl from the freezer, give it an energetic whisk with a whisk or electric mixer, and return the bowl to the freezer. Whisk again after another couple of hours. When it is nearly firm, give one last whisk, transfer to a suitable freezing container with a lid, and let it set in the freezer until it is firm.

Alternatively, pour the mixture into your ice-cream machine and freeze, following the manufacturer's instructions.

preserved orange peel
4¹/₂ POUNDS (ABOUT 10) ORANGES
1²/₃ CUPS SUPERFINE SUGAR

preserved cherries
2¹/₄ POUNDS (ABOUT 5 CUPS) CHERRIES
1¹/₂ CUPS SUPERFINE SUGAR
JUICE OF 1 LEMON

preserved green plums
2¹/₄ POUNDS (ABOUT 6) GREEN PLUMS
1¹/₂ CUPS SUPERFINE SUGAR
1 LONG STRIP ORANGE ZEST, PLUS THE JUICE OF
 1 ORANGE
1 BAY LEAF

figs in syrup
1¹/₄ POUNDS (ABOUT 3 CUPS) NATURALLY DRIED FIGS
 or 2¹/₄ POUNDS (ABOUT 6 CUPS) FRESH FIGS
2¹/₂ CUPS SUPERFINE SUGAR
JUICE OF 1 LEMON
1 VANILLA BEAN, *cut in half lengthwise*
1 TABLESPOON RUM *or* BRANDY

PRESERVED FRUITS
IN SUGAR SYRUP

These are something that many Cypriot and Greek people have in their refrigerator and offer to visitors with a glass of ice-cold water or a coffee. They are eaten straight off the spoon and some people like to then stir their syrupy spoon into their glass of water. You can preserve almost any small fruits with this recipe: baby clementines, tiny eggplants, green walnuts, bergamots, or figs and keep them in the refrigerator. These are normally extremely sweet — I have used slightly less sugar but you can add more if you prefer.

PRESERVED ORANGE PEEL

Rinse the oranges in warm water. Peel off the skin with a good potato peeler, trying not to press too hard so that you leave behind the white pith and remove only the outer orange zest. Do this lengthwise or around the circumference, whichever way works best for you. If lengthwise, you should get six or seven strips. Around the circumference, you should get about three long strips: halve these so you have pieces about 3¹/₂ inches long. If there is a lot of pith on the strips, put them on a wooden board, pith side up, and run a small sharp knife along each strip to remove the white pith. You should be left with about 7 ounces of zest.

Boil the orange zest in water for about 15 minutes until softened, then drain. Roll up each piece of zest fairly tightly and thread onto a length of cotton thread with a needle, as if you were stringing a necklace together (this will help the zest hold its shape in the syrup).

Put the sugar in a saucepan with about 2 cups of water and the juice of one of the oranges and bring to a boil. Decrease to a simmer, drop in the orange zest necklace, and cover the surface with a piece of parchment paper to hold the zest in the syrup. Simmer gently for about 45 minutes, then remove the zest, and take it off the thread. Put the zest in a suitable preserving jar.

The syrup should have thickened during cooking; if not, cook it for slightly longer. Pour the syrup over the zest (it should just cover it). When cool, refrigerate, ensuring the zest is covered by the syrup, and use within a month.

PRESERVED CHERRIES

Pit the cherries carefully with a thin pitter and then rinse them. Put the sugar, lemon juice, and 1 cup of water in a saucepan and bring to a boil. Add the cherries and, when they come to a boil, cover with a piece of parchment paper to keep them submerged. Simmer gently for 6 to 8 minutes, turning them now and then to make sure they are covered. Remove the pan from the heat (the cherries must not be too soft). Using a slotted spoon, spoon the cherries into a suitable preserving jar.

Continue boiling the syrup for about 10 minutes, or until it has reduced by half. Strain through cheesecloth over the cherries and seal the jar when cool. The cherries should always be covered by syrup. These are normally served straight from the refrigerator, with a spoon and small plate and a glass of ice water to cut through their beautiful oversweetness. Use within a month.

PRESERVED GREEN PLUMS

The green plums look nice served whole, so leave the pits in and spit them out as you eat. If you would prefer them to be pitted beforehand, make a small slit and remove the pit.

Rinse the plums. Put the sugar, orange zest, juice, and bay leaf in a saucepan with about 4 cups of water and bring to a boil. Add the plums and, when the syrup comes back to a boil, decrease the heat and cover with a piece of parchment paper to keep the plums submerged. Simmer gently for 8 to 10 minutes, turning them now and then to make sure they are all covered.

Remove from the heat (the plums must not be too soft). Using a slotted spoon, spoon the plums into a suitable preserving jar. Let the syrup boil for 12 to 15 minutes, until it has reduced by about two-thirds. Pour over the plums and seal when cool. The plums should always be covered by syrup. Keep in the refrigerator and use within a month.

FIGS IN SYRUP
If you are using dried figs, soak them in warm water for at least a couple of hours, then drain.

Put the sugar, lemon juice, vanilla bean, and 2½ cups of water in a saucepan and bring to a boil over medium heat. Add the figs, decrease the heat, and cook, uncovered, for about 20 minutes. Transfer the softened figs with a slotted spoon to a plate. If your syrup is still very watery and pale, boil it until it has thickened a little.

Put the figs into a suitable preserving jar. Let the syrup cool and then pour it over the figs in the jar. Pour the rum or brandy over the top. Top with a circle of parchment paper (or a preserving paper disk), pushing down on the figs to keep them submerged in the syrup, and seal the jars tightly. Once opened, store in the fridge and use within a month. These are particularly delicious served with thick cream.

Pappou's orange tree

Pappou used to climb up the ladder propped against his orange tree and twist off the oranges that my grandmother would later preserve with sugar syrup. My father remembers them all sitting there — Yayia, Aunty Annou, and a couple of others — threading the orange necklaces.

— Cyprus —

Serves 12

sponge
3 EGGS
$^1/_2$ CUP SUPERFINE SUGAR
$1^1/_4$ CUPS ALL-PURPOSE FLOUR
A PINCH OF SALT
1 TEASPOON VANILLA EXTRACT

$^2/_3$ CUP ALMONDS
8 CUPS MILK, PLUS 4 TABLESPOONS
1 LARGE EGG
$^1/_3$ CUP SUPERFINE SUGAR
$^3/_4$ CUP CORNSTARCH
3 TABLESPOONS ROSE WATER
3 TABLESPOONS COGNAC
1 (13-OUNCE) CAN PRESERVED FRUITS IN SUGAR SYRUP
 (*drained weight*), *cut into chunks, plus some syrup* (PAGE 201)

CHARLOTTA
(CYPRIOT TRIFLE WITH ROSE WATER
AND PRESERVED FRUITS)

 This is my father's favorite dessert; it reminds him of his childhood.
Charlotta is a dessert that many Cypriot children have grown up with — a
Middle Eastern flavored trifle, which is good to serve after a meal that has
even a hint of those Middle Eastern spices. Between the two layers of sponge
are pieces of special fruit in their sweet syrup, a splashing of brandy and rose
water, and a layer of pastry cream. Try your hardest to get hold of green
(unripe) walnuts in syrup — they seem an essential special taste in this dessert.
If not, choose your favorite fruits in syrup, either bought or homemade.
I like to make this in that same oval glass dish that my grandmother
always used.

Preheat the oven to 350°F. Butter and flour a 14 by 10 inch baking dish. To make the sponge,
whip the eggs and the sugar for about 10 minutes with an electric mixer on high speed until
they are very, very thick and creamy, and have bulked up a lot. Add the sifted flour, the salt,
and vanilla, and fold in gently. Scrape out every drop into your dish, swinging the dish from side
to side so that the batter goes to the edges evenly. Bake for about 20 minutes, or until the top
is golden brown and the cake is cooked through and feels spongy. Turn out the sponge onto a
wooden board to cool, and halve it horizontally through the middle with a long bread knife.
Set aside for now and wash the dish.

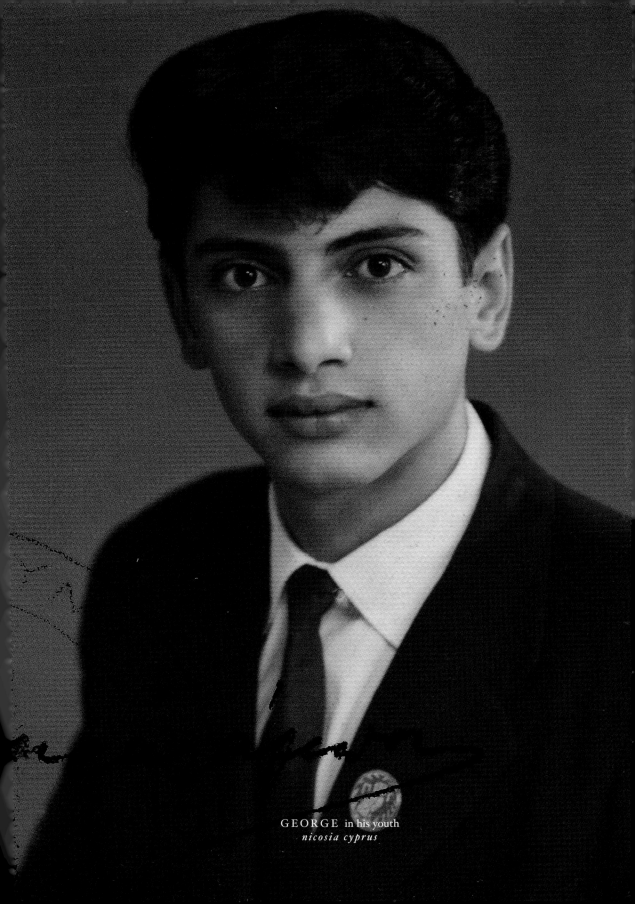

GEORGE in his youth
nicosia cyprus

Put the almonds in a blender and pulse-chop for a bit until they are coarse chunks. Remove about 4 tablespoons of the coarser chunks and continue pulsing the rest until they are finely chopped. Lightly toast the 4 tablespoons of coarser nuts under the broiler or in a dry skillet until they are lightly golden. Set aside for now.

Meanwhile, make the cream. Put most of the 8 cups of milk in a saucepan, keeping about half a cup on one side, and bring just to a boil, them remove it from the heat for now. Whisk together the egg and sugar with an electric mixer until fluffy. Put the half a cup of cold milk in a bowl and gradually add the cornstarch, stirring until it is smooth and dissolved. Whisk the dissolved cornstarch into the egg mix. Add a ladleful of the hot milk to the egg mixture, whisking quickly to prevent any curdling, and then add another ladleful. Incorporate all the egg mixture into the milk pan and put it back over gentle heat, whisking all the time, until it starts to thicken and make bubbles on the surface. The whisk will start to leave thick trails behind it, so let it bubble for a few minutes and then remove the pan from the heat. Stir in a tablespoon of rose water and the finely chopped almonds. Let cool a bit, whisking now and then. (The cream should look like a very pale, fairly loose custard and will thicken more as it cools, and then later in the refrigerator.)

Put one layer of sponge back into the clean glass dish. In a cup, mix together the 4 tablespoons of milk, the rose water, and Cognac, and drizzle (or brush) about half of this evenly over the sponge layer. Cut up about four pieces of fruit in syrup and arrange these over the sponge. Drizzle about 2 tablespoons of the thick fruit syrup over the sponge, and then top with about half of the cooled cream, spreading it gently to cover the sponge completely.

Put the second layer of sponge on top. Drizzle the rest of the milk, rose water, and Cognac mixture over the sponge, scatter with another four pieces of chopped fruit, and drizzle with 2 more tablespoons of syrup. Finally spread the rest of the cream over the sponge, so that it is almost flush with the top of the dish. Scatter with the toasted almonds and let cool. Once cooled, cover the dish and put into the refrigerator. Chill it for at least a couple of hours before serving.

Yayia's red sweets

The sweets from Yayia, my grandmother, were perfect square treasures, wrapped up in red. I can definitely remember their taste, even though I was so small. They weren't rose, although my grandparents would use rose or lemon blossom water in their desserts.

— Cyprus —

Serves 4

$^1/_2$ CUP RICE FLOUR
$^1/_3$ CUP SUPERFINE SUGAR
1 TEASPOON ROSE WATER
$2^1/_2$ CUPS MILK

rose water syrup
$^1/_3$ CUP SUPERFINE SUGAR
$^1/_4$ CUP HOT WATER
2 TEASPOONS ROSE WATER
$^3/_4$ CUP ICE WATER

MAHALEPI

Mahalepi always makes me think of Cyprus, jasmine, and those hot, hot summers. It is light, milky, and Middle Eastern tasting and always beautifully refreshing after a spicy meal. It is a taste you have to get used to but I know many people who are crazy about mahalepi.

Put the flour, sugar, rose water, milk, and $2^1/_2$ cups of water in a saucepan and bring to a boil, whisking constantly. Continue whisking for a couple of minutes and then remove from the heat. Let cool slightly, then pour into four serving dishes. Let cool completely, then put in the refrigerator.

Now make the rose water syrup. Dissolve the sugar in the hot water with the rose water, then let cool. Add the ice water (even with a few ice cubes) and put the syrup in the refrigerator to get very cold.

To serve, drizzle a few spoonfuls of syrup over each dish at the last moment. If you want to color the syrup, add a few red rose petals or cherries.

Makes 24

pastry
2 CUP ALL-PURPOSE FLOUR
5 TABLESPOONS COLD BUTTER, *diced*
FINELY GRATED ZEST OF 1 SMALL LEMON

filling
$3/4$ CUP RICOTTA *or* SMOOTH CREAM CHEESE
$1/2$ TEASPOON GROUND CINNAMON
$1/2$ TEASPOON ORANGE BLOSSOM WATER
$1/2$ TEASPOON SUPERFINE SUGAR

LIGHT OLIVE OIL, *for deep-frying*
CONFECTIONERS' SUGAR, *to serve*

BOUREKIA (DEEP-FRIED CREAM CHEESE AND CINNAMON PASTRIES)

These are normally made with anari cheese, but you can use ricotta or a smooth cream cheese or something else similar. These deep-fried pastries are scattered with confectioners' sugar and are best eaten warm.

To make the pastry, put the flour and butter in a large bowl with a pinch of salt. Mix in, sifting and working it through your fingers until it forms large crumbs. Add 5 tablespoons of water and the lemon zest and knead gently and quickly with your hands until the dough just comes together in a mass. Knead for 20 to 30 seconds, or until smooth. Take care not to overwork the dough. Wrap in plastic wrap and set aside for about 1 hour in a cool (but not cold) place.

To make the filling, mix the ricotta or cream cheese with the cinnamon, orange blossom water, and superfine sugar. Refrigerate until needed.

Roll out the pastry very thinly. Cut rounds of about 3 inches in diameter, using a biscuit cutter or sharp-rimmed glass. Put a teaspoon of the filling in the middle of each round. Wet your finger with a little water and run it around the edge of the pastry, then fold it over into a half-moon. Press the edge to make sure it is sealed.

Keep all the pastries on a tray dusted with flour until you are ready to fry them. Fill a saucepan or deep fryer one-third full of oil and heat for deep-frying. Fry the pastries a few at a time for 30 to 40 seconds, turning them around until they are golden. Lift them out with tongs onto a tray lined with paper towels to drain off the oil. Arrange on a serving plate, dust very generously with confectioners' sugar, and serve immediately.

Makes 2¹/₂ cups jam and 4 puddings

jam
2¹/₄ POUNDS RIPE WATERMELON FLESH (ABOUT
 4 POUNDS WATERMELON WITH PEEL)
1³/₄ CUPS SUPERFINE SUGAR
1 LEMON
1 GORGEOUS UNSPRAYED ROSE, *petals separated
 and rinsed*

buttermilk pudding
2 TEASPOONS POWDERED GELATIN
1 CUP HEAVY WHIPPING CREAM
¹/₂ CUP SUPERFINE SUGAR
A FEW DROPS OF VANILLA EXTRACT
2 CUPS BUTTERMILK

WATERMELON AND ROSE PETAL JAM WITH BUTTERMILK PUDDING

As far as I am concerned, roses in food are the epitome of gorgeous. If you want to make this jam more rosy, add a few drops of rose water, and if you have any petals left over you can always scatter them in your bath. This jam is quite runny and has a beautiful color — it would be wonderful drizzled over a not-too-sweet ice cream or served with a blob of crème fraîche. If you can manage it, make the jam with the first of the watermelons and the last of the roses. If you prefer your jam thicker, cook half a chopped apple with the watermelon. You may need more or less sugar, depending on the sweetness of your watermelon. The buttermilk pudding would also be lovely served with some other fruit — perhaps syrupy poached quinces or a mixed berry salad. I like to use smooth pudding saucepans here, but you can use any ramekins you like. You can even serve the pudding in its ramekin with a little bowl of jam on the side.

To make the jam, put the watermelon in a bowl and sprinkle with the sugar. Halve the lemon and cut 3 thin slices from one half. Cut these slices into 8 pieces each and add to the bowl. Juice the remaining lemon and add to the bowl. Cover with plastic wrap and leave in the refrigerator overnight.

Pour the sugary fruit into a heavy-bottomed saucepan suitable for making jam and bring to a boil. Decrease the heat and simmer, uncovered, for about 1 hour, stirring frequently with a wooden spoon so that it doesn't stick. Ten minutes or so before you think it will be ready, transfer half of the jam to a blender (making sure there are no lemon pieces included because those are nice left whole) and leave the rest of the jam to continue cooking. Purée this half and return it to the pan. (A few bits of watermelon and lemon give the jam a nice texture.)

To test if your jam is ready, spoon a little onto a plate and tilt it. It should slide down with resistance rather than just running down. If necessary, cook longer. Add the rose petals and pour into a suitable sterilized jar, using a wide-necked funnel if necessary. Seal the jar tightly and turn over. Let it cool completely before turning the jar upright and storing in a cool place. Once opened, keep in the refrigerator and use up fairly quickly.

To make the puddings, put 2 tablespoons of water in a glass bowl and sprinkle the powdered gelatin evenly over the top. Set aside for it to dissolve and swell.

Put the cream, sugar, and vanilla in a saucepan over medium heat to dissolve the sugar, then remove from the heat. Add the spongy gelatin to the warm cream and stir to dissolve it. Let the mixture cool, stirring from time to time to ensure the gelatine dissolves evenly. When completely cooled, stir in the buttermilk and strain through a sieve to remove any lumps of gelatin. Ladle into four $2/3$-cup capacity ramekins. Put these on a tray, cover lightly with plastic wrap, and chill them in the refrigerator for at least a couple of hours before serving.

To serve, gently loosen around the sides of the puddings with your fingers or the back of a teaspoon. Dip the bottoms of the ramekins in a little hot water for a couple of seconds (no longer, or you'll end up with soup) and turn them out. Or, simply scoop out with a large spoon and pour some jam over the top before serving.

MONKEYS' WEDDINGS

South Africa

MONKEYS' WEDDINGS

On Saturday afternoons we often had picnics on the flat mossy rocks that served as tables in the river at the bottom of our road. On Sundays we liked to pack our barbecue grill in the car and drive to a small waterfall where we would spend our day. This was before we had a garden and we would make barbecued mushrooms, brushing them with lemon, garlic, and olive oil as they cooked. We passed the black ladies in the river on the way, undressed and grating their clothes on the rocks, sloshing away at them with their feet. It was our very favorite spectacle.

From our windows at home we watched boys on bicycles with large sacks of pale long-husked corn, and tore out to buy a couple that would later drip warmly with butter. The sad music from those old white ice-cream vans selling soft-serve would pierce deep into our homes, so that we could run outside with our coins stuffed into our palms.

We liked to sit on the floor with our nanny, in the safety of her big arms, eating with our hands, clumping the soft cornmeal between our fingers and dipping this into the sauce from the meat stew (our nanny loved her meat burnt).

We loved swimming at night. And there were those storms that thrilled us but drove my mother under the bedcovers, terrified, waiting for the thunder and lightning to pass. They never had those kinds of storms in Finland.

It is the smell of those moments before an African summer thunderstorm that remains with me, and the swims afterward as we looked for the rainbow and tried to guess the exact point where the monkeys' wedding was happening.

There is something about the African landscape, the bush and the night sky, that covers me with silence. And those baobab trees that witness all and still stay in standing ovation to the magnificence of such a land.

_ South Africa _

Serves 6 to 8

8 LARGE GARLIC CLOVES
1½ STICKS BUTTER, *softened*
2 TABLESPOONS CHOPPED FRESH PARSLEY
1 LONG BAGUETTE

GARLIC BREAD

 This takes me back many years to one of my favorite restaurants in South Africa. It was a standard everywhere, I think — a good rack of ribs, this bread, and then tiny scoops of vanilla ice cream that had been dipped in chocolate. This quantity will make a generous amount of garlic butter, but you can press any leftover into a long roll in parchment paper, twist the sides like a large, sweet wrapper, and freeze it. Cut off slices to serve with your pan-fried steaks, barbecued sirloin steaks, or pan-fried chicken breasts.

Preheat the oven to 350°F. Chop the garlic very finely, then add a little salt and crush it with the flat of the knife until it is almost a purée. Mix very thoroughly with the butter and parsley.

Cut the baguette in half to make it more manageable. Slice the baguette slightly on the diagonal, without cutting all the way through. Using a teaspoon, spread some garlic butter into each cavity, taking care that the slices don't break off and separate from the loaf. Both sides should be generously buttered.

Wrap the baguette in foil and bake for 20 minutes or so, until the garlic butter has melted completely and the bread is quite crispy. If the bread seems soft, you can open the foil for a few minutes to crisp it up, depending on the type of bread you use. Serve immediately.

(If you don't want to eat the bread immediately, wrap it in foil before baking and keep it in the freezer. When ready to serve, put it straight from the freezer into the hot oven and bake it for a little longer than specified.)

Makes 1 loaf

1 SMALL POTATO
1 (1-OUNCE) CAKE FRESH YEAST
1/4 CUP BEER, *at room temperature*
1/2 TEASPOON SUPERFINE SUGAR
4 TABLESPOONS CORN *or* SUNFLOWER SEED OIL
2^3/4 CUPS KAMUT FLOUR, *or* SPELT FLOUR
3/4 CUP BREAD FLOUR (*or 1 3/4 CUPS if using spelt*)
1 TEASPOON SALT

KAMUT
BREAD

 This is something that I first tasted in South Africa, although it is of Egyptian origin. Kamut is a grain whose taste I love; you could even use all kamut flour and leave out the little bit of white bread flour used in this recipe. Kamut is available in health food shops, but if you can't find it you can use the spelt flour instead. This quantity makes enough for two small loaves or one larger one, and the bread freezes well.

Boil the potato until it is soft, then drain and peel it. Crumble the yeast into a small bowl and add the beer, sugar, oil, and 1 cup of lukewarm water. Let stand for 10 minutes or so, until it begins to activate.

Put the flours in a larger bowl with the salt. Mash up the potato and add it to the flour. Mix in the yeast mixture, first with a wooden spoon and then with your hands when it becomes too thick. Knead for about 10 minutes on your work surface until you have a soft dough. Sprinkle a little white flour onto your work surface to prevent it from sticking, if necessary — the consistency should improve as you knead it.

Put the dough back in the bowl and cover with a clean towel, then with a heavier towel. Let it rise for 1^1/2 to 2 hours, until it has puffed up well.

Preheat the oven to 425°F. Punch down the dough by punching out all the air to bring it back to its original size. Knead for a minute or so and form it into a ball about 8 inches in diameter. Line a baking sheet with parchment paper and put the bread on the sheet. Dust lightly with flour, cover loosely with a dish towel, and leave in a warm place (next to your heating oven) for another 20 to 30 minutes to rise.

Remove the cloth and bake for about 30 minutes or until the bread is nicely golden and the crust feels firm. Let it cool slightly before slicing.

Serves 3 to 4

dipping sauce
1/4 POUND FIRM BLUE CHEESE
1 CUP PLAIN YOGURT (*not too thick*)
1 TABLESPOON LEMON JUICE
1 GARLIC CLOVE, *very finely chopped*
1 TABLESPOON OLIVE OIL

sauce for coating wings
6 TABLESPOONS BUTTER
1 TABLESPOON APPLE CIDER VINEGAR *or*
 WHITE WINE VINEGAR
2 TEASPOONS TABASCO *or* OTHER HOT SAUCE
1/2 TEASPOON SWEET PAPRIKA

6 CHICKEN WINGS
ALL-PURPOSE FLOUR, *for dusting*
VEGETABLE *or* LIGHT OLIVE OIL, *for frying*
ABOUT 8 CELERY STALKS

CHICKEN WINGS WITH BLUE CHEESE DRESSING

I love the crazy combination of the hot spicy sauce (it's up to you how hot you make it), followed by a bite of creamy blue cheese that you've scooped up with a celery stick.

To make the dipping sauce, mash the blue cheese with a fork and mix with the yogurt, lemon juice, garlic, and olive oil. Season with salt and pepper and whisk lightly with the fork, leaving some chunky bits.

To make the coating sauce, melt the butter in a small saucepan until sizzling, then add the vinegar, Tabasco, sweet paprika, and a little salt, and let it bubble up for a minute or so.

Halve the chicken wings, so you have one tiny drumstick and another tiny wing. Pat the wings in the flour and season with salt and pepper. Fry in hot oil until they are deep golden, crispy, and completely cooked through. Transfer them to a plate lined with paper towels to absorb the excess oil.

Toss the chicken in the butter coating sauce and serve immediately. Serve the blue cheese sauce and celery on the side for dipping.

Serves 4 as a side dish

1³/4 POUNDS (ABOUT 22 SMALL) BABY NEW
 POTATOES
OIL, *for deep-frying*
1 CUP SOUR CREAM, *to serve*
SWEET CHILE SAUCE, *to serve*

DEEP-FRIED
NEW POTATOES

Sometimes I just love a bowl of these for dinner. Without the sour cream and chile sauce they can be served as a side dish for any main course, just like a bowl of special fries.

Wash and scrub the potatoes, leaving their skins on. Bring a large saucepan of salted water to a boil. Boil the potatoes for 20 minutes, until they are soft and look like they are bursting out of their skins, but not falling apart. Drain well.

Half-fill a wide saucepan with oil and heat until hot but not smoking. Carefully add the potatoes and fry until they are golden and all the bursting bits have become crispy. Transfer with a slotted spoon to a plate lined with paper towels to absorb the excess oil. Serve immediately, sprinkled with a little salt, with bowls of sour cream and sweet chile sauce alongside for dipping.

Serves 8

1³/₄ CUPS DRIED LIMA BEANS, *soaked overnight*
1 SMALL LEEK, *chopped*
3 RIPE TOMATOES, *peeled and chopped*
1 ZUCCHINI, *chopped*
3 POTATOES, *chopped*
3 CUPS FIRMLY PACKED SPINACH LEAVES,
 or SWISS CHARD, *chopped*
3 CARROTS, *chopped*
1 CELERY STALK (with leaves), *chopped*
ABOUT ¹/₂ POUND (¹/₄ SMALL) BUTTERNUT
 SQUASH, *chopped*
2 BAY LEAVES
3 TABLESPOONS CHOPPED FRESH PARSLEY
EXTRA-VIRGIN OLIVE OIL, *to serve*

MIXED VEGETABLE SOUP

This is a soup that my mother made often. When I asked her for the recipe she said she just put all the vegetables she could get into a big pot and covered them with water. But it had to have butternut squash. Sometimes she served it with raw, chopped-up red onions, fresh parsley, lemon juice, and olive oil over the top. You can add any other vegetables you like to make a huge healthy stockpot that will feed a multitude.

Rinse the soaked lima beans, then put them in a saucepan, cover with water, and boil for about 1¹/₂ hours, or until they are tender. Season with salt toward the end of this time. Remove from the heat and leave in their cooking water.

Put all the other vegetables in a very large saucepan. Add the bay leaves and season with salt. Cover with about 10 cups of cold water (you can add some later if it doesn't all fit now, as it will reduce). Bring to a boil, then decrease the heat and cook, partly covered, for about 1¹/₂ hours.

Drain the lima beans, reserving the water, and add to the pan with 1 cup or so of the cooking water. Add the parsley and cook for another 15 minutes. Taste and add salt if necessary. Serve with a good drizzle of olive oil and some freshly ground black pepper. This soup is good served warm or at room temperature.

Serves 2

2 (4^1/$_2$-OUNCE) SOFT RUMP STEAKS
1/$_2$ CUP RED WINE
2 LARGE GARLIC CLOVES, *lightly crushed with the flat of a knife*
SPRIG OF FRESH ROSEMARY
3 TABLESPOONS OLIVE OIL
1^1/$_2$ TABLESPOONS BUTTER
2 KAISER ROLLS, *halved*
CHOPPED CHILES IN OIL *(PAGE 160), to serve*
LEMON WEDGES, *to serve*

PREGO ROLLS

This is probably a South African–Portuguese combination. Whatever their origins, I love prego rolls and actually crave them at times. The steaks should just be about ½ inch thick and the wine not be too heavy. The best bread rolls to use are the floury kaiser type. You have to have everything ready, as the meat will only take a couple of minutes to cook and these really need to be eaten warm.

Marinate the meat in the wine, whole garlic cloves, and rosemary for a couple of hours. Set aside, covered, in a cool place. If it is in the refrigerator, bring it back to room temperature before cooking.

Reserving the marinade, pat the meat dry with paper towels. Heat a large nonstick skillet to very hot and add 1 tablespoon of the olive oil. Fry the steaks quickly on both sides until cooked and lightly golden, sprinkling a little salt on the cooked side. Take care not to overcook and dry out the meat. Transfer the meat to a plate. Remove the rosemary sprig and quickly add the marinade to the pan with the butter. Return to the heat and cook until it bubbles up and thickens slightly.

Spoon some juice over the bottom half of each roll, top with a steak, drizzle over a little more juice, and then dip the cut side of the roll top in the pan juice. Drizzle any remaining juice and about a tablespoon of olive oil over each steak. People can dress their rolls themselves with a bit of chopped chile in oil, salt, and lemon juice.

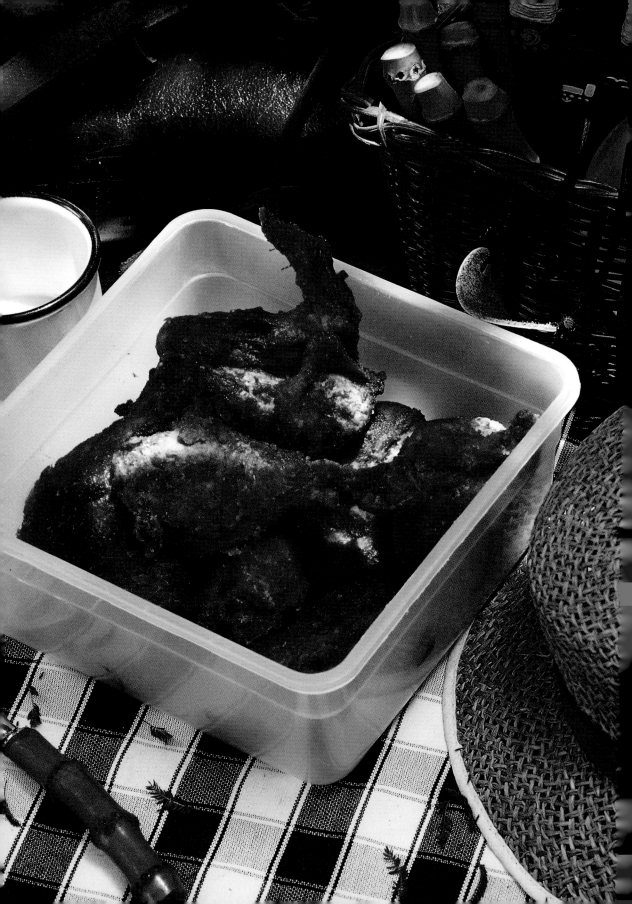

Serves 4

1 (2¹/4-POUND) WHOLE CHICKEN WITH SKIN, *cut into 8 pieces*
3 FRESH SAGE LEAVES
1 CARROT, *cut into 2 or 3 chunks*
1 CELERY STALK, *cut into 3 or 4 chunks*
2 GARLIC CLOVES
2 EGGS
¹/2 TEASPOON SWEET PAPRIKA
³/4 CUP ALL-PURPOSE FLOUR
LIGHT OLIVE OIL *or* VEGETABLE OIL, *for shallow-frying*

FRIED CHICKEN

This is another great chicken recipe that makes two dishes at one time: fried chicken and a chicken soup. Use the broth to cook some pasta or rice and make a soupy meal. You can also add an extra egg to the leftover marinade and make a quick omelette for after your soup.

Rinse the chicken and put in a large saucepan with the sage, carrot, celery, and one garlic clove. Cover with 4 cups of cold water and season with salt. Bring to a boil, uncovered, then decrease the heat slightly to medium. Simmer for another 15 minutes, then remove from the heat. The chicken will be just boiled, not overcooked.

Transfer the chicken with a slotted spoon to a plate and pat dry with paper towels. (At this stage you're left with the basis of a very good chicken broth in the saucepan. Add another cupful of water and simmer the soup for another 45 minutes. Store in the refrigerator or freezer until needed.)

Whisk the eggs in a shallow bowl. Finely chop the remaining garlic and add to the egg with the paprika and a little salt. Put the chicken pieces in the egg, turning to coat them well, then let marinate for 10 to 15 minutes.

Put the flour on a flat plate. Heat enough oil for shallow-frying in a skillet or wide saucepan. Lift the chicken out of the marinade, shaking off any excess egg, then pat in the flour, pressing down gently with your palm so that the flour sticks. Fry the chicken in the hot oil, until it is deeply golden and crispy on both sides. Serve with lemon wedges if you like.

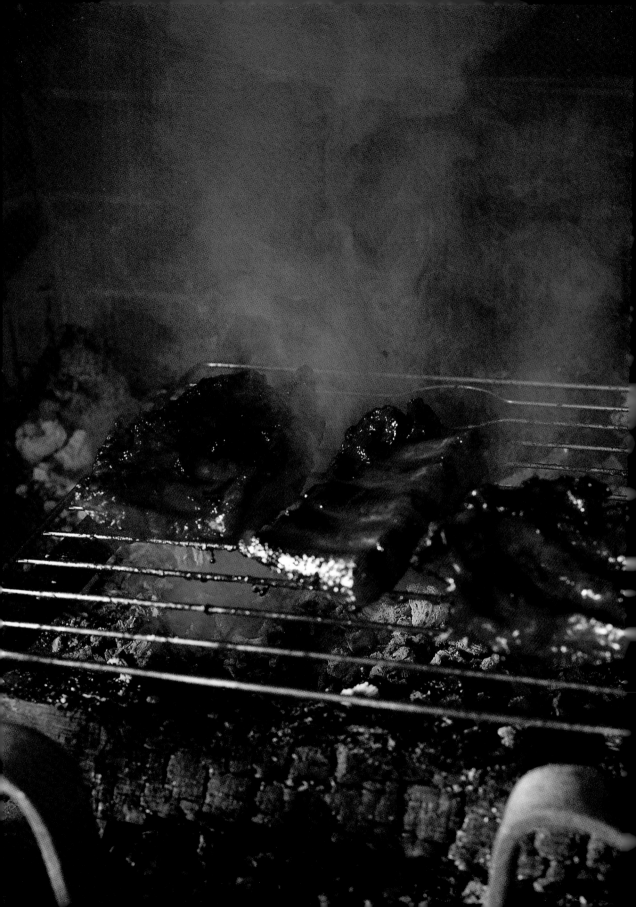

Serves 4

6 TABLESPOONS BUTTER
1 ONION, *minced in a processor or very finely chopped*
1 CUP KETCHUP
2 TABLESPOONS WORCESTERSHIRE SAUCE
2 TABLESPOONS APPLE CIDER VINEGAR
4 TABLESPOONS BROWN SUGAR
$^1/_3$ CUP LEMON JUICE
$^1/_3$ CUP THIN HONEY
$2^1/_4$ POUNDS BABY-BACK PORK RIBS (*halved horizontally if large*)

BARBECUED SPARE RIBS

These are those wonderful sweet ribs that you find at the steak houses in South Africa. They bring you just a great big rack of spare ribs and perhaps some garlic bread and you eat with your fingers. I love making this type of thing from time to time. These need a bit of marinating beforehand.

Heat the butter in a wide nonstick saucepan and sauté the onion over gentle heat until softened but not browned. Add the rest of the ingredients (except the ribs) and 1 cup of water to the pan and simmer for about 10 minutes until the sauce has thickened.

Put the ribs and the sauce in a large ovenproof dish so that they fit quite compactly and chill them in the refrigerator for at least a few hours.

The ribs are best cooked on a barbecue grill. Either heat a gas grill to medium-high or heat your charcoal. If using charcoal, let them begin to die down, making sure there are no flames as you don't want to burn the meat. Scrape off any excess marinade and barbecue the ribs until they are deep golden on both sides and charred in some places. Check that the pork is cooked all the way through to the bone. If there are any really thick ribs, cut them up individually and put them back over the coals.

Remove the ribs from the grill and put them back into the marinade in the dish. Add $^1/_2$ cup of water to the marinade. Put the dish on the barbecue and cook until the sauce boils and becomes sticky, thick, and dark (the sauce must come to a boil and boil for a few minutes). Turn the ribs over a few times while you are reducing the sauce. Serve immediately, either cut up individually or in their racks.

Serves 10

2³/4-POUND PIECE BEEF FILLET
2¹/4 POUNDS (ABOUT 8) RIPE TOMATOES, *sliced*
A FEW SPRIGS FRESH ROSEMARY AND SAGE
A FEW BAY LEAVES
4 RED ONIONS, *thinly sliced*
³/4 POUND UNSMOKED PANCETTA, *thinly sliced*
2¹/4 POUNDS (ABOUT 4 TO 5 SMALL) SWEET POTATOES
2 GARLIC CLOVES, *chopped*
1¹/2 TEASPOONS DRIED OREGANO
JUICE OF 1¹/2 LEMONS
4 TABLESPOONS OLIVE OIL
10 LARGE CREMINI MUSHROOMS

BARBECUED BEEF FILLET
WITH SWEET POTATOES AND
GRILLED MUSHROOMS

My friend Jason made this years ago on a farm in South Africa. It was beautiful. The beef fillet is simply seasoned and spiced and then mummified in bacon before being seasoned and spiced again. It is then covered in sliced tomatoes and onions, wrapped in foil, and placed under the red-hot charcoal. This is best served with baked sweet potatoes, next to the fire, under a star-filled African sky.

This is best cooked on a charcoal or wood barbecue grill. When it is very hot, put a rack over the barbecue and sear the fillet all over so it is golden. Remove from the heat. Lay down six pieces of foil, overlapping well, to make a rectangle at least 24 inches long. Arrange half the tomato slices in the middle and season with salt and pepper. Top with a sprig of rosemary, sage, and a couple of bay leaves. Arrange half the onions over the top and season with salt and pepper. Arrange half the pancetta on top, slightly overlapping each slice, to make a rectangle.

Lay the fillet on top of the pancetta, sprinkling with salt and pepper. Wrap up the fillet in the pancetta from the bottom up and then lay the rest of the pancetta over the top. Repeat the onions and other ingredients in reverse order. Wrap up tightly in the foil (it's great if you have someone to help) and then roll a few more layers of foil around the meat, so you have a neat package. Cook directly in the barbecue coals for about 1¹/4 hours for rare beef and longer if you prefer. Turn the meat every 15 minutes or so during the cooking time.

Meanwhile, scrub the potatoes and prick the skins in a couple of places. Sprinkle with salt and wrap in foil. Bake among the coals for about 50 minutes, turning occasionally.

Combine the garlic, oregano, lemon juice, and oil and season with salt and pepper. Brush over the mushrooms and grill on a rack over the hot coals for about 5 minutes on each side, or until they are cooked through, brushing with more marinade during cooking. Serve immediately.

_ *South Africa* _

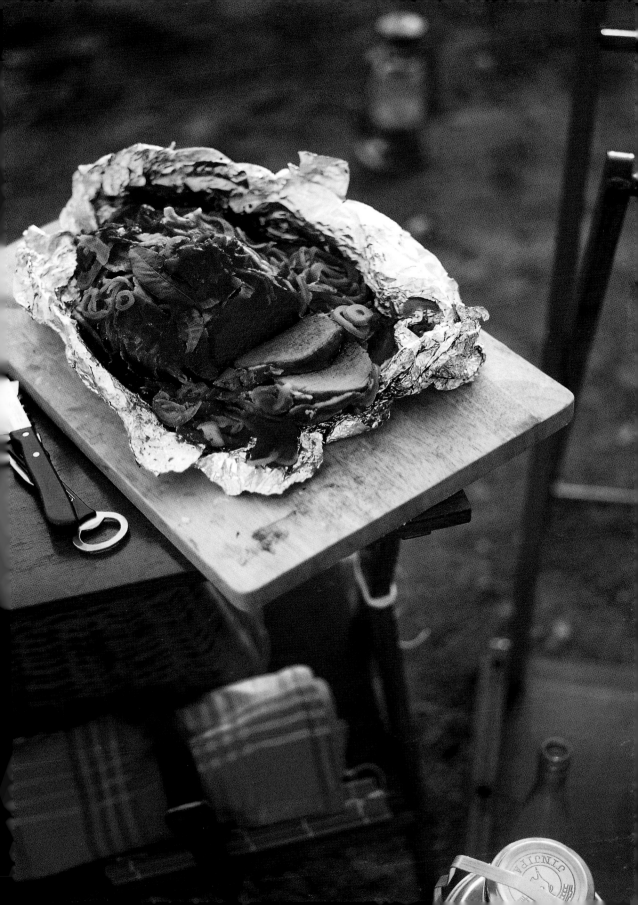

Serves 8

4¹/2 POUNDS OXTAIL, *cut into 1-inch pieces*
1 CUP ALL-PURPOSE FLOUR
6 TABLESPOONS OLIVE OIL
2 TABLESPOONS BUTTER
3 CARROTS, *chopped*
2 CELERY STALKS, *chopped*
2 ONIONS, *chopped*
1 CUP RED WINE
2 SPRIGS FRESH SAGE
2 BAY LEAVES
3 FRESH PARSLEY STALKS

OXTAIL

Ask your butcher to cut up the oxtail for you unless you have a professional cleaver at home (in which case, cut through the natural ridges of the oxtail to make pieces of about 1 inch). This is lovely served with the sweet potatoes in orange juice (see page 244) or just plain mashed potatoes. You could also use osso buco instead of the oxtail.

Bring a large saucepan of water to a boil. Add the oxtail and boil for about 15 minutes, skimming away the scum with a slotted spoon. Drain and rinse the oxtail, then pat dry. Put the flour on a flat plate and lightly coat the oxtail on all sides.

Heat half the oil in a nonstick skillet, and fry the oxtail until golden on all sides. Sprinkle with a little salt and pepper as you turn the pieces over. Fry in batches if necessary, adding extra oil if needed, to ensure the flour doesn't burn. Put the cooked oxtail in a casserole dish. Preheat the oven to 325°F.

Wipe out the skillet with a paper towel and heat the remaining oil and the butter. Add all the vegetables and a little salt and pepper, and sauté for about 10 minutes, until softened. Add the wine and cook, uncovered, for a little longer until it has almost all evaporated. Add the vegetables and any cooking juices to the dish and add the sage, bay leaves, parsley, about 5 cups of hot water, and a little more salt and pepper. Cover and put in the oven.

After 1 hour, add up 4 cups or so of hot water (depending on how much has been absorbed) and continue cooking for another 2¹/2 hours. Add another couple of cups of water and cook for a final 30 to 40 minutes. It's important not to add all the water at the beginning or you'll end up with a soup.

You should have a meltingly soft dish: the meat should come away from the bone very easily, and there should be some thickened sauce with the vegetables to serve with the meat.

Serves 6 as a side dish

1¹/4 POUNDS (ABOUT 3 TO 4) ORANGE
 SWEET POTATOES
2 TABLESPOONS OLIVE OIL
3 TABLESPOONS BUTTER
¹/2 CUP SUPERFINE SUGAR
2 TEASPOONS GROUND CINNAMON
1 TEASPOON SALT
2 LONG STRIPS ORANGE ZEST
JUICE OF 1 LARGE ORANGE

ALLAN'S MOM'S SWEET POTATOES WITH SUGAR, CINNAMON, AND ORANGE JUICE

This could almost be a dessert. It is very good served alongside game, wintery roasts, and full-flavored spicy food. Allan's mom, Sue, is a wonderful cook — loaded with instinct — and everyone loves her food. She often makes her potatoes even sweeter than these.

Peel the sweet potatoes and rinse them, then cut them lengthwise into ¹/4-inch slices. Put them in a saucepan with the rest of the ingredients and about 3 cups of water (or enough to just cover the potatoes). Toss them about and bring to a boil. Cover the pan, decrease the heat, and simmer for about 15 minutes before taking off the lid.

Simmer, uncovered, for another 40 minutes, until the potatoes are very soft but not falling to pieces and are covered in a thickened sticky syrup. Don't stir them at any point, but hula-hoop the pot around now and then to make sure nothing is stuck at the bottom. Take care at the end that the caramel doesn't stick and burn. Let them cool down a little before serving.

Serves 6

2¼ POUNDS TOPSIDE, BLADE, *or* SILVERSIDE BEEF
1 WHITE ONION
1 CELERY STALK
1 LARGE CARROT, *cut into large chunks*
ABOUT 8 WHOLE PEPPERCORNS

sauce
½ TABLESPOON BUTTER
1½ TABLESPOONS ALL-PURPOSE FLOUR
JUICE OF HALF A LEMON
1 TEASPOON SOFT BROWN SUGAR
1 LARGE PINCH GROUND CHILE POWDER
½ TEASPOON GROUND CINNAMON
A PINCH OF GROUND CLOVES
¾ CUP GOLDEN RAISINS
2 TABLESPOONS HEAVY WHIPPING CREAM

BEEF
WITH RAISIN
SAUCE

The original recipe given to me (by Allan's mom, again) was with tongue, which is boiled up a few times in water and vinegar. I have used beef, but you can use any meat suitable for boiling. You will only need a couple of cups of the cooking liquid here to make the raisin sauce, but you can save the rest of the broth and serve it with some small pasta as a starter.

Put the beef in a large, heavy-bottomed saucepan with the onion, celery, carrot, and peppercorns. Add about 16 cups of water, season with salt and bring to a boil. Skim the surface of any scum, cover with a lid, and simmer for about 2½ hours, or until the meat is really soft. Check the water level occasionally and add a little more if it looks like it needs it. Remove from the heat.

To make the sauce, pat the butter into the flour and put in a small saucepan. Add 2½ cups of the beef broth, the lemon juice, sugar, chile, cinnamon, and cloves, whisk well, and then add the raisins. Heat through until it thickens a bit and then add the cream. Heat until it starts to bubble.

Slice the meat fairly thickly and serve immediately with the hot raisin sauce spooned over.

Serves 6

5 CUPS ALL-PURPOSE FLOUR
1 TEASPOON SALT
1/3 CUP SUPERFINE SUGAR
1 (1-OUNCE) CAKE FRESH YEAST, *crumbled,*
 or 1/2-OUNCE DRIED YEAST
1 CUP LUKEWARM MILK
1/4 CUP VEGETABLE OIL
2 LARGE EGGS, *lightly beaten*

cinnamon filling
1 TABLESPOON GROUND CINNAMON
1/2 CUP DARK BROWN SUGAR, *firmly packed*
4 TABLESPOONS BUTTER, *softened*

1 EGG YOLK
2 TEASPOONS MILK
2 TABLESPOONS BROWN SUGAR, *to sprinkle*

BOBBA'S BABKA

Babka is similar to Finnish buns. I remember this exaggerated puffed-up bread so well from the Jewish bakeries in South Africa and the homes of many friends. This is a recipe from Lisa's grandma (*Bobba* is Yiddish for "grandma"). The cinnamon just streaks through the babka and it is great alone, slightly warm, or spread with a little extra butter and jam. You can freeze the cooked bread and pull it out to thaw a couple of hours before serving.

Mix together the flour, salt, and sugar in a large bowl. Crumble the yeast into a smaller bowl, add the milk and oil, and mix well. Let it sit for 10 minutes or so to begin activating, then pour the yeast into the flour mixture, scraping out the bowl well. Using an electric mixer with a dough hook, mix until well combined. Alternatively, mix with very well-floured hands.

Add the eggs and mix a little longer to combine. The dough should be thick and a little difficult to mix, even with the mixer. It will seem very sticky. Turn it out onto a floured work surface, incorporating more flour if necessary, so that it is still very sticky but not actually sticking to your hands. Work it around, kneading for about 10 minutes. Grease a large, clean bowl with a little melted butter.

Put the dough in the greased bowl, turning it greased side up. Cover with plastic wrap and let it rise in a warm place for about 1 1/2 hours, or until it is light and doubled in size. Divide the dough in half and roll out one-half on a lightly floured surface. It will still feel quite sticky. Roll it out to make a 10 by 18 inch rectangle that is 1/4 inch thick.

Mix the cinnamon with the brown sugar. Spread half the butter over the rolled-out dough and scatter half of the cinnamon sugar over the surface. Roll up the dough into a long sausage along its longest edge. Set aside and do the same with the other half of the dough. Braid the two dough ropes together, pressing hard to seal the edges together. Twist the dough braid to tighten the loaf.

Put into a large, greased tube pan. Cover with plastic and leave in a warm place for another hour or so, until it puffs up again. Preheat the oven to 350°F. Mix the egg yolk with the milk and brush over the top of the babka, then sprinkle with brown sugar. Put the pan in the bottom third of the oven with no shelves above it and bake for 30 to 40 minutes. It will have risen more and be beautifully golden. A skewer inserted should come out clean and not have any dough sticking to it. If the ends look too brown but the dough doesn't seem cooked, cover the ends with a bit of aluminum foil and cook for a little longer. Cool for a few minutes before turning out onto a wire rack.

This is a dream served just slightly warm but it is a little more difficult to cut. It will keep for 24 hours, or toast it lightly and spread with a little butter or even a citrus curd.

spice

In the afternoons after school I became well known for my spice mix. I have always been crazy about lemons, and often found a couple hidden away from me in an unused pot, stashed quietly in the bottom of a cupboard by my mother. I would squeeze a lemon or two into one of those brown bowls, then I would open our spice cupboard, pick a few jars, and shower the lemon juice with a pinch of this and a shake of that...some oregano, ground cinnamon, paprika, and hundreds of other things, it seemed. Salt and pepper were always the final additions, while my brother and sister and other neighborhood friends lined up waiting. Then we would all sit around the bowl, dunking bread in our spice mixture.

South Africa

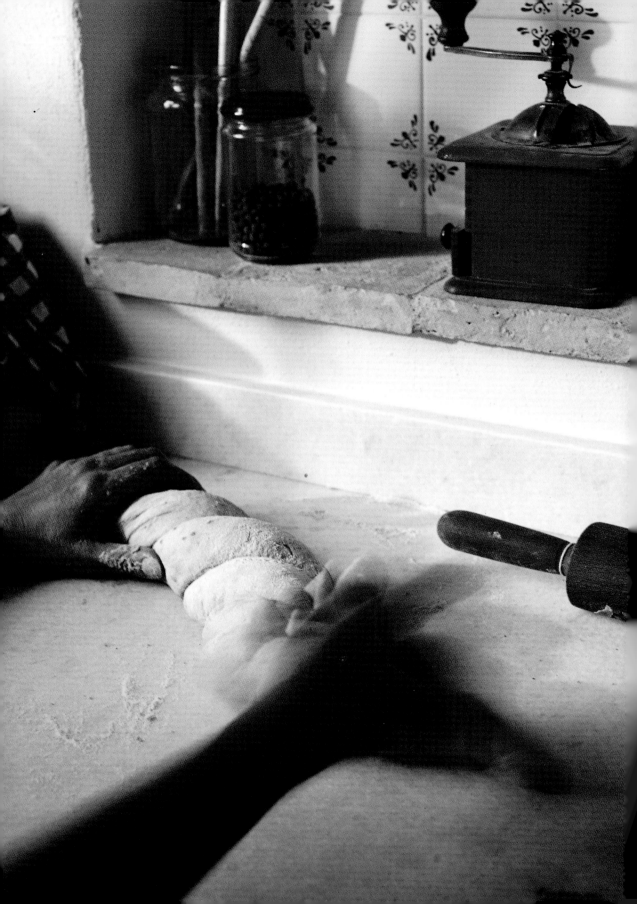

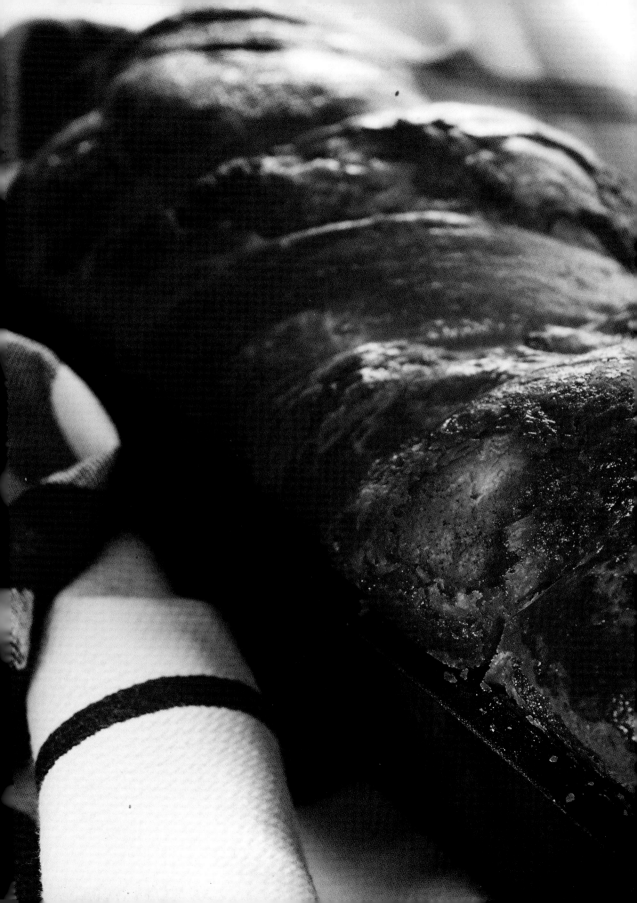

Serves 8

pastry
7 TABLESPOONS COLD BUTTER, *cut into cubes*
1/2 CUP SUPERFINE SUGAR
1 CUP ALL-PURPOSE FLOUR
1/2 TEASPOON BAKING POWDER
1 EGG, *lightly beaten*

filling
3 CUPS MILK
5 TABLESPOONS BUTTER
3 EGGS, *separated*
1/2 CUP SUPERFINE SUGAR
1 TEASPOON VANILLA EXTRACT
1/4 CUP CORNSTARCH

1 TABLESPOON SUGAR
1 TEASPOON GROUND CINNAMON

MILK TART

Milk tart was something we ate often in South Africa; it was on the menu in many tearooms and bakeries. You might like to make double the pastry and freeze it ready rolled-out in the pan so that you can whip it straight into the oven whenever you need to produce a dessert in a hurry.

To make the pastry, mix the butter and sugar together with a wooden spoon until softened. Add the flour, baking powder, and a pinch of salt, and mix with your fingers until damp and sandy. Add the egg and knead very gently so that the pastry comes together. Flatten a little and wrap in plastic. Refrigerate for 1 hour before rolling out. Preheat your oven to 350°F.

Roll out the pastry on a floured work surface to line a 10½-inch tart pan with sides at least 1¼ inches high. Line with parchment paper, fill with baking beans or weights, and blind bake for 20 minutes. Remove the beans and paper when the visible pastry is golden. Prick the pastry base a few times with a fork and bake for a further 10 minutes to dry out the bottom.

Meanwhile, make the filling. Put the milk and butter in a pan over medium heat to melt the butter. Whisk the egg yolks with the sugar and vanilla, then whisk in the cornstarch. Add a ladleful of the hot milk to the eggs, whisking to avoid scrambling them. Add the rest of the milk, mix it all together well, and let cool. Whisk the egg whites to soft peaks, then gradually fold into the filling. Pour into the tart case, sprinkle the sugar and cinnamon over the top, and return to the oven for 30 minutes, or until it is set and just a bit wobbly. Cool before serving.

Serves 8

spice mixture
5 CLOVES
1 CINNAMON STICK
6 ALLSPICE BERRIES
 or ¹⁄₂ TEASPOON GROUND ALLSPICE
ZEST OF HALF A LEMON

syrup
JUICE OF 1 ORANGE
4¹⁄₂ TABLESPOONS BUTTER
¹⁄₃ CUP BROWN SUGAR, *firmly packed*
1 PINEAPPLE (ABOUT 2³⁄₄ POUNDS)

cake
¹⁄₂ POUND PLUS 2 TABLESPOONS BUTTER, *softened*
1 CUP BROWN SUGAR, *firmly packed*
3 EGGS
2 CUPS ALL-PURPOSE FLOUR
2 TEASPOONS BAKING POWDER
³⁄₄ CUP MILK

PINEAPPLE, CINNAMON, AND ALLSPICE CAKE

You can use any fruit you like here...raspberries, bananas, apples, pears, or mangoes. I think apricots would be beautiful.

Preheat your oven to 400°F. To make the spice mixture, put all the ingredients in a spice or coffee grinder and grind to a coarse powder.

Now make the syrup. Put the orange juice, butter, and sugar in a small pan with ¹⁄₂ teaspoon of the spice mixture and bring to a boil. Decrease the heat and simmer for 8 to 10 minutes, until you have a thick caramel syrup.

Line a 9¹⁄₂-inch springform cake pan with aluminum foil, so that the bottom and sides are covered. Flatten the foil completely against the sides so that it won't interfere with your cake. Peel the pineapple and cut into ¹⁄₂-inch slices. Cut each ring in half, either side of the core. Fit the pineapple pieces in the bottom of the pan in a single layer.

To make the cake batter, whisk the butter with an electric mixer until fluffy, and then beat in the sugar. Beat the eggs in one by one and then sift in the flour and baking powder. Mix to combine. Add the milk to thin the mixture, beating it in well. Add 1½ teaspoons of the ground spice mixture and give it a final whisk.

Pour the syrup over the pineapple in the pan, making sure that it covers it fairly evenly, and then spoon the cake batter over the syrup and smooth the top. Bake for about 1 hour 20 minutes, decreasing the temperature to 350°F after 10 minutes and covering the cake with foil after an hour. The cake should be deep golden on the top and a skewer inserted into the center should come out clean. Remove from the oven and let cool slightly before turning out onto a serving plate. Remove the bottom of the cake pan and peel away the foil.

Serve with crème fraîche ice cream (page 379), or slightly sweetened whipped cream, or even completely on its own, very slightly warm.

Our garden in South Africa had a beautiful pomegranate tree. We loved picking the gorgeous heavy pomegranates and throwing them onto the white wall just behind the tree. Then we'd charge toward the ruby-streaked wall to gather our broken-up fruit, our bleeding jewels, that lay like coins sprayed from an open purse on our sun-warmed driveway, and suck out all the juice.

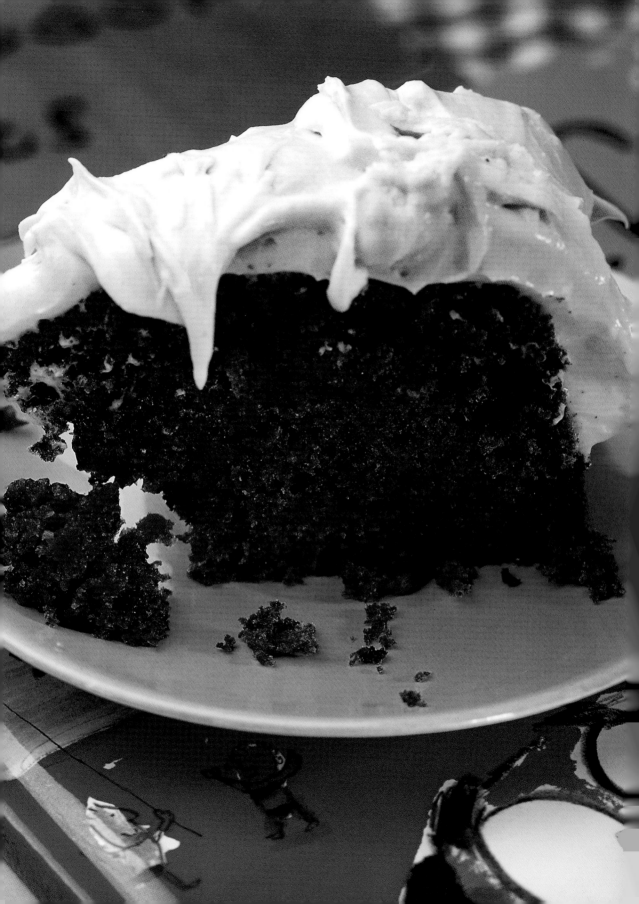

Serves about 10

4 EGGS, *lightly beaten*
2 CUPS SUPERFINE SUGAR
$^3/_4$ CUP SUNFLOWER *or* LIGHT OLIVE OIL
$2^1/_2$ CUPS ALL-PURPOSE FLOUR
$^3/_4$ TEASPOON SALT
2 TEASPOONS BAKING POWDER
1 TEASPOON BAKING SODA
2 TEASPOONS GROUND CINNAMON
4 MEDIUM CARROTS, *peeled and grated*
$^1/_2$ CUP CHOPPED WALNUTS

icing
$1^1/_2$ STICKS BUTTER, *softened*
2 CUPS CONFECTIONERS' SUGAR
$^3/_4$ CUP CREAM CHEESE
3 DROPS VANILLA EXTRACT

CARROT CAKE

This is one of those classic cakes that can disappear for a year or two, but I would always welcome back a slice from time to time with an afternoon coffee, or even for breakfast. This recipe is my friend Anette's. Every time she makes it, people ask her for the recipe...so I did, too.

Preheat your oven to 350°F. Grease and flour a $9^1/_2$-inch Bundt pan or springform cake pan.

Whip together the eggs and sugar until creamy, then whisk in the oil. Sift together the flour, salt, baking powder, baking soda, and cinnamon. Add to the egg mixture and whisk to combine. Add the carrots and walnuts and mix in quickly with an electric mixer to make sure it is all properly combined. Scrape out the batter into the pan. Bake for about an hour, or until a skewer inserted into the center comes out clean. The cake should have risen up impressively high. Cool a little before turning out onto a plate.

While the cake is baking, make the icing. Whip together the butter and confectioners' sugar, mashing it together at first with a wooden spoon and then whisking until it is stiff. Quickly beat in the cream cheese and vanilla to just combine.

When the cake is cool, spread the icing over the top and side with a spatula (you don't need to spread it too smoothly; it looks better in peaks).

Serves 4

2 CUPS HEAVY WHIPPING CREAM
GRATED ZEST AND JUICE OF 1 LEMON
1 TEASPOON FINELY CHOPPED FRESH
 SAGE LEAVES
⅔ CUP SUPERFINE SUGAR

LEMON ICE CREAM

 This is fresh and summery, eaten on its own or with a few berries and a cookie. Or serve it on a platter with other lemony desserts for as many people as you like. Here I have added a couple of sage leaves to the ice cream. You could even try infusing the cream with some thyme, rosemary, or other herbs, but you'll need to strain them out before churning.

Put the cream, lemon zest, and sage in a saucepan and bring slowly to a boil. Set aside to cool and infuse the lemon and sage flavors into the cream.

Meanwhile, whisk the sugar with the lemon juice and 1 tablespoon of the cream mixture until the sugar dissolves. Add the remaining cream mixture and whisk well for a couple of minutes. Transfer to a bowl, cover, and put in the freezer.

After an hour, remove the bowl from the freezer, give an energetic whisk with a whisk or electric mixer, and return the bowl to the freezer. Whisk again after another couple of hours. When it is nearly firm, give one last whisk, transfer to a suitable freezing container with a lid, and let it chill in the freezer until it is firm.

Alternatively, pour the mixture into your ice-cream machine and freeze, following the manufacturer's instructions.

Makes 6

7 TABLESPOONS BUTTER, *slightly softened*
1/2 CUP SUPERFINE SUGAR
1 LARGE EGG, *separated*
1 TEASPOON VANILLA EXTRACT
3/4 CUP ALL-PURPOSE FLOUR, *sifted*
2 TEASPOONS FINELY GRATED LEMON ZEST
1 TEASPOON BAKING POWDER
1/4 CUP MILK
JUICE OF HALF A LEMON

frosting
1 1/2 TABLESPOONS LEMON JUICE
1/2 CUP CONFECTIONERS' SUGAR

LITTLE LEMON CAKES

These are light, fluffy, and wonderful as part of a lemon platter. Instead of making the frosting, you could halve and spread them with your favorite jam and a dollop of crème fraîche or whipped cream. If you don't have ramekins, you could make one large cake instead (use an 8-inch cake pan).

Preheat your oven to 350°F. Butter and flour four 3/4-cup ramekins or molds.

Cream the butter and sugar for a few minutes, then add the egg yolk and vanilla and whisk in well. Add the sifted flour, lemon zest, and baking powder and fold in with a large metal spoon to incorporate it all. Pour in the milk and lemon juice and stir well. With clean beaters, whisk the egg white in a small bowl until it is very white and fluffy, and then fold it into the cake mixture with a metal spoon.

Drop 2 heaped tablespoons of the mixture into each ramekin, ensuring that the base is covered and the mixture is even. Bake for about 30 minutes, until the cakes are deep golden and a bit crusty on the top, but still soft to touch and a skewer inserted comes out clean. Put the ramekins on a wire rack to cool completely. Remove the cakes by putting a spoon or knife down the side of each ramekin and lifting them out.

To make the frosting, whisk the lemon juice and confectioners' sugar together until smooth and fairly thick, adding a little more of either if it seems necessary. Put the cooled cakes on a flat plate, make a few holes with a skewer in the top of each one, and drizzle the frosting over the top.

Serves 6

2 LEMONS
3 TABLESPOONS SUPERFINE SUGAR

custard
2 CUPS HEAVY WHIPPING CREAM
1 VANILLA BEAN, *split lengthwise*
8 EGG YOLKS
2/3 CUP SUPERFINE SUGAR

praline top
1/2 CUP SUPERFINE SUGAR

LEMON
CRÈME BRÛLÉE

This is a classic crème brûlée with a lemon bottom — serve it on its own or with other lemon desserts. Or you could leave out the lemon altogether and add various other flavors to the infused cream here: rose water, a piece of orange zest, some lavender, or a piece of ginger, cinnamon, or cassia bark. There are various ways to burn your layer of sugar over the custard — you can also use a brûlée iron or blowtorch.

Finely grate the yellow zest from one of the lemons and set aside. To fillet the lemons, cut the top and bottom from both of them. Sit the lemons on a board and, with a small, sharp knife, cut downward to remove the skin and pith.

Remove the segments by slicing between the white pith. Remove any seeds. Discard the lemon "skeleton."

Put the sugar in a small saucepan with 1/2 cup of water and the lemon zest. Bring to a boil and boil for a few minutes, until the syrup thickens and becomes lightly golden. Add the lemon fillets and simmer for a few minutes more, until thick and syrupy. Remove from the heat and let cool a little. Divide among six 3/4-cup ramekins and put in the refrigerator.

To make the custard, put the cream and vanilla bean in a heavy-bottomed saucepan and bring to just below the boiling point. Turn off the heat and let sit for 30 minutes to infuse, then remove the vanilla bean, scraping the seeds into the cream with the point of a knife.

Whisk the egg yolks and sugar in a bowl for 2 minutes until thick and creamy. Whisk a ladleful of cream into the yolks. Then pour in all the cream, mixing it well, and return the whole egg mixture to the pan, over the lowest possible heat. Whisk almost continuously to keep moving

the heat around for about 10 minutes, or until you notice the custard thickening. It should make ribbons when you whisk. Take care not to let the custard get too hot or the eggs will split — if they do, quickly take a handheld mixer and purée on full power for a couple of minutes.

Pass the custard quickly through a fine sieve into a cold bowl and continue whisking to prevent the egg's cooking further. You can also hold the bowl in a sink filled with cold water while you whisk. When the custard is quite cooled, ladle it into the ramekins, not filling them too full and trying not to send the lemon syrup everywhere. When they are completely cool, cover with plastic wrap and chill them in the fridge for a few hours before serving.

To make the praline top, put the sugar in a small saucepan with a few drops of water and simmer until it darkens to caramel. Lightly butter a metal or marble surface. Pour out the caramel onto the surface and let it cool and harden before you break it off and smash it with a meat mallet or pulse it in a blender until it is in crumbs.

Preheat the broiler to very hot. Take the custards from the refrigerator at the last minute and sprinkle about a tablespoon of praline over each one. Spread it thinly over the whole surface with the back of a spoon. Put the custards on a rack as close as possible to the broiler until the praline has melted — the custard should be still cold on the inside and the sugar crisp on the top. Serve immediately.

Makes 12

pastry
5 TABLESPOONS BUTTER, *slightly softened*
2 TABLESPOONS SUGAR
$^2/_3$ CUP ALL-PURPOSE FLOUR
$^1/_4$ CUP GROUND ALMONDS

lemon curd
5 TABLESPOONS BUTTER
3 EGGS, *lightly beaten*
1 CUP SUGAR
JUICE AND FINELY GRATED ZEST OF 2 LEMONS

LEMON
CURD TARTLETS

I love these tiny tartlets for a tea party or as part of a lemon dessert platter. If you have any leftover curd (you can always make double the quantity so that you have some to keep) store it in the refrigerator for up to a week and spread it on toast.

To make the pastry, cream together the butter and sugar with a wooden spoon. Add the flour, ground almonds, and a pinch of salt, and mix well, using your hands when it becomes a little stiff, until the pastry comes together. Flatten slightly, cover with plastic wrap and refrigerate for at least half an hour before using. (You can also freeze the pastry at this stage.)

Now make the curd. Melt the butter in a metal bowl over a saucepan of barely simmering water. Whisk in the eggs. Add the sugar and whisk until thoroughly combined. Whisking continuously, gradually add the lemon juice and zest. Cook over the simmering water for about 20 minutes, stirring often, until thickened. Let cool to room temperature.

Preheat your oven to 350°F. Roll out the pastry thinly on a lightly floured work surface and cut out circles of pastry to line about 12 shallow tartlet tins. Line with baking paper, fill with baking beans or weights, and blind bake for 8 to 10 minutes, or until the visible pastry is golden and cooked. Remove the paper and beans and cook for another couple of minutes to dry the bases. Remove from the oven and let cool before gently removing from the tartlet tins. When completely cooled, fill with lemon curd.

Makes about 5 cups

6 THIN-SKINNED LEMONS, *rinsed well*
6 CUPS SUPERFINE SUGAR
1 VANILLA BEAN, *halved lengthwise*

LEMON VANILLA JAM

You must use good lemons here — I like the thin-skinned, bright ones that don't have much white pith. This is delicious spread on toast, brioche, or pancakes. I love it spooned into tiny sweet pastry cases (like the ones opposite) and served as part of a lemon platter. You could also serve a little dish of this and a dish of mascarpone cheese next to a simple sponge cake for afternoon tea. Use the jam immediately or seal it in jars where it should keep, unopened, for many months. It is best to use a lot of smaller jars because, once opened, the jam should be eaten fairly quickly.

Cut the ends off the lemons, then slice them thinly. Remove all seeds and then quarter the slices. Put them in a large, tall, heavy-bottomed saucepan and add 5 cups water. Bring to a boil, then decrease the heat and simmer, uncovered, for 45 minutes to 1 hour, or until the lemons are soft (this may take longer if you don't have a heavy-bottomed pan). Make sure you cook on low heat as the water tends to splash up a bit and threaten to boil over. Watch it carefully toward the end and stir often. Add the sugar and vanilla bean and simmer, uncovered, for another 45 minutes to 1 hour (you can add more water if it seems necessary). To test if the jam is ready, spoon a little onto a plate and tilt it. It should slide down with resistance and not just run down. If necessary, cook for longer.

If you are storing this, pour the warm jam into your sterilized jars (use a wide-necked funnel if you have one). Close the lids and turn the jars upside down, then cover them with a dish towel. Let cool completely before turning them upright. A vacuum should have formed on the lid. Store in a cool place and keep in the fridge once opened.

Serves 8

6¹/₂ TABLESPOONS BUTTER
1¹/₄ CUPS SUPERFINE SUGAR, PLUS
 EXTRA 2 TEASPOONS
4 EGGS, *separated*
1 TEASPOON VANILLA EXTRACT
1¹/₂ CUPS ALL-PURPOSE FLOUR
1 TEASPOON BAKING POWDER
¹/₄ CUP MILK
¹/₂ CUP CHOPPED BLANCHED ALMONDS
2 TEASPOONS GROUND CINNAMON
1 CUP HEAVY WHIPPING CREAM
1 TABLESPOON CONFECTIONERS' SUGAR,
 PLUS EXTRA FOR DUSTING
1¹/₄ CUPS FRESH RASPBERRIES

NUT MERINGUE
CAKE WITH WHIPPED CREAM

This is a wonderfully textured cake, filled with whipped cream, that is good for teatime or as a dessert. You will need two springform cake pans that will fit in the oven at the same time.

Butter and flour two 8¹/₂-inch springform cake pans. Preheat the oven to 350°F.

Whip the butter with half the sugar until it is white and creamy. Add the egg yolks and vanilla extract and whisk well. Sift in the flour and baking powder, add the milk, and mix well. Divide the mixture evenly between the two cake pans, smoothing it out gently with a spatula so that it covers the bases of the pans.

Wash your beaters and whisk the egg whites until fluffy. Add the other half of the sugar and whisk until white and fluffy. Divide in half and spread loosely over the cake batter in the pans. Sprinkle with the almonds and then dust each cake evenly with 1 teaspoon of cinnamon and 1 teaspoon of the extra superfine sugar. Bake for about 30 minutes, until the tops are deep golden, but make sure that the nuts don't burn.

Remove from the oven and let them sit in the pans to cool completely. Turn out one half and put it on a serving plate, nut side up. Whip the cream and confectioners' sugar to soft peaks. Loosely spread over the cake base and scatter with the raspberries. Place the other half of the cake on top, nut side up. Dust with confectioners' sugar and cut into wedges to serve.

Serves 8 to 10

3 APPLES
7 TABLESPOONS BUTTER, *softened*
1 CUP SUPERFINE SUGAR
1 TEASPOON VANILLA EXTRACT
3 EGGS
1²/₃ CUPS ALL-PURPOSE FLOUR,
 PLUS EXTRA FOR DUSTING
2 TEASPOONS BAKING POWDER
¹/₄ CUP MILK

topping
1¹/₂ TABLESPOONS BUTTER
¹/₂ CUP SUPERFINE SUGAR
¹/₂ CUP HEAVY WHIPPING CREAM

APPLE CAKE
WITH TOFFEE
TOPPING

This is a recipe from a friend of mine, Nicci. Her mom, Brenda, often served this cake at their house and I always loved it. It has probably changed, bit by bit, over the years, as I have swapped the recipe from one of my notebooks to another. Golden Delicious are good apples to use.

Preheat the oven to 375°F. Grease and flour a deep 9¹/₂-inch springform cake pan. Peel the apples and cut them in half lengthwise. Cut each half into about 6 slices, removing the core. Arrange the apple slices in the pan (they should fit well into two tight circles).

Using an electric mixer, cream the butter, sugar, and vanilla until pale and creamy. Add the eggs, beating well after each one. Sift and beat in the flour and baking powder. Beat in the milk until the mixture is soft and fluffy. Scrape out the batter over the apple and smooth the top. Bake for 35 to 40 minutes, or until a skewer inserted into the center comes out clean. Remove from the oven and make the topping.

Put the butter and sugar in a small pan and cook over medium heat for 3 to 4 minutes, until the sugar melts and turns light caramel. Add the cream, drop by drop initially, then in a steady stream, taking care that it doesn't splash. Decrease the heat a little and simmer for another minute.

Loosen the side of the cake and pour the caramel over the top. Let it cool before removing the side of the springform pan. Serve warm or at room temperature with a scoop of vanilla or crème fraîche ice cream (page 379).

South Africa

mulberries and silkworms

We had a huge mulberry tree at the bottom of our garden and spent ages collecting fresh leaves for our silkworms who lived part-time in a shoe box and breathed through the thousands of holes we had stabbed in the lid with a freshly sharpened pencil. We loved witnessing their various stages — from the steady munching of the mulberry leaves to the miraculous opening of the cocoons that would breathe out new lives.

The mulberries themselves were such a beautiful surprise, with their curly outsides that would explode into sweets in our mouths. At night we would take longer than usual washing our purply-black stained feet, before we could flop into bed, exhausted.

_South Africa _

Serves 8

$^1/_2$ POUND (ABOUT 18) GRAHAM CRACKERS,
 coarsely crushed in a blender
$^1/_4$ POUND PLUS 1 TABLESPOON UNSALTED
 BUTTER, *melted,* PLUS A LITTLE EXTRA
3 CUPS CREAM CHEESE
$1^1/_2$ CUPS SUPERFINE SUGAR
4 EGGS
1 TEASPOON VANILLA EXTRACT
2 TEASPOONS CORNSTARCH
$3^1/_4$ CUPS FRESH *or* FROZEN BERRIES
1 TEASPOON FINELY GRATED LEMON ZEST

BERRY CHEESECAKE

If you are using frozen berries, leave them in a bowl to come to room temperature before you start (you probably won't need to add any water when you sauté them later). Raspberries on their own are beautiful here, but choose your favorite berries or use a mixture. Blueberries, blackberries, and strawberries all work well. You can leave out the cornstarch when you heat the berries, if you prefer, but they won't hold onto the cake so well. Or simply serve a slice of plain cheesecake with a spoonful of berries on the side.

Preheat your oven to 350°F. Grease a $9^1/_2$-inch springform cake pan. Mix together the crushed cookies and melted butter. Press the cookie mixture into the pan so that it covers the bottom and comes about two-thirds up the side, kneading down with your palms to push it along evenly.

Whisk the cream cheese in a bowl with 1 cup of the sugar. Beat in the eggs one by one and then the vanilla, until you have a smooth thick cream. Pour over the base and smooth the top with a spatula. Bake for 40 to 50 minutes, until it is lightly golden in parts and wobbles only a little when you shake the pan. Let cool completely, then chill in the fridge for a few hours.

Meanwhile, mix the cornstarch with a couple of tablespoons of cold water until it is smooth. Pour into a saucepan to heat up, then add the berries, grated lemon zest and the remaining sugar — the amount of sugar may depend on the sweetness of the berries. Cook for a couple of minutes, adding some water if it seems too thick, to just combine everything, and then remove from the heat before the berries collapse. Set aside to cool completely.

Carefully remove the ring from the cheesecake and spoon the berries over the top. Cut into wedges to serve. If you are not serving it immediately, keep the cake in the fridge.

Makes about 50

1/2 POUND PLUS 2 TABLESPOONS BUTTER, *cut into
 small pieces,* PLUS ABOUT 2 TABLESPOONS EXTRA
6 CUPS ALL-PURPOSE FLOUR
2 CUPS SUPERFINE SUGAR
1 TEASPOON SALT
2 TEASPOONS BAKING POWDER
1 3/4 CUPS MILK
2 TABLESPOONS WHITE *or* RED WINE VINEGAR

SUE'S
BISCOTTI

These are what we had in South Africa for breakfast, often dipped in warm milk or coffee. I love having a jar of them in the house always. They are crisp and rustic and beautiful. Sue says her kids always liked to scatter the remaining crumbs over their breakfast cereal.

Preheat your oven to 375°F. Mix the butter into the flour with your hands or in a blender. Add the sugar, salt, and baking powder and then mix in the milk and vinegar until you have a smooth, soft dough. Grease a large baking sheet with butter and flour.

Roughly divide the dough into three portions. Wet your hands with a little cold water and quickly roll long dough sausages, each about 12 inches long. Your baking sheet needs to be big enough to accommodate them — mine is 14 inches by 10 inches and looks very big when I put the mixture in. Arrange the dough rolls parallel on the sheet with a few extra dots of butter between them.

Bake for 45 minutes to 1 hour until the tops are golden and crusty. Remove from the oven and turn the heat down to 300°F. The dough rolls will have joined together but their outlines will still be visible. Cut down their lengths to separate them, then cut each roll into 1 1/4-inch pieces. Don't touch them for now, leave them on the sheet to cool a bit and make them more manageable. Then lift them up and break them in half through their middles so that they look rustic and imperfect. If you find it easier, begin with a knife, chopping through a little and then breaking them apart with your hands.

Return them to the baking sheet (lay them on their sides) and the oven for about 30 minutes on each side to dry out a bit. They should be not too toasted, but crumbly and firm. Let them cool completely before storing in a closed container or paper bag, where they will keep well for up to five days.

WASHING LINES + WISHING WELLS

When I drive along the country roads of Italy I watch the hills and they look like women, voluptuous women, wearing skin-tight velvet and corduroy dresses to show their beautiful curves. I love the faithful lifestyle...the way the milk joins the coffee in the cup, the same way the beautiful words join for music that a whole nation sways proudly to. It makes me feel safe, as if I could walk with my eyes closed and grope only onto the ropes of consistency to find my way. That civilized apperitivo hour, just at the special time of day when the sun may be going down, making that aging ochra and stone wall that's holding together the piazza seem even more magnificent. Just at that time of day I like to sip prosecco with all the others and bite into something small, perhaps an artichoke crostino. It makes me happy, as if a box of inspiration had landed in my lap and I want to hold it forever.

Makes 2 small loaves

1 (¹/2-OUNCE) CAKE FRESH YEAST
3 TABLESPOONS OLIVE OIL
1 TEASPOON SUGAR
3¹/4 CUPS BREAD FLOUR
1¹/2 TEASPOONS SALT
ABOUT ¹/3 CUP OVEN-ROASTED TOMATOES (PAGE 288)

OLIVE OIL BREAD

 This is an ideal picnic bread. It is great filled as a large roll, cut into slices for crostini or bruschetta, or just broken off to eat as it is. It is quite wonderful plain or with some chopped sautéed mushrooms, roasted tomatoes, olives, nuts, or herbs mixed through before its second rising.

Put the yeast in a large bowl with the olive oil, sugar and 1 cup of lukewarm water and mix together. Let sit for 10 to 15 minutes, until it starts activating and looks frothy.

Add the flour and salt, and mix with your hands until it comes together. Turn out onto a work surface and knead for about 10 minutes, or until it is firm, smooth, and elastic.

Put the dough back in the bowl and cover with a dish towel and then with a heavier cloth. Put the bowl in a draft-free warm place for 1¹/2 to 2 hours, until the dough has puffed up.

Punch down the dough by punching out all the air to bring it back to its original size. Divide it in half. Now is the time to mix through any ingredients that you will be adding — in this case the roasted tomatoes. Work each half with your hands to form two small baguette-shaped loaves. Scatter a little flour onto a baking sheet large enough to hold both loaves. You could also line it with parchment paper or oil it. Put the loaves on the sheet, cover loosely with the dish towel and leave in a warm place for 20 to 30 minutes. Preheat the oven to 425°F.

Take off the dish towel and bake the loaves for 20 minutes or so, until they are nicely golden both top and bottom, and the bottom sounds hollow when you knock on it. Let cool slightly before serving.

Makes 16

1³/4 CUPS ALL-PURPOSE FLOUR
¹/2 POUND CHILLED BUTTER, *diced*
4 TO 5 TABLESPOONS ICE WATER
7¹/2 CUPS FIRMLY PACKED SPINACH LEAVES
¹/4 POUND MOZZARELLA *(drained weight)*
1 TABLESPOON "CREMA DI FUNGHI PRATAIOLI AL
 PROFUMO DI TARTUFO" *(cream of mushrooms with truffle)*
1 TABLESPOON OLIVE OIL
1 TEASPOON TRUFFLE OIL
1 EGG, *beaten, for brushing*

SPINACH AND TRUFFLE PIES

This recipe is from my brother-in-law, Marco, who has a lovely restaurant, the Taverna di San Giuseppe, in Siena. I always have these when I go there. You should be able to find a mushroom "crema" perfumed with truffle in an Italian delicatessen. The one I use is a purée of porcini and other wild mushrooms.

To make the pastry, sift the flour and a pinch of salt into a bowl. Add the butter and stir well to coat it with flour. Add enough of the ice water to make the dough come together. Gather into a ball and transfer to a floured work surface. Flour your hands and form the dough into a block. Roll this out to make a rectangle about ¹/2 inch thick with the short side closest to you. Fold up the bottom third of the rectangle and fold down the top third. Seal the edges lightly with a rolling pin. Turn the dough through 90 degrees, and roll it out again into a rectangle that is about ¹/4 inch thick. Fold as before, turn the dough, and roll out again. Do this once more, then put the dough in a plastic bag and chill in the fridge for 30 minutes.

Blanch the spinach in boiling salted water for about 5 minutes, or until it is soft, then drain well and squeeze out the excess water. Pass half the spinach through a food mill with the Mozzarella so that it is very finely chopped. Chop up the remaining spinach by hand to keep some texture in the filling (or chop it all by hand if you don't have a food mill). Mix in the mushroom "crema," olive oil, and truffle oil, and season with salt and pepper.

Preheat the oven to 400°F. Line a baking sheet with parchment paper. Roll out the pastry to make a square just larger than 16 inches. Trim away the edges to make a neat square. Now cut lengthwise and widthwise to make sixteen 4-inch squares.

Dollop a tablespoon of the spinach mixture in the center of each square, then fold over to form a triangle, pressing the edges down to seal. Arrange the pies on the baking sheet and brush the tops with beaten egg. Bake for 10 to 15 minutes, or until they are golden and the undersides are also firm and golden. Let cool a little, just so you don't burn your mouth.

Serves 4 as a side salad

1/4 CUP SHELLED WHOLE ALMONDS
20 SHELLED PISTACHIO NUTS
1 GREEN APPLE, *cored*
3 TABLESPOONS EXTRA-VIRGIN OLIVE OIL
1 TABLESPOON BALSAMIC VINEGAR
1²/3 CUPS FIRMLY PACKED SPINACH LEAVES
1/2 CUP GRATED PARMESAN, OR MATURE
 PECORINO CHEESE
2 OUNCES FINELY SLICED BRESAOLA, *left whole or*
 cut into thin strips

BABY SPINACH, BRESAOLA, APPLE, AND NUT SALAD

Naturally, the oil and vinegar here can be adjusted to suit your personal taste. This is a simple, healthy, and nutritious salad that will serve four as a side dish and two as a light main course.

Put the nuts in a skillet over medium heat and dry-fry until they are lightly golden. Sprinkle with salt and set aside. Cut the apple into about 10 or 12 slices. Whisk together the olive oil and balsamic vinegar and season with salt and pepper.

Place all the salad ingredients in a large bowl, splash with the dressing, and add extra salt and pepper to taste. Mix well and serve immediately.

Serves 2

1 LARGE JUICY RED POMEGRANATE
1 SMALL HEAD OF ARUGULA, *rinsed, dried and
 stalks broken off*
2 TABLESPOONS OLIVE OIL
1 TABLESPOON BALSAMIC VINEGAR
$^1/_2$ CUP GRATED PARMESAN CHEESE,

ARUGULA, PARMESAN, AND
POMEGRANATE SALAD
WITH BALSAMIC VINEGAR

This salad has a definite Italian-Lebanese feeling about it. I first had it at my friend Niki's house and I've been making it ever since. You might like to add some crisp cucumber, or anything else you think would go well.

Cut the pomegranate in half. Remove and reserve the seeds from one half, taking care not to get any of the white pith. Squeeze the juice from the other half with a lemon juicer. Arrange the arugula on two plates.

Mix together the olive oil and balsamic vinegar in a small bowl and whisk in the pomegranate juice. Season with salt and pepper.

Scatter the pomegranate seeds and grated Parmesan over the arugula and drizzle a couple of tablespoons of dressing over each serving. Serve immediately.

Makes about ¹/₂ pound (about 2 cups)

3¹/₄ POUNDS (ABOUT 22 SMALL) RIPE TOMATOES
¹/₂ CUP OLIVE OIL
2 GARLIC CLOVES, *lightly crushed*

OVEN-ROASTED
TOMATOES

These are an essential ingredient in my house. I would like to have a constant supply, but I don't always get around to it. They are fabulous alone on bread, or with Mozzarella and a little pesto; beautiful on pasta with their own oil; and can be added to any antipasto or meze platter. They are also good on hamburgers, and can even be added to a saucepan of pan-fried chicken escalopes at the last moment. They just wear a more elegant and tasty coat than the ordinary versatile tomato. Don't worry too much about following the quantities and the first time you make them might be a bit stressful, but after a couple of times you'll know exactly when to shift them around and when to take them out of the oven. To the oil, you can add a bay leaf, a rosemary sprig, a couple of sprigs of thyme and a couple of cloves of garlic, or whatever else you choose. Fresh basil, parsley, and cilantro might be best mixed through at the last moment. Here I have estimated very ripe, smallish tomatoes of about 2¹/₂ ounces each, just to give you a guideline.

Preheat the oven to 400°F. Line a 14-inch baking sheet with aluminum foil, then brush the foil with oil to prevent sticking.

Rinse the tomatoes, pat dry, and cut in half from their tops down. Pack them very close together, seeded side up, on the foil. Scatter with salt and pepper and bake for 15 minutes, or until you begin to notice them sizzling or coloring. Reduce the oven temperature to about 300°F and bake for another 1¹/₂ hours or so, until they are golden around their rims and a little shriveled, but not completely dried out. They should not be soggy and collapsed, but firm and less dry than the sun-dried tomatoes that we buy.

Remove the tomatoes from the oven in batches if necessary, leaving the underdone ones to roast a little longer. If you won't be serving them immediately, let them to cool completely, then transfer them to a container suitable for the fridge. Pour the oil over the top and add the garlic and any other seasonings you're going to use. They will keep for a few days in the refrigerator. Add more oil if you like and then, when your tomatoes are used up, you can drizzle just the flavored oil over pasta, rice, salad, bread, or baked potatoes.

Serves 6 as a starter

18 PERFECT ZUCCHINI FLOWERS
3 EGGS, *separated*
3/4 CUP ALL-PURPOSE FLOUR
1/2 CUP COLD SPARKLING WATER
1/4 CUP WHITE WINE
9 NOT-TOO-BIG ANCHOVIES, *cut in half*
1/4 POUND MOZZARELLA, *cut into 18 cubes*
CORN, SUNFLOWER, *or* LIGHT OLIVE OIL, *for frying*
18 FRESH SAGE LEAVES, *rinsed and dried*

FRIED MOZZARELLA- AND ANCHOVY-FILLED ZUCCHINI FLOWERS WITH SAGE LEAVES

This is beautiful. I was always impressed by this dish. It is something I have learned in Italy and will always keep in my long-term favorites file. I also like the flowers just plain, but definitely eaten as soon as fried and sprinkled with lemon juice and a little salt.

Remove the inner stamens from the zucchini flowers by opening them up carefully and gently twisting the stamens away. Drop the flowers into cold water and swish them through carefully with your hands. Remove them from the water and drain. Use paper towels to pat dry to remove any remaining water.

Whip the egg yolks in a good-sized bowl. Add the flour, sparkling water, and wine. Season with salt and whisk until fairly smooth. In a clean bowl, whisk the egg whites into stiff peaks, then gently fold into the batter.

Fill each flower with an anchovy half and a piece of mozzarella. Loosely twist the end of the flower to stop the filling's falling out. Pour about 1 1/2 inches of oil into a large saucepan and heat until it is hot enough for deep-frying. Dip the filled flowers into the batter and fry, in batches, on both sides until they are golden and crispy. Take care not to overcrowd the pan. Remove them with a slotted spoon and drain on paper towels to soak up the excess oil. For the last 30 seconds, dip the sage leaves into the batter and fry them quickly on both sides. Add them to the zucchini flowers and serve immediately with lemon wedges and a small scattering of salt.

Serves 3

5 TABLESPOONS BUTTER
8 ANCHOVY FILLETS IN OIL, *drained*
GRATED ZEST AND JUICE OF HALF A LEMON
1 TABLESPOON DRAINED GREEN
 PEPPERCORNS *in brine, coarsely crushed*
1/2 (16-OUNCE) PACKAGE SPAGHETTINI
GRATED PARMESAN CHEESE, *to serve*

SPAGHETTINI WITH PEPPERCORNS, ANCHOVIES, AND LEMON

You can be quite versatile with this pasta, adding more of one ingredient, less of another. And you could easily introduce another flavor, such as tuna, diced tomato, a fresh herb like basil, or a dash of cream. I like this pasta with freshly grated Parmesan, but you may decide to serve it without.

Put about 3 1/2 tablespoons of the butter with the anchovies in a small saucepan over low heat. When they are hot, break up and mash the anchovies with a wooden spoon. Add the lemon zest, juice, and peppercorns, and heat through. Remove from the heat.

Cook the pasta in boiling salted water, following the package instructions. Drain it but reserve some of the cooking water. Toss the pasta with the sauce and the remaining butter. Add a little of the cooking water to make the sauce coat the pasta thoroughly and serve immediately with Parmesan.

Serves 6

1¹/4 POUNDS (ABOUT 30 SPEARS) FRESH ASPARAGUS,
 trimmed of the woody ends
1 TABLESPOON OLIVE OIL
3 TABLESPOONS BUTTER
¹/2 SMALL ONION, *roughly chopped*
2 GARLIC CLOVES, *roughly chopped*
A COUPLE OF THYME OR MARJORAM SPRIGS
¹/2 CUP WHITE WINE
³/4 POUND SMALL PEELED RAW SHRIMP
2 TABLESPOONS BRANDY
1 (16-OUNCE) PACKAGE LINGUINI
GRATED PARMESAN CHEESE, *to serve*

LINGUINI WITH ASPARAGUS AND SHRIMP

This has to be eaten as soon as it is ready. It won't do well sitting around waiting for you: the pasta will absorb all the sauce and the whole thing will become too dry. Some broad beans would also be beautiful, cooked until soft and then added to the asparagus purée. Use good-quality brandy.

Boil the asparagus spears in salted water for 4 to 5 minutes, or until they are cooked but still slightly firm. Drain them but reserve the water. If the ends of the asparagus are still hard and woody, cut these away. Cut off the asparagus tips (if they are large, cut them in half lengthwise) and set them aside. Roughly chop the remaining asparagus.

Heat the oil and half the butter in a saucepan. Sauté the onion until it is softened, then add the garlic, the chopped asparagus (not the tips), and thyme. Sauté gently for about 5 minutes and then add the wine. Simmer until the wine has thickened at the bottom of the pan and then add about 1³/4 cups of the reserved asparagus water. Simmer over quite high heat for a few minutes, then remove from the heat. Remove the thyme and purée the rest until smooth. Transfer to a large, warm bowl and add the asparagus tips. Season to taste.

Wipe out the saucepan, melt the rest of the butter over high heat and, when it is sizzling, add the shrimp. Cook for a couple of minutes, until the shrimp are opaque and darkened on the outside. Sprinkle with salt and pepper, then add the brandy and ignite or let it burn itself out. Remove from the heat and add to the asparagus. Cook the pasta in boiling salted water, following the package instructions. Drain it but reserve some of the cooking water. Mix the pasta and sauce in the bowl or in the saucepan if it will all fit. If it seems to need more liquid, add a little of the cooking water. There may seem to be a lot of sauce, but you will find the pasta absorbs it. Serve immediately, sprinkled with Parmesan and black pepper.

Serves 4

JUICE OF HALF A LEMON
2 ARTICHOKES
4 TO 6 CUPS HOT VEGETABLE BROTH
3 TABLESPOONS OLIVE OIL
2 TABLESPOONS BUTTER, PLUS 1 TEASPOON
1 SMALL ONION, *finely chopped*
2 BY 3 OUNCES ITALIAN SAUSAGES, *skin removed and meat crumbled*
2 GARLIC CLOVES, *lightly crushed*
A COUPLE OF THYME *or* TARRAGON SPRIGS
1^1/4 CUPS ARBORIO RICE
1/4 CUP GRATED PARMESAN CHEESE, *plus extra to serve*

RISOTTO WITH ARTICHOKES AND ITALIAN SAUSAGE

It is simple to throw together a broth — just put some water on to boil with a carrot and onion, celery, and peppercorns. Add a bit more water than the recipe calls for and boil it for at least half an hour. A broth adds depth to a risotto; however, you can also use water.

Fill a bowl with cold water and add the lemon juice. Trim the artichokes of their tough outer leaves. Chop off about a third of the top spear. Cut off the stem, leaving about about 1 inch. Trim away the dark outer stem. Cut the artichokes in half vertically and scrape out the chokes. Slice each one into 8 or 9 thin slices and put them in the lemon water.

Put the vegetable broth or water in a saucepan, cover, and bring to a simmer. Keep at the simmering point while you make the risotto.

Heat the olive oil with the teaspoon of butter in a wide, heavy-bottomed saucepan or a skillet with high sides. Sauté the onion until golden and then add the crumbled sausage. Continue cooking until golden, stirring often so it doesn't stick. Add the garlic, drained artichokes, and the sprigs of thyme or tarragon. Sauté until the artichokes are slightly softened and lightly golden.

Add the rice to the pan, stir well, and season with salt and pepper. Add about 1 cup of the hot broth or water, decrease the heat to a simmer, and cook, stirring often, until almost all the liquid has evaporated. Add more liquid and continue cooking, stirring regularly and adding more liquid as it is absorbed, for about 20 minutes, or until the rice is tender. The risotto should still have some liquid and the rice grains should be firm yet soft and creamy. Stir in the butter and cheese and serve immediately with extra Parmesan.

Serves 6

3 TABLESPOONS OLIVE OIL
2 SMALL FRENCH SHALLOTS, *finely chopped*
2^1/2 CUPS ARBORIO *or* CARNAROLI RICE
2^3/4 CUPS CHAMPAGNE
1/2 CUP GRATED PARMESAN CHEESE,
 plus extra, for serving
2/3 CUP GRATED UNSMOKED SCARMOZA
 or CACCIOTTA CHEESE, *grated*
3 TABLESPOONS BUTTER

CHAMPAGNE
RISOTTO

This is elegant, delicate, and so simple, and I think would beautifully precede a main course broiled fish. People may appreciate smaller portions here, so it could serve even more. You could add an extra ingredient — a couple of shelled shrimps or some asparagus — but I actually like the almost startling honesty of just Champagne. I have also seen a whisked egg yolk incorporated into the risotto at the last moment. It is not necessary to use the best Champagne; you could also use prosecco. You will need just a couple of cupfuls for the risotto, so you can have a glass yourself while you are stirring and definitely serve it with a glass or two as well. Scarmoza and cacciotta are types of dry mozzarella cheese.

Heat the oil in a large heavy-bottomed saucepan with high sides. Sauté the shallots gently for 5 minutes, until they are softened and slightly golden. Add the rice and cook, stirring, for 30 seconds or so, until it is well coated with the oil. Add 1^1/3 cups of Champagne, stir, and let the rice absorb it before you add one ladleful of hot water. When it has been absorbed, add another ladleful, stirring continuously to prevent the risotto's sticking. Continue cooking the risotto in this way, making sure the water is absorbed before the next ladleful is added. After about 20 minutes you should have added about 4 cups of water. Add salt to taste.

When the rice has absorbed all the water, add the remaining Champagne. Stir well and then stir in the Parmesan, scarmoza, and butter. Taste for salt again and serve immediately, with freshly ground black pepper and extra grated Parmesan.

Serves 6

ABOUT 2 3/4 POUNDS SMALL FRESH SARDINES
1 LARGE HANDFUL WILD FENNEL *or*
 BABY FENNEL FRONDS
3 SLICES WHITE BREAD, *crusts removed*
3/4 CUP OLIVE OIL
1 (16-OUNCE) PACKAGE LINGUINI
2 GARLIC CLOVES, *lightly crushed with the flat*
 of a knife
1 SCALLION, *white part only, finely sliced*

PASTA WITH SARDINES AND WILD FENNEL

This is lovely and quite delicate in its simplicity. It will make six filling portions. Use small sardines, up to about 5 inches long and around 1 ounce each. If you like a stronger taste, you could also add a few mashed-up anchovies. You will need a large handful of beautiful soft wild fennel here.

Fillet each sardine by cutting off the head and making a slit along the underside with a small, sharp knife. Remove the guts, then remove the central bone by pulling it away by the tail with one hand while holding the sardine with the other. You will be left with two attached fillets.

Remove any tough stalks from the fennel, leaving them in wisps or breaking them up if they are very long.

Crumble the bread into coarse crumbs. Heat 3 tablespoons of the olive oil in a nonstick skillet and fry the crumbs until they are deep golden and crisp. Transfer to a small bowl. Cook the pasta in a large pan of boiling salted water, following the package instructions.

Heat the remaining olive oil in a large nonstick skillet. Add the garlic, fennel, and spring onion, and sauté for a few seconds to flavor the oil, then add the sardines. Continue to cook for a few minutes over a high heat, flipping them around in the pan but taking care not to break them up. Cook for a couple of minutes until the fish are just opaque. Remove from the heat, until your pasta is ready.

Drain the pasta but reserve a cup or so of the cooking water. Add the pasta to the skillet if it fits; if not, transfer the pasta and sardines to a large bowl and carefully toss together, adding some of the pasta cooking water if necessary. Serve immediately with a small handful of bread crumbs and a grinding of black pepper over each bowl.

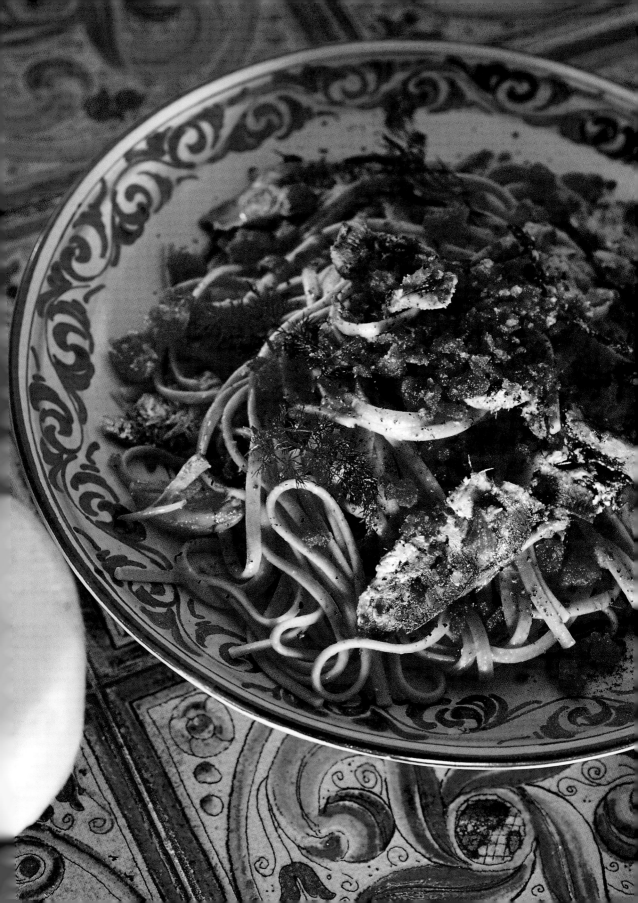

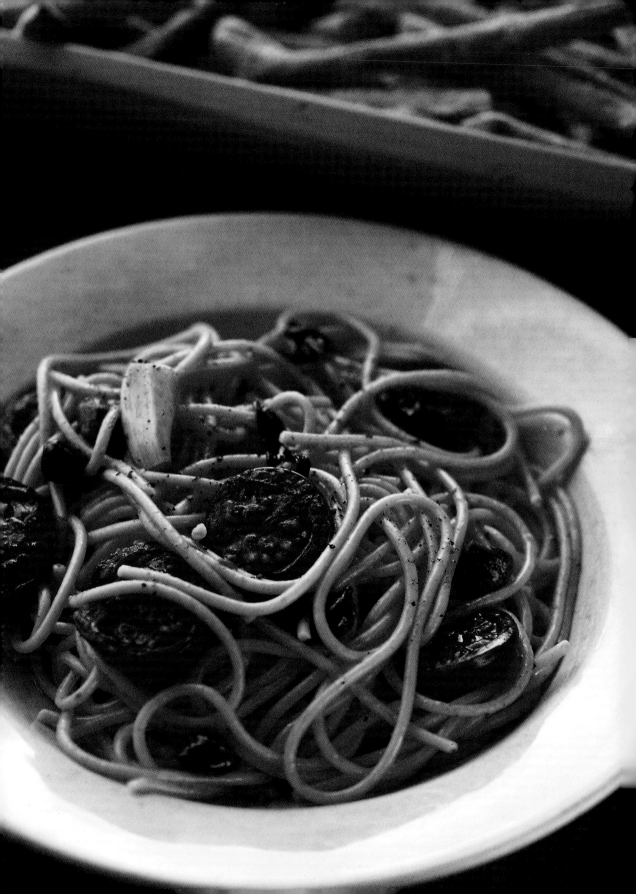

Serves 3

12 RIPE CHERRY TOMATOES, *halved*
ABOUT 30 BABY SALTED CAPERS, *rinsed and squeezed dry*
$^1/_2$ CUP EXTRA-VIRGIN OLIVE OIL
2 GARLIC CLOVES, *lightly crushed with the flat of a knife*
ABOUT 8 FRESH BASIL LEAVES, *torn*
$^3/_4$ (16-OUNCE) PACKAGE SPAGHETTI

DANIELE'S TOMATO PASTA

Fresh tomato pasta is always good and very quick to prepare. Of course, you will need beautiful tomatoes as they won't be disguised by any cooking. You might like to try this with a pinch of chile as well.

Put all the ingredients except the spaghetti in a bowl and season with salt and pepper. Set aside for at least an hour if possible, to let the flavors mingle. Cook the spaghetti in a large pan of boiling salted water, following the package directions. Drain and add to the tomato sauce, tossing well to coat the pasta. Serve immediately, with or without grated Parmesan.

Giovanni's very soul is Italian. He loves a deep plate of pasta; says it puts him right. He taught our girls how to slurp spaghetti before they could even chew.

Serves 6

2¹/4 POUNDS (ABOUT 8) RIPE TOMATOES
4 TABLESPOONS OLIVE OIL
A FEW FRESH BASIL LEAVES
JUICE OF HALF A LEMON
2 GARLIC CLOVES, *lightly crushed*
1 (16-OUNCE) PACKAGE SPAGHETTI

FRANCO'S
TOMATO PASTA

Here is another version of an uncooked tomato sauce, which you can try in summer when tomatoes are at their very best.

Peel the tomatoes and cut them lengthwise into long, thin slices. Put in a bowl with the olive oil, basil, lemon juice, and garlic, and season with salt and pepper. If the tomatoes are at all bitter, you could sprinkle a teaspoon or so of sugar over them. Toss them around a bit, then cover and refrigerate for 3 or 4 hours.

Remove from the refrigerator to come back to room temperature and remove the garlic cloves. Cook the pasta in boiling salted water, following the package instructions. Drain well, toss with the tomatoes, add salt and pepper to taste, and serve immediately, perhaps with a little extra olive oil on top.

Serves 4

1½ POUNDS CALAMARI, *cleaned*
 (ABOUT 16 OUNCES *cleaned weight*)
4 TABLESPOONS OLIVE OIL
1 TABLESPOON CHOPPED FRESH PARSLEY
1 SMALL DRIED RED CHILE, *chopped*
3 GARLIC CLOVES, *crushed*
½ CUP WHITE WINE
1 TOMATO, *peeled and chopped*
1 CUP FISH BROTH OR WATER
4 CUPS FIRMLY PACKED SPINACH LEAVES, *chopped*
¾ (16-OUNCE) PACKAGE SPAGHETTI

JULIETTA'S PASTA WITH SPINACH AND CALAMARI

This is a Mediterranean combination that works well and you might even like to serve it with a drizzle of chile oil. The calamari and spinach is also very good served with rice, or on toasted bread. You can use octopus instead of the calamari.

Cut the calamari into small pieces of about 1 inch. Gently heat 3 tablespoons of the olive oil in a skillet. Add the calamari, parsley, chile, and two of the garlic cloves. Season with salt. Sauté over medium heat for 10 minutes or so, until the calamari is lightly golden.

Add the wine and, when that has evaporated, add the tomato and cook until reduced. Gradually add the fish broth or water, adding more as it is absorbed. Decrease the heat, cover the pan, and simmer for about 1 hour, topping up with a little water or broth as the liquid is absorbed.

Meanwhile, heat the remaining tablespoon of olive oil and garlic in another pan. Add the spinach and sauté until wilted. Remove from the heat and set aside.

About 10 minutes before the calamari is ready, add the spinach to the sauce and simmer, uncovered, for the last 10 minutes so that the flavors blend well. Check the seasoning.

Meanwhile, cook the pasta in boiling salted water, following the package instructions. Drain well but reserve a cupful of the cooking water.

Mix the pasta with the calamari, adding a little of the cooking water if you think it needs more liquid. Serve immediately with an extra drizzle of olive oil.

Makes 1 1/2 cups

2 GARLIC CLOVES
1/3 CUP SHELLED PISTACHIOS (ABOUT 3/4 CUP *with shells*)
3/4 SMALL HEAD *of* ARUGULA
1/2 CUP GRATED PARMESAN CHEESE
1 CUP OLIVE OIL

PISTACHIO AND RUCOLA PESTO

This is wonderful mixed through pasta. It has an interesting sharp-sweet flavor. Sometimes, I leave out the Parmesan (although you don't necessarily have to) and stir a few tablespoons through just-ready roast potatoes, then roast them for another five or ten minutes.

Crush the garlic finely with a little salt until it is almost a paste. Put the nuts in a blender and pulse into coarse bits. Add the arugula and continue to pulse until you have a crumbly, not-too-smooth paste. Scrape it out into a bowl, stir in the garlic, Parmesan, and oil, and mix well. Taste for seasoning — the arugula can be quite peppery and you may not need extra salt, either.

If you won't be using the pesto right away, or if you have some left over, store it covered with a thin layer of olive oil for up to five days in the refrigerator. Bring it to room temperature before stirring it into just-cooked pasta.

Makes 3 pizzas

1 (1-OUNCE) CAKE FRESH YEAST
1 TEASPOON THIN HONEY
4 CUPS ALL-PURPOSE FLOUR
A LITTLE OLIVE OIL
2 TEASPOONS SALT
1 (14-OUNCE) CAN TOMATOES, *roughly puréed*
OLIVE OIL, *to drizzle*

ham, artichoke, and mascarpone topping
¼ POUND PIZZA MOZZARELLA
 (well drained, if in liquid, and patted dry), roughly chopped
2 THIN SLICES HAM, *torn into pieces*
¼ (12-OUNCE) JAR ARTICHOKES IN OIL, *drained,*
 or FRESH ARTICHOKES, *(broiled, then marinated in*
 olive oil), thinly sliced
5 TEASPOONS MASCARPONE

pancetta and rosemary topping
¼ POUND PIZZA MOZZARELLA
 (well drained, if in liquid, and patted dry), coarsely chopped
2 OUNCES VERY THINLY SLICED PANCETTA
2 SMALL SPRIGS FRESH ROSEMARY

pepper, arugula, and avocado topping
ABOUT 4 PIECES ROASTED *or* FRIED RED
 PEPPERS (PAGE 155), *cut into chunks,*
 or bought from a delicatessen (ABOUT ¼ POUND *or* ⅔ CUP)
1 RIPE AVOCADO
JUICE OF HALF A SMALL LEMON
⅔ CUP FIRMLY PACKED ARUGULA LEAVES
10 BLACK OLIVES
TABASCO SAUCE OR CHILE OIL

PIZZA

 This is the method my friend Julia uses to make her pizza and I love
the puffy texture it achieves. If you prefer a very thin-crusted pizza, leave
the dough to rise in the bowl for the full time and not once it is shaped for
baking. As soon as you have shaped it in its pan, scatter on the toppings and
bake it immediately in the hottest oven possible. These pizzas will each
serve from three to six people. Or you could make all the dough, then make
one pizza and freeze the rest of the dough for another time. Here are my
pizzas with my three favorite toppings.

You will need 3 round pizza pans that are about 11 inches in diameter.

Crumble the yeast into a large bowl. Add the honey, 1½ cups warm water, and about 1¼ cups of the flour. Mix well with an electric mixer. Cover the bowl with a cloth and leave in a warm place for about 30 minutes, or until the yeast begins to activate. Add the remaining flour and 1 tablespoon olive oil and mix in (with the dough hook of the mixer or by hand) until the dough comes together. It may be necessary to add a drop more water or flour, but the dough should be soft and sticky, not dry. Add the salt and mix in thoroughly. Cover the dough and leave for about 10 minutes.

Lightly brush the pizza pans with olive oil. Gently extend one-third of the dough into each of the pans. Don't worry if it doesn't pull to the edge easily (it will become easier if you leave it for a bit). Leave uncovered for about 15 minutes and then work the dough with your hands, flattening it to the edge of the pizza pans. Cover and leave to rise in a warm place for about 1 to 1½ hours, or until the dough is nice and puffy.

Preheat the oven to 425°F or to its hottest temperature. Season the tomato with salt and spread thinly over the bases, leaving a very thin border around the edge. Divide the mozzarella between two of the pizza bases, reserving a little.

To make the ham, artichoke, and mascarpone topping, scatter ham pieces over one of the mozzarella-based pizzas. Scatter with artichokes and then with a little more mozzarella to prevent the ham from drying out. Dot the mascarpone over the top. Drizzle very lightly with good olive oil (or the oil from your artichokes).

To make the pancetta and rosemary topping, drape half the pancetta over the other mozzarella-based pizza and scatter with a little more mozzarella. Scatter the rosemary leaves over the top and drizzle lightly with olive oil.

To make the pepper, arugula, and avocado topping, scatter the pepper over the last pizza. The remaining toppings will be added once the base is cooked.

Bake the pizzas for 10 to 15 minutes (depending entirely on the heat of your oven), or until the top is golden in parts and the bottom is lightly golden and firm. The two mozzarella pizzas are now ready to serve.

To complete the pepper pizza, scoop out the avocado flesh and add the lemon juice. Season with salt and pepper. Dot the avocado over the pizza, scatter with the arugula, olives, a dash of Tabasco, and a drizzle of olive oil (if you are using chile oil, leave out the extra olive oil). Serve quickly, before the arugula looks tired.

Serves 6

2^{1}/$_{4}$ POUNDS SALT COD, *soaked in cold water for 2 days*
3 TABLESPOONS OLIVE OIL, *plus extra for shallow-frying*
4 RED ONIONS, *halved and thinly sliced*
2 TABLESPOONS BUTTER
3 GARLIC CLOVES, *crushed*
1 CUP WHITE WINE
2 (14-OUNCE) CANS CRUSHED TOMATOES
1/$_{2}$ CUP ALL-PURPOSE FLOUR

BACCALÀ WITH RED ONIONS

This is one of my mother-in-law's favorite ways of cooking baccalà. She is an amazing cook: the grandmother cook that I always look for. This is a strong dish, I think, and not one that draws indifference. The cooked onions alone would go beautifully in an omelette, added in at the last moment onto the just setting egg, and are also great on bread even without the baccalà. If you can, soak the salt cod under a dripping tap so the water is constantly changing. If you can't manage that, soak it for two days, changing the water regularly. You can taste a small piece of the fish to see how salty it still is and take care when you add extra salt to the sauce. This dish also works really well with tuna (obviously without the soaking beforehand).

Drain the fish well and cut into pieces about 1^{1}/$_{2}$ by 2^{1}/$_{2}$ inches. Pat dry with paper towels. Heat the olive oil in a large skillet and sauté the onions over medium heat for about 5 minutes, until they begin to soften. Decrease the heat and continue cooking for about 15 minutes, stirring often, until they are soft and richly colored, then add the butter.

Add the garlic and, when it has colored a bit, add the wine, season, and continue cooking until the wine has evaporated. Add the tomato and a little more salt and pepper, and simmer for about 5 minutes, until the tomato has softened a bit. The sauce shouldn't be too dry or too runny but just loose. Add a few drops of water if it seems dry, or cook for a little longer if it seems too runny.

Meanwhile, heat the extra olive oil in a nonstick skillet over medium heat. Put the flour on a plate and dust the pieces of fish. Fry the fish in batches for about 8 minutes, or until it is golden on both sides (let it form a bit of a crust before you turn it over, as it can be a bit crumbly). Put the cooked pieces on a plate lined with paper towels to absorb the oil.

Arrange the fish, skin side down, on top of the tomato and onions in the skillet and spoon a little of the sauce over it. Heat through for a few minutes, shaking the pan from side to side to distribute the sauce, rather than turning the fish over and breaking it up. Serve immediately with some bread and a side salad. Some people also like this dish at room temperature.

Serves 4

3 TABLESPOONS OLIVE OIL
1 GARLIC CLOVE, *lightly crushed with the flat of a knife*
1 (14-OUNCE) CAN TOMATOES, CHOPPED
2 TABLESPOONS CAPERS
1/4 CUP PITTED GREEN OLIVES, *chopped*
2 TABLESPOONS CHOPPEE FRESH
 ITALIAN PARSLEY
1/4 CUP ALL-PURPOSE FLOUR
8 RED MULLET FILLETS (ABOUT 1 OUNCE EACH),
 all bones removed but skin left on

TRIGLIE AL POMODORO (RED MULLET WITH TOMATOES)

This is also good served at room temperature as an antipasto. It doesn't need much else to accompany it as a main course; just bread or maybe some boiled potatoes and a salad. You can use capers in vinegar (just drain them first), or the salted ones, rinsed.

Put the olive oil and garlic in a large saucepan over medium heat. When you can smell the garlic, add the tomatoes and a little salt and cook for about 10 minutes, until the tomatoes have melted, adding about ½ cup of hot water toward the end of this time. Stir in the capers, olives, and parsley.

Meanwhile, sprinkle the flour onto a flat plate. Lightly pat the fish fillets in the flour, season with a little salt, and add to the tomato. Cook for about 8 minutes, turning them over once, until they are cooked. Check the seasoning and serve with black pepper and some bread.

Serves 2

1 TABLESPOON OLIVE OIL
1½ TABLESPOONS BUTTER, *plus an extra knob*
2 VEAL CHOPS, *about ⅝-inch thick*
6 FRESH SAGE LEAVES, *rinsed and dried*
1 GARLIC CLOVE, *crushed*
JUICE OF 1 SMALL LEMON
⅓ CUP MASCARPONE

PAN-FRIED VEAL CHOPS WITH LEMON, SAGE, AND MASCARPONE

One of my favorite chefs in the world, Angela Dwyer, taught me this recipe. I love lemon; I love veal, sage, and mascarpone; so it is unlikely that I wouldn't love the finished dish. You have to work quickly here so that the butter in the pan doesn't burn and the chops get nicely browned — so have everything ready before you start.

Heat the oil and butter in a large skillet. When it is sizzling, add the chops and cook over high heat, turning over when the underneath is golden. Now add the sage leaves and garlic and season the meat with salt and pepper. Add another knob of butter to the pan to prevent burning. Take out the sage leaves when they are crisp and move the garlic around (or take it out if it starts to look too dark). You might like to turn the meat onto its fat side with a pair of tongs so that the fat browns.

Add the lemon juice to the pan and swirl it around, then add the mascarpone. If the veal is cooked, transfer it to a serving plate while you finish the sauce. If you think the veal needs longer, then leave it in the pan. It should be golden brown on the outside and rosy pink, soft, but cooked through on the inside. Add about 3 tablespoons of water to the pan and scrape up all the bits that are stuck to the bottom. Cook for another couple of minutes, then pour the sauce over the veal and scatter with the crispy sage. Serve immediately with some bread for the sauce.

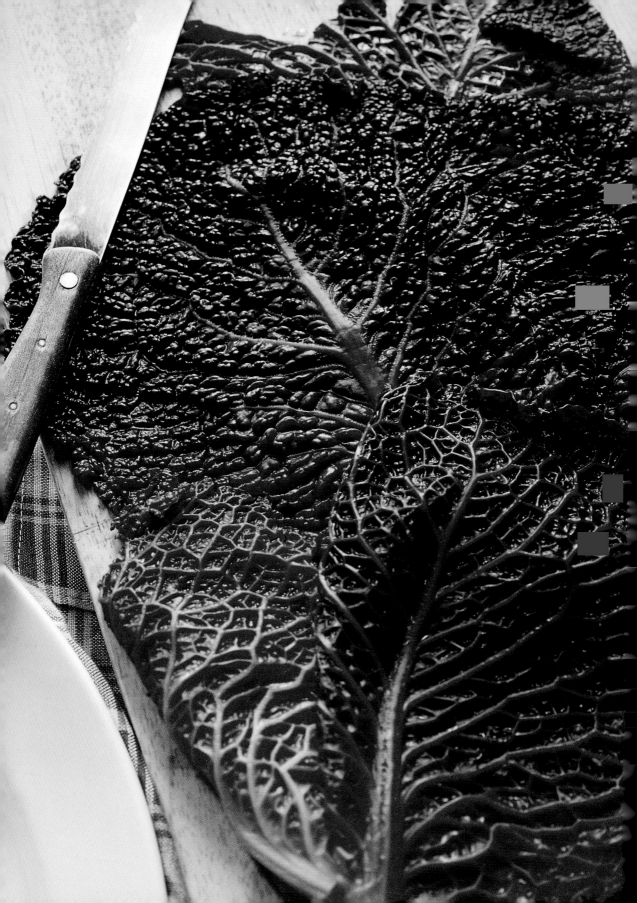

Serves 4 to 6

8 LARGE CABBAGE LEAVES *(savoy or Chinese)*
2 OUNCES CAUL FAT *(available from good butchers)*
5 TABLESPOONS OLIVE OIL
2³/4 POUNDS BONED LOIN OF VEAL *(keep the bone if possible)*
4 TABLESPOONS MILD MUSTARD *(grainy or smooth)*
8 THIN SLICES UNSMOKED PANCETTA
 or LARDO DI COLLONATA
2 CUPS WHITE WINE

VEAL LOIN WITH MUSTARD, PANCETTA, AND CABBAGE

This is a dish my sister-in-law Luisa taught me. It is a great dinner: it looks impressive but, once you've done the first bit of preparation and wrapped the meat up, you can just put it in the oven and not think about it too much. If you can find lardo di collonata then use that, otherwise pancetta is just fine.

Slice away the bottom third of the thick stem of the cabbage leaves so that they sit flat. Bring a saucepan of lightly salted water to a boil. Blanch the cabbage leaves for a couple of minutes to soften them (depending on their thickness). Drain and spread them out flat on a clean dish towel to cool.

Soak the caul fat in a bowl of warm water for 10 minutes or so. Drain, squeeze out the water, and carefully lay it down flat on the work surface. Keep it in one piece if possible; if not, in overlapping pieces.

Pour the olive oil into a rectangular ovenproof baking dish that can also be put on the stovetop. Put the dish on the stove over fairly high heat. Add the veal and brown on all sides. Remove the dish from the heat and cool the veal slightly. Transfer to a wooden board and season all over with salt and pepper. Spread the top with half the mustard.

Preheat your oven to 400°F. On a space next to the veal or on another board, arrange about four of the cabbage leaves, overlapping them to form a bed. Lay half of the pancetta strips next to each other on top to form a smaller layer over the cabbage. Put the veal, mustard side down, over the pancetta. Spread the top with mustard and then arrange the remaining pancetta over the veal loin, enclosing it like a neat wrapping. Put the remaining cabbage leaves over the top (or as many as you will need to enclose the veal), tucking them in neatly. Put the whole package onto the caul fat

and wrap it up securely so that it is completely enclosed in whichever way you see best. The caul fat will hold, but you can tie a bit of string around the meat just so that you can turn it around easily in the oven dish.

Put the meat back into the oil in the baking dish and add any bones to the dish. Bake in the oven for about 1½ hours. Halfway through cooking, when the bones have browned a bit, turn the meat over and add the wine. Continue cooking until the outside is browned.

Remove the meat from the dish, remove the string, and leave it for 10 minutes or so before slicing. Serve with the pan juices.

...so, I learnt to make the right bowl of pasta, the one Giovanni's very bones know, standing by his mamma's side. But I still love to go to her. With no effort or fuss at all, she runs the show in her soft and matriarchal manner, settling her four sons and chef husband into their places. Her real-life knowledge of the soups and sauces, her earth instinct and her lifetime behind her, have armed her. Her wooden spoon is her sword, defending and letting her rise, just like her olive oil bread, to every occasion.

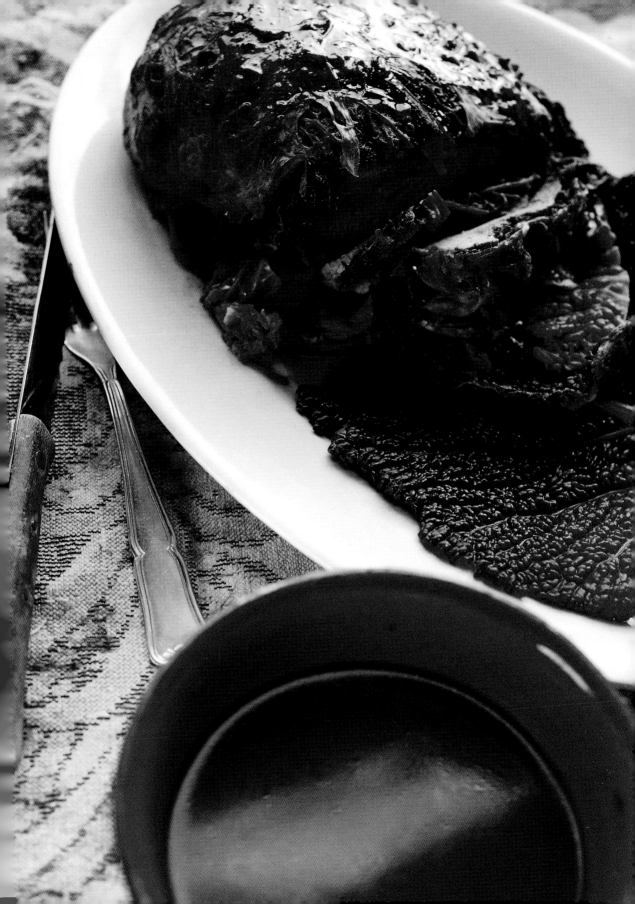

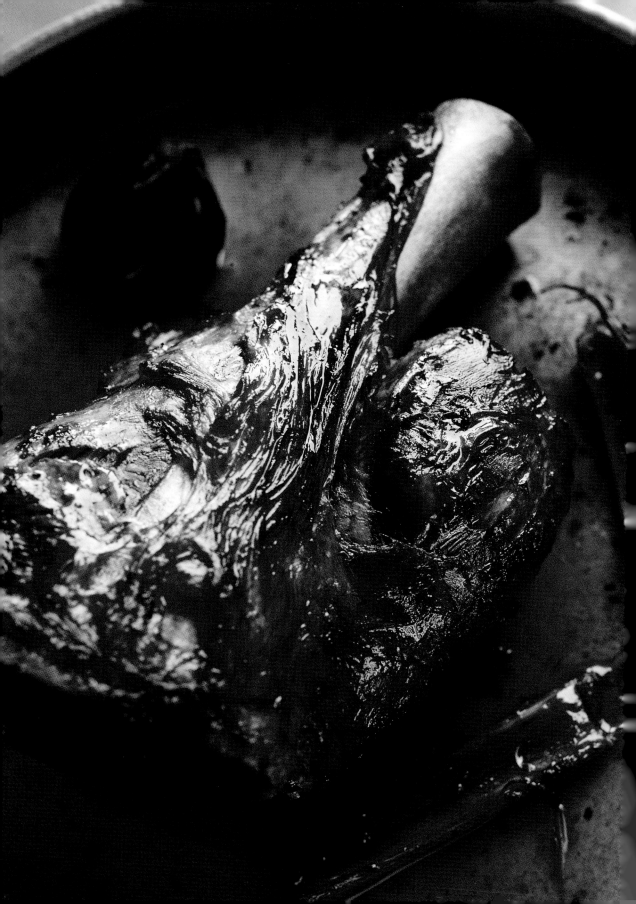

Serves 4 to 6

LEAVES FROM 1 *or* 2 ROSEMARY SPRIGS, *finely chopped*
6 FRESH SAGE LEAVES, *chopped*
LEAVES FROM 1 *or* 2 THYME SPRIGS, *chopped*
3 GARLIC CLOVES, *chopped*
4 POUNDS VEAL SHIN
4 TABLESPOONS OLIVE OIL
1 SMALL ONION, *cut into quarters*
1 CELERY STALK, *cut in half*
1 CARROT, *chopped*
2 CUPS WHITE WINE
2 TABLESPOONS BUTTER

STINCO DI VITELLO
(SHIN OF VEAL)

You could also add some other herbs instead of, or with, these and also a little finely grated lemon zest in the herb mix. Serve with cannellini bean purée (see page 322).

Preheat the oven to 425°F. Combine the rosemary, sage, thyme, and garlic in a bowl. Put the veal shin on a board and, with a sharp knife, make two small slits on the meaty side. Try to judge exactly where they would meet up on the other side of the veal and make a couple of slits there, too. Poke the knife through a bit to open up a canal, then take the handle of a wooden spoon and push it all the way through. Repeat with the other slit, to make a second canal. Push the herb garlic mix into these canals with the handle of the wooden spoon (the mixture will flavor the inside of the meat without burning during the long cooking).

Put the veal in an ovenproof dish and drizzle all over with the olive oil. Bake in the oven for about 20 minutes to brown on both sides. Remove and season the outside all over with salt and pepper. Add the vegetables and wine to the dish and return to the oven for about 15 minutes, or until it starts bubbling up. Cover the dish with foil, decrease the oven temperature to 350°F, and cook for another 2½ hours, or until it is very soft, turning the meat over a couple of times and basting. Remove the foil and cook for a little longer on each side to brown a little more, making sure it doesn't dry out. Transfer the meat to a serving dish. Put the oven dish directly over heat on top of the stove. Add the butter to the dish and scrape up any tasty-looking bits that are stuck to the bottom. Let it bubble up and reduce a bit to make a slightly thickened sauce.

Carve the meat away from the bone, then slice thickly into pieces or chunks. Serve with the vegetables and some pan juices drizzled over the top.

Serves 6 to 8 as a side dish

2 CUPS DRIED CANNELLINI BEANS,
soaked in cold water overnight
1 SMALL CARROT
1 SMALL CELERY STALK
1 SMALL ONION
3 or 4 FRESH SAGE LEAVES
½ CUP OLIVE OIL
1 GARLIC CLOVE, *lightly crushed with the flat of a knife*
2 SMALL SPRIGS OF ROSEMARY

CANNELLINI BEAN PURÉE

This is wonderful with the shin of veal but it could also be nice with a couple of pan-fried Italian sausages or grilled (broiled) lamb chops. Prepare it beforehand and warm it up quickly in a saucepan, stirring continuously so that it doesn't stick, then drizzle with oil to serve.

Drain the soaked beans and put them in a large saucepan. Cover with cold water and bring to a boil. Remove the scum that rises to the surface with a slotted spoon and decrease the heat slightly. Add the whole carrot, celery, onion, and sage leaves. Cook for about 1¼ hours, or until the beans are tender. Remove the beans from the heat and remove as much of the carrot, celery, onion, and sage bits as you can manage.

Meanwhile, put the olive oil in a saucepan with the garlic, rosemary sprigs, and some ground black pepper. Heat until the oil is well flavored and you can smell the garlic and rosemary, taking care that they don't burn. Let cool.

Drain the beans, reserving the water. Purée the beans and about ½ to 1 cup of the bean water in a blender or with a handheld mixer directly in the saucepan. You should have a very smooth, thick purée that is not too dense. If it seems to be too liquid, put it back over the heat in a saucepan to thicken a bit, stirring all the time. Season to taste and serve warm, drizzled with the flavored oil.

Serves 6 as a side dish

1¹/4 POUNDS (4 REGULAR STALKS) SWISS CHARD
1¹/4 POUNDS (10 CUPS) FIRMLY PACKED
 SPINACH LEAVES
1¹/4 POUNDS (10 CUPS) FIRMLY PACKED
 CHICORY LEAVES
3 TO 4 TABLESPOONS OLIVE OIL
1 SMALL CELERY STALK, *trimmed and chopped*
2 GARLIC CLOVES, *chopped*

SAUTÉED
MIXED GREENS

For me there is nothing like a healthy and simple plate of greens to serve with any broiled or roast meats. This is a recipe from Osteria, one of my favorite eating houses in Siena.

Bring a large saucepan of salted water to a boil. Wash and trim the Swiss chard, spinach, and chicory, and cook them for a few minutes in the boiling water. If they don't all fit, cook them in batches. Drain well and, when cooled slightly, chop them up.

Heat the oil in a large skillet over low heat and sauté the celery until it has softened. Add the garlic and, when you can smell it, add all the greens and a little salt and pepper if necessary. Sauté for a few minutes, mixing well so that all the flavors mingle nicely. Serve hot or at room temperature.

Serves 2

4 TEASPOONS GROUND ROASTED COFFEE
3 TEASPOONS SUPERFINE SUGAR
$^{1}/_{2}$ CUP HEAVY WHIPPING CREAM
$^{1}/_{2}$ TABLESPOON CONFECTIONERS' SUGAR
$^{1}/_{2}$ CUP WELL-CRUSHED ICE

COFFEE GRANITA WITH WHIPPED CREAM

I love the Italian way of serving coffee granita with a big dollop of fresh cream after a summer meal. You could even add some ground cardamom or cinnamon to your coffee for a slightly different flavor, and adjust the amount of sugar to your taste. You will need an Italian-style "moka" machine (three espressos capacity) or an espresso machine. I like to serve these in tall, tapered glasses.

Put $^{3}/_{4}$ cup of water in the bottom of your moka machine, put the top on, and pack in the coffee. Close the lid and put it on the stovetop to heat up. Alternatively, make three espressos. Pour the coffee into a small jug or a cup, stir in the sugar, and let it cool completely (you could even make it beforehand and keep it in the refrigerator).

Whip the cream with the confectioners' sugar until soft peaks form. Divide the ice between two glasses, pour the coffee over the ice, and top each with a couple of dollops of cream. Serve immediately.

Serves 12

1¹/₂ OUNCES (ABOUT 3 TO 4) AMARETTI
 COOKIES
6 JUICY BUT FIRM, RED PLUMS
ABOUT 3 TABLESPOONS BUTTER, CUBED
ABOUT 2 TABLESPOONS SUPERFINE SUGAR
3 TABLESPOONS VIN SANTO

mascarpone cream
1 CUP HEAVY WHIPPING CREAM
1¹/₄ CUPS MASCARPONE
2 TABLESPOONS CONFECTIONERS' SUGAR
1 TEASPOON VANILLA EXTRACT

BAKED AMARETTI
AND VIN SANTO PLUMS WITH
MASCARPONE CREAM

 I like to eat this when the plums are warm, and I sometimes have it with a slice of pandoro or panettone. If the season is right, you can use peaches or nectarines instead of the plums. Save any leftover amaretti crumbs to sprinkle over ice cream.

Preheat your oven to 400°F. Crush the amaretti cookies to coarse crumbs. Cut through the plums all the way around through to the pit. Hold the plum in your palm and twist the other half away so that it comes off smoothly. Sit the plums cut side up in a baking dish. Remove the pits with a teaspoon, twisting the teaspoon a little deeper than the natural cavity to make it a bit bigger and letting any juice drizzle into the baking dish.

Spoon a heap of amaretti crumbs over the plums, so they settle into the cavities and over the tops (keep any leftover). Dot a little butter over each plum top and scatter with sugar. Scatter the rest of the sugar and butter around the plums with the vin santo. Bake for 15 minutes, or until the liquid starts to get a bit of a caramel look, then add about ¹/₃ cup of hot water around the plums. Bake for another 15 minutes or so, until the tops are golden and crusty and the plums are soft but still in shape. Remove from the oven.

To make the mascarpone cream, whip the cream, mascarpone, sugar, and vanilla together until smooth and beautifully thick. Serve a plum half with a good spoonful of mascarpone cream and any pan juices drizzled over the top.

FERIAE MATRICULARUM MM
TEATRO DEI RINNOVATI

Nelle sere del 15-16-17 Maggio
il Princeps e la Balìa
presentano

"LA TARGA VOGLIO!"
ovvero
"Cresce solo nel giardino del Rettore..."

Operetta Goliardica in due atti, tre verbali e una targa

TTO
O IMPERATORE
CONQUISTATORE
CHE HA PIANTATO
IA PERPETRATO...
ONNIPOTENTE
SISTENTE
ANDARE
PE...

		IN BANCA
CARDI........ SEMPRE PIEND.....OZZO..... VITELLOZZO	BANC-O LIBERO.... NON PASSANO MAI GLI A	
ANDREASSI..... SE ERO FURBO.....PONE..... TONFOLO	BANC-ADATI........ PA LE FERIAE UN ALTRO POS	

R UN D TINO........................MORINO.... BANC-C.................GLI ANNI
DI LAUREAKSI NON SE LA SENTE.....BUBBA.... BANC-H................IL DIO DELLA
BANC-ONE..........IL GOLIARD
BANC-AROTTA......SEMPRE STREG
BANC-ARIO..........PER DA

FATE TUTTI COCCODÉ........BOCCALONE PRENCE
ALLE SCENE FACCIO UN FIGLIO.....EMILIO
SÌ, ORA TROMBO, MA DOVE.........BRODO
UN CASCO SO DIVENTATO..........BIRIELO
TRA DUE FETTE DI PANE...........SALAME
SENZA SCUOLE CHE PAREI.........AGNUSDEI
DELLA MENS SANA...............BRADIPO
DALLA SÙ CITTA PARECCHIO.......V VECCHIO

AME
MIGAR
BALCUL
ASPIDE
EUNUCO
ECONOMO
VICE-ECONOM
ADDETT ALL

SO' MATTO E NEMME........MITINO
LA BALI NO, GRAZI.........NOTTO
TTE SEMP.........DIRO
AL P LA PANC.........CIUL

di sa
con la

Il capite
sentirsi

E ESAMI E CE L
ME PIACE IL
SE T

UN TOR NELL

ONDE

ELLA

DLA

Serves 8 to 10

7 TABLESPOONS BUTTER, *slightly softened*
1/3 CUP SUPERFINE SUGAR
1 1/4 CUPS ALL-PURPOSE FLOUR
1/4 CUP UNSWEETENED COCOA POWDER
1 EGG, *beaten*

filling
3 EGGS, *beaten*
2/3 CUP SUPERFINE SUGAR
1 HEAPED TEASPOON FINELY GRATED
 ORANGE ZEST
3 CUPS SMOOTH RICOTTA CHEESE
1 TABLESPOON LEMON JUICE
2 TABLESPOONS ORANGE JUICE

RICOTTA TART
WITH A CHOCOLATE CRUST

This is a typical southern combination of flavors: ricotta, the burstingly ripe oranges and, every Italian's obsession, chocolate. It is quite simple to make, so don't be intimidated by the thought of the pastry crust. If it seems too soft, just add more flour as you're rolling it, then lift it over your rolling pin and gently lower it into the pan. If it breaks, just patchwork it in.

To make the pastry base, use a food processor to mix together the butter and sugar until pale and creamy. Sift in the flour and cocoa and then beat in the egg to make a nice soft pastry. Scrape out onto plastic wrap, flatten into a disk, and wrap up. Refrigerate for about an hour.

Preheat your oven to 350°F. Roll out the pastry on a lightly floured work surface until large enough to line a 9 1/2-inch removable-bottomed tart pan or springform cake pan with high sides. Line the pastry with parchment paper and baking beans or uncooked rice and bake for about 20 minutes. Remove the paper and beans and bake for a further 5 minutes to slightly dry the base.

For the filling, whisk together the eggs and sugar until thick and creamy. Whisk in the orange rind and ricotta until smooth. Whisk in the lemon and orange juice and scrape into your pastry case. Bake for 30 to 40 minutes, or until the top seems set and is lightly golden here and there. Let cool before cutting into portions. This can be served slightly warm, at room temperature, or even cold from the refrigerator.

Serves 12

2 CUPS HEAVY WHIPPING CREAM
6 EGGS, *separated*
1 CUP SUPERFINE SUGAR
ABOUT $^{1}/_{2}$ CUP MARSALA
1 LONG ESPRESSO COFFEE ($^{1}/_{4}$ CUP)
$^{1}/_{4}$ CUP BITTERSWEET CHOCOLATE, *coarsely grated or chopped*

ZABAGLIONE SEMIFREDDO

You might like to serve this with a few cookies on the side (you can even use a firm cookie rather like a spoon, to scoop up the semifreddo). Don't be discouraged as you are whipping the eggs: they will become very thick and fluffy eventually. The bowl you whip the egg yolks in must sit comfortably over the pot of simmering water. You can make this in 12 individual pudding dishes that are freezer suitable or one large loaf mold.

Whip the cream until it is very thick, ribbony, and almost buttery looking. Put it in the refrigerator for now and wash your beaters. Put the egg whites in a large bowl and set aside for now.

Put the egg yolks in a wide, heatproof bowl. Add the sugar, Marsala, and coffee, and whisk together well. Half-fill a saucepan with water and bring to a boil, then decrease the heat to very low and sit the bowl over the simmering water. The water must not touch the bottom of the bowl, so pour out a little bit if necessary. Start whisking and continue until the zabaglione is very thick and ribbony and looks almost like marshmallow. It should cling to your whisk as you work. (The egg on the side of the bowl may start to look like scrambling as it gets close to ready, so just keep whisking this back in well.) Remove from the heat and let cool for a bit, mixing now and then.

Whip the egg whites to very fluffy stiff peaks and gently fold the slightly cooled zabaglione into the egg whites. Then fold in the cream with a large metal spoon. Hold the bowl firmly with one hand and fold with the other in long sweeping circles to incorporate all the cream, egg whites, and zabaglione smoothly, without deflating the texture.

With the large spoon, dollop the mixture into twelve $^{1}/_{4}$-cup pudding dishes or ramekins so that they are very full and peaking over the rims. Or spoon it into one large serving dish that is suitable for the freezer. Put straight into the freezer and freeze for a few hours before serving. Serve either directly from the dishes, with a scattering of chocolate over the top, or spoon out with a large tablespoon in one swift scoop. Either way, the zabaglione should be taken out of the freezer 5 to 10 minutes before serving so that it is not rock hard.

SUITCASE OF RECIPES

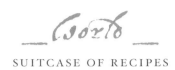

SUITCASE OF RECIPES

Souvenirs and memories from my travels are all around me. I remember struggling back with an overweight iron tortilla machine, fabrics that I had bartered off certain beaches, and spices and wooden boxes that now hold my ingredients. And always there would be pages of recipes flapping everywhere, flavors and tastes hastily jotted down while sandwiched between rows of people and ingredients at markets. Beautiful spices that I might never use but had to have, and some songs that crocheted all these memories together.

My diaries held my memories when I wanted to record the atmosphere and my feelings — walking along sand and smelling vanilla tea and oranges; eyeing street vendors selling a slice of their souls; and longing to know every last drop of what that Mexican had folded in my meat, lime, mayonnaise, lettuce, and chile torta. Always squeezing out the last details from people; from those families that interested me, sitting around their tables for hours and just watching. I could excuse myself, blaming lack of language for irrelevant questions. I would come home, luggage fat to bursting on the conveyor belt, anxious to unwrap my memories. I found this recharges my soul, and longed to return to those moments when my bare feet played with the sand under the table and my tongue danced with chile and ginger.

Serves 4

1^1/$_2$-INCH PIECE OF GALANGAL *or* GINGER, *peeled and sliced*
SMALL BUNCH FRESH CILANTRO WITH ROOTS
4 MAKRUT LEAVES, *torn*
1 STEM LEMONGRASS, *halved lengthwise*
3 TABLESPOONS FISH SAUCE
JUICE OF 2 SMALL LIMES
1^3/$_4$ CUPS COCONUT MILK
1/$_2$ POUND SKINLESS CHICKEN BREAST, *cut into thin strips*
1 RED CHILE, *seeded and sliced*

TOM KA GAI
(THAI CHICKEN SOUP WITH COCONUT MILK, LIME, AND CILANTRO)

I just wouldn't cope with not knowing how to make some version of this soup. I love it. You can add a few mushrooms, a couple of fresh spinach leaves, or some slices of zucchini in with the chicken. Also wonderful instead of the chicken is to cook some large, shelled shrimp on a barbecue or grill pan and toss them into the soup just before serving. The fish sauce is the salt in this soup so adjust the quantities according to your taste (and the same with the chile). I like it not too strong. Keep the cilantro stems in your freezer to add flavor to a broth or stew.

Put the galangal, cilantro roots, lime leaves, lemongrass, and 4 cups of water in a saucepan and bring to a boil. Add the fish sauce and lime juice, decrease the heat, and simmer for 10 minutes. Remove the cilantro roots. Add the coconut milk, bring back to a boil, and boil for a couple of minutes. Add the chicken pieces and cook for just a minute or so, until the chicken is soft and milky looking and cooked through. Throw in the chile and mix well. Serve in bowls with the cilantro leaves roughly chopped and scattered over the top.

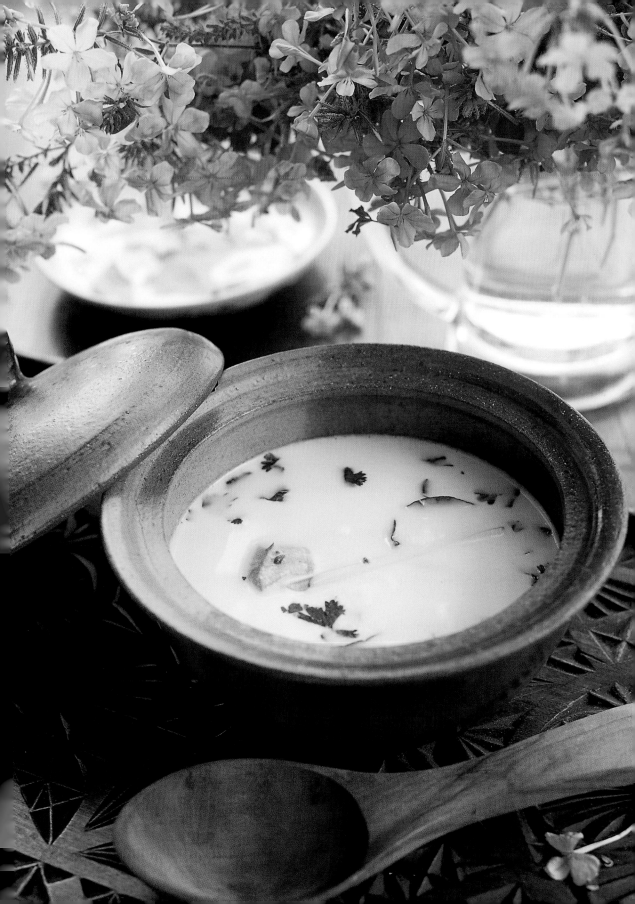

Serves 4 to 6

1 1/4 POUNDS SKINNED SALMON FILLET
JUICE OF 4 LIMES
2 *or* 3 RED CHILES, *seeded and finely chopped*
2 TABLESPOONS CHOPPED FRESH CILANTRO
1/4 TEASPOON GROUND CUMIN
2 GARLIC CLOVES, *very finely chopped*
1 1/2-INCH PIECE OF GINGER, *peeled and grated*

SALMON CEVICHE WITH CILANTRO, CHILI, AND LIME

This is a wonderful dish of my friend Ana's that, thank goodness, has managed to grace our table many times. If you love every single ingredient that goes into something, how can you not love the finished dish? Changing quantities here is very simple: just add more of anything you like. You could also add a little olive oil if you are not using an oily fish such as salmon. Ana says ceviche is often eaten in Peru, using all kinds of fish: you can try shrimp, squid, mussels, oysters, and just about any other fish fillet. This could be served with some firm green leaves and sliced red onions as a salad or with boiled potatoes. It would serve six as an antipasto or four as a salad or light main meal. Ceviche should be prepared at least four hours before you want to eat, to allow the flavors to mingle well and for the fish to "cook" in the lime juice. It is even good the next day.

Remove any bones from the salmon (you can check for bones by stroking the salmon up and down). Slice it into pieces about 1/2-inch thick and put in a wide, nonreactive bowl.

Pour the lime juice, chile, cilantro, cumin, and garlic over the fish and season with salt and pepper. Take the grated ginger between your fingers and firmly squeeze the juice over the salmon (discard the pulp that's left). Mix gently, cover with plastic wrap, and refrigerate for at least 4 hours before serving.

Serves 4

4 RED PEPPERS, *cut in half lengthwise and seeds removed*
2 TABLESPOONS OLIVE OIL
2 GARLIC CLOVES, *lightly crushed with the flat of a knife*
1 SMALL RED ONION, *sliced*
4 RIPE TOMATOES, *peeled and chopped,*
 or 1 (14-OUNCE) CAN TOMATOES, *chopped*
1^{1}/$_{4}$ CUPS PLAIN GREEK YOGURT
1/$_{3}$ CUP PITTED BLACK OLIVES, *roughly chopped*
FINELY GRATED ZEST OF 1 LEMON
LEAVES FROM 2 ROSEMARY SPRIGS, *finely chopped*

RED PEPPER SOUP
WITH OLIVES, LEMON ZEST, AND YOGURT

You can add any flavors you like to the base of this soup. Here, I use fresh rosemary and serve the soup with a yogurt, black olive, and lemon flavor. You might like to use another herb like fresh basil with a swirl of cream, or try adding a good kick of chile oil to serve. You could even add a drop of truffle oil and a couple of broiled shrimp. Serve with or without the yogurt.

Preheat the broiler to high. Line a large baking sheet with foil and arrange the peppers, skin side up, in a single layer. Broil for about 30 minutes, until the skin has darkened in places and swelled up and the peppers are soft. You might need to move them around on the sheet so they are evenly broiled or remove the halves that are blackened and leave some in for longer.

Transfer the peppers to a bowl, cover with plastic wrap (or put in a plastic bag and seal) and let sweat for 10 minutes to make peeling easier. Peel off the skin.

Heat the olive oil in a large saucepan and sauté the garlic and onion for about 5 minutes. Add the tomato and cook until it begins to bubble. Add the pepper halves, tearing them into large chunks as you put them in the pan. Season with salt and pepper. Add 3 cups of water and bring to a boil, then lower the heat, cover the pan, and simmer gently for about 30 minutes. Remove from the heat and purée. The soup should be fairly thick: if it seems too watery, simmer uncovered for a while longer. If it seems too thick, add a little more water.

Check the seasoning and serve the soup hot with a dollop of yogurt and a sprinkling of chopped olives, lemon zest, and rosemary.

Serves 6

1²/3 CUPS COUSCOUS
ABOUT 1 CUP OVEN-ROASTED TOMATOES (PAGE 288),
 halved or quartered if large, plus their oil
1 SMALL CUCUMBER, *unpeeled and diced*
4 SCALLIONS, *chopped*
¹/2 CUP CHOPPED FRESH MINT LEAVES
3 TABLESPOONS LEMON JUICE
¹/3 CUP OLIVE OIL
1 CUP GOAT'S CHEESE (*soft or a little harder*), *crumbled*

COUSCOUS
SALAD

The original version of this salad also uses broken-up pieces of pita bread: this is a Middle Eastern variation. The oven-roasted tomatoes are wonderful here (make them a day or so in advance, so they flavor the oil nicely) and you can vary the ingredients with different cheeses or herbs from time to time. This works very well served with yogurt-marinated lamb. The dressing is light and not overpowering, so if you are serving the salad on its own, you could add a little extra lemon juice and olive oil.

Put the couscous in a large bowl and season well with salt and pepper. Add a splash of the oil from your oven-roasted tomatoes and 2 cups of just-boiled water. Stir, cover, and let cool completely, fluffing it up gently now and then, so that the bottom does not become a stiff pudding.

Add the cucumber, scallion, mint, and lemon juice to the couscous. Add the tomatoes and the rest of their oil, topping up with the extra olive oil if you don't have enough from the tomatoes, and stir well. Add the goat's cheese and stir in carefully, especially if it is soft.

Serves 6

dressing
2 SOFT ROSEMARY SPRIGS, *rinsed*
2 GARLIC CLOVES
8 OIL-PACKED ANCHOVY FILLETS, *drained and chopped*
1 HEAPED TABLESPOON DIJON MUSTARD
2 TABLESPOONS LEMON JUICE
1/2 CUP VEGETABLE OIL
1/2 CUP OLIVE OIL
2 EGGS, *at room temperature*

salad
1 FENNEL BULB, *halved and very finely sliced*
1/4 POUND (ABOUT 4 CUPS LOOSELY PACKED) RADICCHIO
 or TREVISE LEAVES, *torn into large chunks*
1/2 POUND (ABOUT 10 CUPS LOOSELY PACKED) FIRM INNER
 LETTUCE LEAVES
2 CELERY STALKS, *finely sliced*

CODDLED
EGG AND ANCHOVY
SALAD

This is how my friend Jo makes her salad. She is an exceptional cook, full of enthusiasm and fun. She says she also likes this dressing with warm asparagus, broad beans, and peas. I find it also goes well with olives and fresh raw vegetables for dunking into the sauce, or just with a plain steak and some fat fries for dipping. This will make a couple of cups of dressing that you can use as you like.

Bring about 3 cups of salted water to a boil and dunk the rosemary and garlic in the water a few times to soften them slightly. Strip the rosemary leaves off the stem and chop very finely with the garlic. Put in a bowl.

Whisk in the anchovies, mustard, and lemon juice, a few grindings of black pepper, and a little of each of the oils. Whisk well until it all comes together, a bit like mayonnaise.

Meanwhile, lower the eggs into the boiling water and boil for 3 minutes. (To be perfect, all of the white and a fine layer of yolk should be set; the rest of the yolk should be soft.) Rinse under cold water until cool enough to peel. Add to the dressing, whisking to break the eggs into small bits. Add the rest of the oil, whisking continuously until completely combined. Whisk in a teaspoonful of warm water to finish the dressing.

Put all the salad ingredients in a large bowl. Splash the dressing over the top, tossing well so that all the leaves carry a heavy coat of dressing, and serve immediately.

Serves 6

2 RED ONIONS, *chopped*
2 TEASPOONS SALT
5 TABLESPOONS OLIVE OIL
2 LARGE GARLIC CLOVES (*1 chopped, the other
 left whole*)
1 LARGE RIPE TOMATO, *peeled and chopped*
2²/₃ CUPS BROWN LENTILS
3³/₄ CUPS UNCOOKED LONG-GRAIN RICE
JUICE OF 1¹/₂ LEMONS
1 SMALL RED CHILE, *seeded and finely chopped*
²/₃ CUP PLAIN GREEK YOGURT

LENTILS,
RICE, AND RED ONION
SALAD

 This is more or less what they make in Peru: I have just added the yogurt.
The red onion salad gives the lentils such a lift and is also very good served
with broiled foods. I love this after it has been marinating for a few hours,
even overnight, and has taken on a special fuchsia tone.

Rinse the onions and drain in a fine sieve. Reserve about a quarter and put the rest in a bowl.
Cover with cold water, sprinkle with the salt, and set aside for 30 minutes or so.

Heat 3 tablespoons of the oil in a saucepan. Add the handful of onion and the chopped garlic
and sauté until golden. Add the tomato and season lightly with salt and pepper. Cook for
5 to 10 minutes, until the tomato has melted and the water evaporated and you can see the
oil actually frying. Remove from the heat and set aside.

Rinse the lentils and pick out any hard bits. Put the lentils in a saucepan and cover with cold
water. Bring to a boil over high heat. Drain, then return to the saucepan. Add about 6 cups
of hot water and season with salt. Bring back to a boil, then lower the heat slightly and cook,
uncovered, for about 20 minutes. Add the tomato mixture and cook for another 10 minutes or
so, until the lentils are soft but not mushy and there is not much liquid left. Stir occasionally
to make sure they don't stick to the pan. If it seems like the lentils are drying out, add a little
more hot water.

Heat 1 tablespoon of oil in a saucepan and add the whole clove of garlic. Add the rice, season with salt, mix well, and cook for a minute. Add enough water to come about about 1 inch above the top of the rice and bring to a boil, stirring once. Cook, uncovered, for 3 to 4 minutes, until a lot of the water seems to have evaporated and there are some holes on the surface. Drizzle with a tablespoon of oil, cover the pan, and decrease the heat to a minimum. Cook for about 15 minutes, or until the rice is dry and steaming, then fluff it up with a fork to make sure it hasn't stuck to the pan. Remove from the heat and leave the lid on if you are not eating immediately.

Drain and rinse the soaked onion in a fine sieve. Mix with the lemon juice and chile and a splash of olive oil, and season with salt and a little pepper. Arrange a pile of lentils, a pile of rice, a small pile of onion salad, and a dollop of yogurt on each plate — some people will eat them separately while others like to stir it all together on the plate.

You can add to, change, mix up, or use
a recipe exactly as it is, but the way you put it
on the plate and give it away is yours.

Serves 6

1 TEASPOON GROUND CORIANDER
1 TEASPOON GROUND CUMIN
A PINCH OF GRATED NUTMEG
$^1/_2$ TEASPOON GROUND CARDAMOM
4 CLOVES
1 BAY LEAF
1 HEAPED TABLESPOON GARAM MASALA
A PINCH OF FRESHLY GROUND BLACK PEPPER
$^1/_2$ CUP VEGETABLE OIL
2$^3/_4$ POUNDS BONED AND SKINNED CHICKEN
 THIGHS, *cut into bite-size pieces*
2 ONIONS, *chopped*
$^1/_2$ CUP DESICCATED COCONUT
$^1/_2$ CUP ROASTED, UNSALTED CASHEW
 NUTS, *cut in half*
1 CUP PLAIN GREEK YOGURT

CHICKEN, COCONUT, AND CASHEW NUT CURRY

This recipe belongs to my friend Maria. She is a fantastic cook and has a real love for ethnic food.

Heat a large nonstick saucepan over high heat. Add the coriander, cumin, nutmeg, cardamom, cloves, bay leaf, garam masala, and black pepper. Stir-fry for about a minute, or until you can really smell the spices. Pour out of the pan onto a plate and set aside.

Heat the oil in the saucepan and brown the chicken with the onions. Add the spice mixture and stir until you can smell the perfume, making sure it doesn't stick. Season with salt. Add the coconut and 2 cups of water and bring to a boil.

Decrease the heat, cover, and simmer for about 30 minutes, stirring now and then. Add the cashews and cook for another 10 minutes or so. If it seems like the curry needs more liquid, add a little more hot water. You should have a thick sauce. Stir in the yogurt, turn the heat down to minimum, and simmer for a minute or so, without allowing it to boil. Serve with rice with butter and lemon, and the carrot and cardamom salad (pages 356–57).

Serves 4 to 6

²/₃ CUP OLIVE OIL
1 (3-POUND) WHOLE CHICKEN, *cut into 8 portions*
A SMALL BUNCH OF FRESH CILANTRO
2 CUPS FIRMLY PACKED SPINACH LEAVES
2 GARLIC CLOVES, *chopped*
2 CARROTS, *diced*
¹/₂ RED PEPPER, *seeded and diced*
¹/₃ CUP FRESH *or* FROZEN PEAS
1 TEASPOON CAYENNE PEPPER *or strong paprika*
2¹/₄ CUPS SHORT-GRAIN RICE
CHILES IN OIL, (PAGE 160), *to serve*

spiced yogurt
1 CUP PLAIN GREEK YOGURT
1 TEASPOON GROUND CUMIN
2 TEASPOONS OLIVE OIL

CHICKEN
WITH CILANTRO
AND SPINACH RICE

This is another of my friend Ana's recipes. It is a little like a Peruvian pilaf. When we made it for the first time in Italy, after just one mouthful her husband had a look on his face as if he had found something. The Peruvians were all nodding and clucking in agreement that there was enough of this and that...there could have been more of this...but that it was just right. Just the way they knew and had grown up with. I added the spiced yogurt and even Ana thought it was a good addition. Leave out the chile oil if you are feeding children.

Heat half the olive oil in a large heavy-bottomed pan and fry the chicken until it is browned and crusty on all sides and just about cooked. Remove from the heat and discard the oil from the pan.

Break off the cilantro leaves from the stems (freeze the stems for later use) and purée in a small food processor with the spinach and ¹/₂ cup of water.

Heat the remaining oil in the same pan and add the garlic. When you begin to smell it, add the carrots, pepper, and peas. Sauté for 5 minutes to soften, then add the cayenne pepper and mix well. Add the cilantro and spinach purée and cook for a couple of minutes before adding the chicken. Season with salt and pepper. Sauté for a minute to mix the flavors and then add 3 cups of water. Bring to a boil, then cover, decrease the heat to medium, and cook for about 15 minutes for the chicken to absorb all the flavors.

Remove the chicken to a plate and add the rice to the pan, together with 2 cups of hot water (or enough to cover the rice by about $1^{1}/4$ inches). Cook, uncovered, for 5 or 10 minutes, or until the rice seems to have absorbed most of the water. Decrease the heat to an absolute minimum, cover, and cook for about 15 minutes, or until the rice is cooked. Stir only a couple of times during cooking, so that it doesn't stick. Check the seasoning. If you are not serving immediately, cook the rice for a little less time, then turn it off and leave covered for 5 or 10 minutes to steam.

To make the spiced yogurt, mix together the yogurt, cumin, and olive oil, and season with salt and pepper.

Pile the rice on a large serving platter. Arrange the chicken on the rice and each person can add a dollop of spiced yogurt and a drizzling of chile oil to their own serving. Serve hot or at room temperature.

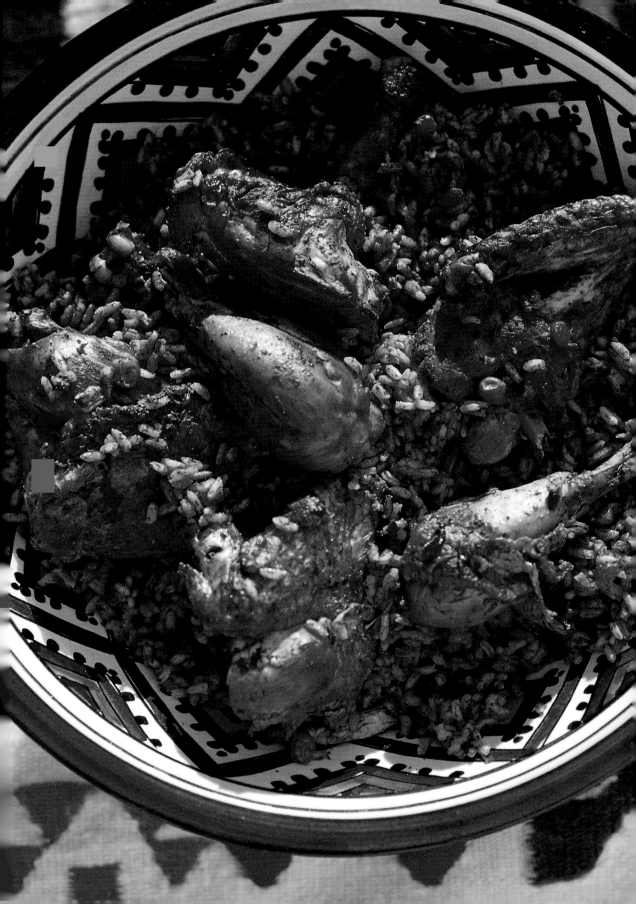

Serves 6 as a side dish

2½ TO 3 TABLESPOONS BUTTER
1 LONG STRIP OF LEMON ZEST
2 CUPS UNCOOKED BASMATI RICE

RICE
WITH BUTTER AND
LEMON

Put the butter, lemon zest, a pinch of salt, and 4 cups water in a saucepan. Bring to a boil and boil for a couple of minutes. Rinse the rice a few times with cold water, drain, and add to the pan. Stir through once and then leave the rice. When it comes back to the boil, decrease the heat to a high simmer, and cook for 10 minutes, uncovered, until the rice seems dry and there are lots of holes in the surface. Don't stir the rice at all. Remove from the heat, fluff up from the bottom upward with a fork, and transfer gently to your serving bowl.

Take care with the quality of your ingredients. If you love them from the very beginning, even the taste of the butter alone, then chances are you'll love the way they show up in your food.

Serves 6 as a side dish

1¹/4 POUNDS (ABOUT 8 MEDIUM) CARROTS
¹/2 RED ONION, *finely chopped*
JUICE OF 2 LEMONS
²/3 CUP OLIVE OIL
2 TEASPOONS SALT
1 TEASPOON SUGAR
A PINCH OF WHITE PEPPER
1¹/4-INCH PIECE OF GINGER, *finely chopped or grated*
¹/2 TEASPOON GROUND CARDAMOM
A SMALL HANDFUL OF FRESH MINT LEAVES,
 to serve

CARROT SALAD
WITH CARDAMOM, GINGER, AND LEMON

I tasted this at the house of my mother's friend, Iria. She is Finnish, but she picked up the recipe in India and it is certainly a salad that works well with spicy food. Make sure you use very fresh, young sweet carrots.

Put the carrots in a blender and pulse into small pieces (not too fine as you need to keep some texture). Transfer to a bowl, add the onion, and mix together well.

To make the dressing, whisk together the lemon juice, oil, salt, sugar, white pepper, ginger, and cardamom. Add to the carrots and onion, toss well, and then chill for a few hours. Toss in a few mint leaves before serving.

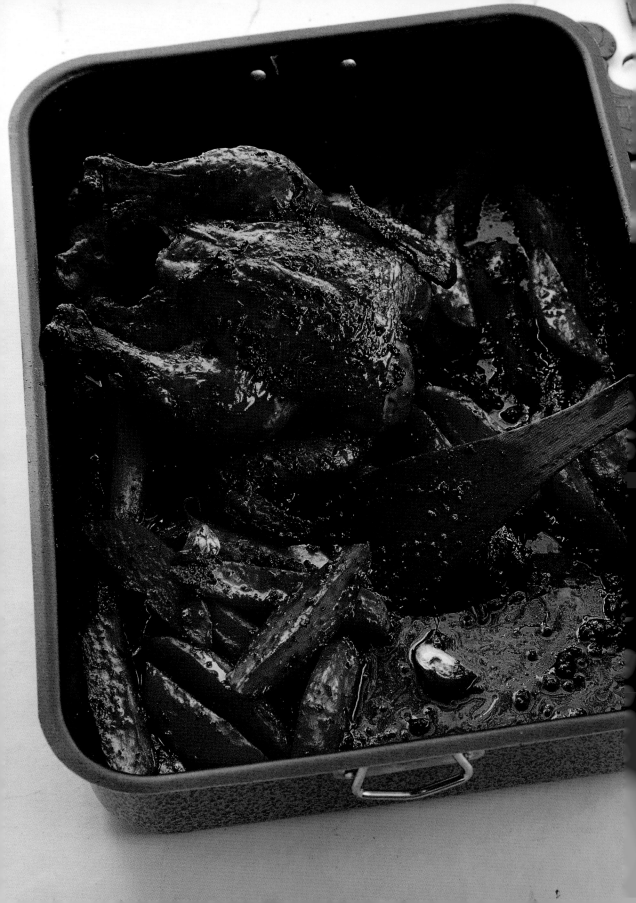

Serves 4

4 *or* 5 LARGE POTATOES, *peeled*
2 HEAPED TABLESPOONS GRAINY MUSTARD
JUICE OF 2 LEMONS *(but save the squeezed lemon halves)*
1 TABLESPOON DRIED OREGANO
 or THYME, *crumbled*
4 TABLESPOONS OLIVE OIL
1 (3-POUND) WHOLE CHICKEN
2 RED ONIONS, *peeled and cut into wedges*
2 BAY LEAVES
6 GARLIC CLOVES, *with their skin left on*
$^1/_2$ CUP WHITE WINE

LUDI'S CHICKEN

This is my sister Tanja's recipe. Ludi is a nickname: she calls me Ludi, and I call her Ludi (our children often look puzzled). This dish just seems to work for all ages and however many people happen to end up eating. You can even serve it at room temperature and the potatoes still end up tasting good — which is not a common thing for roast potatoes, really.

Preheat the oven to 350°F. Halve the potatoes lengthwise and then cut them into three or four pieces so that they look like giant fries.

Mix together the mustard, lemon juice, oregano, and olive oil to make a marinade. Put the chicken, potatoes, onion wedges, bay leaves, and 4 garlic cloves in a large oven dish. Season the potatoes and chicken (outside and in the cavity) with salt and pepper. Put two of the squeezed lemon halves and the remaining garlic in the chicken cavity. Splash the marinade over the chicken and potatoes, tossing them around with your hands so they are well coated. Gently pour a cup of water into the dish (trying not to wash away the marinade). Roast for about 1 hour.

After an hour the top of the chicken should be getting brown. Pour the wine over the top, turn the potatoes and onions, and roast for another hour, turning the chicken when it is well browned on top. Check that the potatoes are still in a little liquid — if they look dry, add a little more hot water.

The chicken should be golden brown, juicy, and cooked through. If it seems done but you think the potatoes might need longer, remove the chicken to a warmed serving platter. The potatoes, however, should not be crispy but golden and juicy, and there should be a little sauce in the dish to serve with the chicken. If it is dry, add some hot water to the dish and scrape the bits from the bottom and sides to make more sauce. Serve hot or even at room temperature.

Serves 2

1¹/₂ STICKS BUTTER, *slightly softened*
2 SMALL FRENCH SHALLOTS, *chopped*
1 TABLESPOON BRANDY
¹/₄ CUP GREEN PEPPERCORNS IN BRINE, *rinsed*
OIL, *for brushing*
2 (6-OUNCE) FILLET STEAKS

PEPPER STEAK

I love pepper steak and this version is simple, elegant and always good. You could try it sometimes with cream — you will need to heat up some of the pepper butter in a saucepan, add a splash of cream, let it all bubble up, and then pour this over your hot steak. If you like your meat well done, use two thinner pieces so that they don't burn in the pan (they need to sear quickly so that the outside is darkly lined and the inside remains pinky, with enough juice to mingle with the pepper butter).

Melt about 3¹/₂ tablespoons of the butter in a small saucepan and add the shallots. Cook over low heat for a few minutes, until the shallots are golden and softened. Stir almost continuously so that the butter doesn't burn. Add the brandy and cook until it evaporates. Remove the pan from the heat and let cool.

Put the peppercorns in a small blender with the cooled shallots and pan juices and use the pulse button to coarsely chop. If the quantity is too small for your machine, you can chop by hand or add a bit of the remaining butter to the blender. Transfer to a small bowl and work in the rest of the butter. Put onto parchment paper and roll up into a log, twisting the ends of the paper like a candy wrapper. You can freeze it at this point, refrigerate until you are ready, or keep it at room temperature if you're going to be using it soon.

Heat a grill pan to very hot, lightly brush with oil, and then add the steaks. Cook them for a couple of minutes on each side (this will depend on the heat of your pan and the thickness of the meat). Transfer to a plate, sprinkle with a little salt, and then serve immediately with a good tablespoon of pepper butter melting over the top.

Serves 4

1½ CUPS PLAIN YOGURT (*not too thick, not too thin*)
3 GARLIC CLOVES, *very finely crushed*
1 TEASPOON GROUND ALLSPICE
1 TEASPOON GROUND CARDAMOM
1 TEASPOON SWEET PAPRIKA
1 TEASPOON GROUND CORIANDER
1 TEASPOON GROUND CUMIN
1 TEASPOON SALT
½ TEASPOON GROUND BLACK PEPPER
3 POUNDS LEG OF LAMB ON THE BONE,
 trimmed of fat
4 TABLESPOONS OLIVE OIL
3 SPRING SCALLIONS, *chopped*
2 TEASPOONS FINELY CHOPPED FRESH GINGER
A LARGE HANDFUL OF FRESH CILANTRO LEAVES,
 roughly chopped
JUICE OF 1½ LIMES
DASH OF CHOPPED RED CHILES IN OIL (*PAGE 160*)

CORINNE'S LAMB WITH SPRING ONION, GINGER, AND CILANTRO RELISH

You can buy these spices whole and grind them fresh yourself each time, or use them ready-ground. The lamb is best marinated for as long as you can manage, even overnight, and then cooked in a hot oven (or you could use a really hot broiler). This is good served with saffron rice or a plain butter pilaf.

Put the yogurt in a bowl and stir in the garlic, allspice, cardamom, paprika, coriander, cumin, salt, and pepper.

Put the lamb in a container where it will fit compactly and pour the marinade over the top, turning the lamb and patting the marinade all over it with your hands. Cover and let marinate overnight or even longer in the refrigerator.

Bring the lamb to room temperature for about 30 minutes before you want to cook it. Preheat the oven to 400°F. Line a baking sheet with aluminum foil (to make cleaning up easier) and fit it with a rack. Shake the lamb out of the marinade and put it on the rack so the bottom doesn't touch the baking sheet. Cook for about an hour, turning once, until the lamb is deep golden and a firm crust has formed. If, when you turn the lamb over, some of the marinade has come away, then brush on some more. The lamb should be cooked through inside.

Meanwhile, heat half the olive oil in a small saucepan. Gently sauté the spring onions until they are very lightly golden, then add about 3 tablespoons of water and cook for another few minutes, until the water has reduced and the onions are soft and dry. Remove from the heat, stir in the ginger, and let cool. Transfer to a serving bowl and stir in the cilantro, lime juice, remaining olive oil, and a dash of chiles in oil, then season with salt.

Let the lamb stand for at least 10 minutes before carving. Serve with a spoonful of the spring onion, ginger, and cilantro relish alongside.

We had Marimekko bedcovers and sheets, and gorgeous bright colors in our tablecloths and handwoven floor rugs. We drank mainly from Itaala glasses and ate cooked-for-hours Greek lamb.

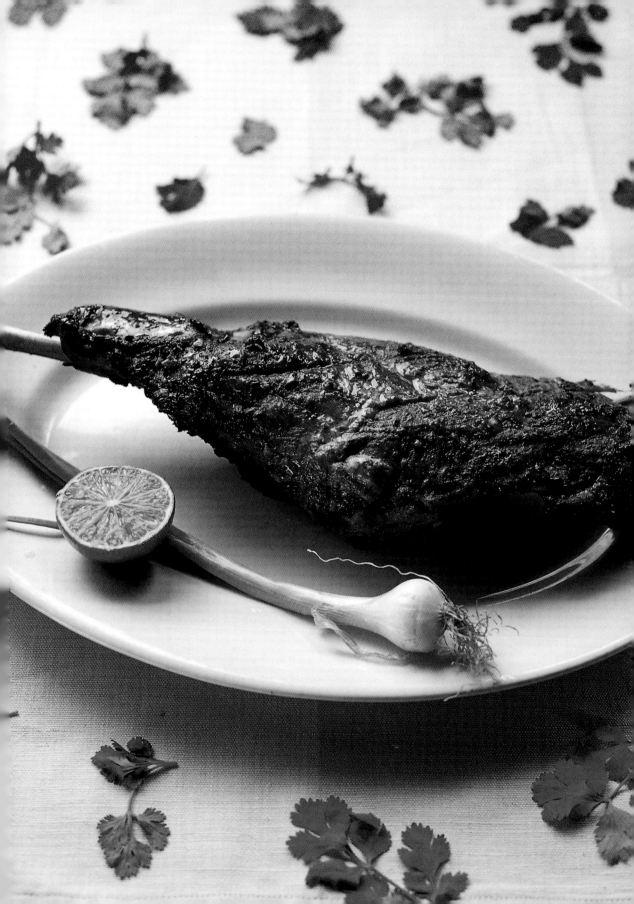

Serves 8 to 10

2 CUPS SUGAR
4 CUPS MILK
1 TEASPOON VANILLA EXTRACT
6 EGGS

CRÈME CARAMEL

I have always loved this effortless dessert. It doesn't scream for attention, and its lightness and gentle caramel flavor need no extra decoration.

Preheat the oven to 310°F. To make the caramel, put 1 cup of the sugar and a few drops of water in a heavy-bottomed saucepan over high heat. As soon as the side starts to color, decrease the heat and swirl the pan around to distribute the heat. Watch the sugar closely as it can burn in a second.

When the caramel is deep gold, remove it from the heat and immediately pour it into a 9½-inch cake or tube pan, or into 8 or 10 small ramekins. Holding the pan with a cloth, swirl it around to quickly spread the caramel all over the base and a little up the side. Take care as it sets quickly. Set the pan aside while you make the custard.

Heat the milk in a saucepan until almost boiling, then remove from the heat. Whisk together the vanilla, eggs, and the rest of the sugar in a large bowl. Add a ladleful of the hot milk to the eggs to acclimatize them, and whisk to prevent them from cooking. Slowly add the rest of the milk to the eggs, trying not to make them too frothy.

Strain the custard carefully into a large pitcher and then pour onto the caramel. Put the cake pan in a deep baking dish and carefully pour enough boiling water into the dish to come halfway up the side of the pan. Bake for 50 to 60 minutes in the center of the oven, until the top is golden in parts, quite set but still a little wobbly. Remove from the oven and from the water bath, and let cool. Cover with plastic wrap and refrigerate for at least a few hours (or overnight) before serving.

Gently loosen the side of the crème caramel with the back of a spoon or your fingers. Put a large serving dish (with a slight rim to contain the caramel juice) upside down over your pudding. Holding the plate and cake pan firmly with your fingers, carefully and quickly flip them over, so that the plate is the right way up and the pudding plops gently down with the caramel sauce. Serve thick slices with the caramel spooned over.

Serves 6

1 SCANT CUP MILK
1 CUP COARSELY CHOPPED SEMISWEET
 CHOCOLATE
1 TEASPOON VANILLA EXTRACT
2 EGGS, *separated*
2½ TABLESPOONS SUPERFINE SUGAR
1 SCANT CUP HEAVY WHIPPING CREAM

BAKED CHOCOLATE PUDDINGS

These are rich and delicious yet not too heavy, and I think they are best served straight from the fridge. You will need six individual ovenproof saucepans or ramekins of 5 fluid ounce capacity.

Preheat the oven to 400°F. Put the milk and chocolate in a saucepan and heat until completely melted. Stir often so that the chocolate doesn't stick. Add the vanilla.

Whip the egg whites in a small, clean bowl, until fluffy peaks form. Set them aside (you could put them in the refrigerator) and work quickly so the whites don't deflate. In a separate bowl, whisk the yolks and sugar until combined. Whisk in a ladleful of the chocolate milk so that the eggs don't scramble, and then add the rest in a slow, steady stream, whisking continuously. Whisk in the cream. Fold in the egg whites and spoon into six ovenproof ramekins.

Sit the ramekins in a deep baking dish. Carefully pour enough boiling water into the dish to come halfway up the side of the ramekins. Bake for 25 to 30 minutes, or until the puddings are slightly crusty on the surface. Remove from the water bath and let cool. Serve warm, or refrigerate and serve cold with cream or a very light dusting of confectioners' sugar.

Serves 8

7 TABLESPOONS BUTTER, *plus extra for greasing*
1/2 CUP SUPERFINE SUGAR
3/4 CUP COARSELY CHOPPED SEMISWEET
 CHOCOLATE
3 EGGS, *separated*
1 TEASPOON VANILLA EXTRACT
1 1/2 TABLESPOONS ALL-PURPOSE FLOUR, *plus extra*
 for dusting
1/3 CUP FINELY GROUND HAZELNUTS

hot chocolate
1 1/2 CUPS HEAVY WHIPPING CREAM
3/4 CUP COARSELY CHOPPED SEMISWEET
 CHOCOLATE

CHOCOLATE
TRUFFLE TART WITH
HOT CHOCOLATE

Serve this in small portions: it is enough for eight people and is just on the right side of richness in a tiny slice. On its own it is gorgeous with a pile of fresh fruit and another pile of crème fraîche. If you prefer a frosting to the little espresso cups of wintery hot chocolate, then melt 2/3 cup of cream with 1 cup of chocolate and pour over the cooled cake.

Preheat the oven to 350°F. Butter and flour an 8-inch springform cake pan. Melt the butter in a small saucepan over low heat. Add the sugar and chocolate and stir until the chocolate melts and the sugar dissolves. Remove from the heat and scrape into a mixing bowl. Let cool for about 30 minutes. Add the egg yolks and vanilla and whisk in well with an electric mixer. Sift in the flour and whisk until well combined, then fold in the hazelnuts.

Whip the egg whites until very fluffy and then fold in the chocolate mixture a spoonful at a time. Scrape the mixture into the cake pan and bake for about 35 minutes, or until a skewer inserted in the center comes out clean and the cake feels firm and is a little cracked on the top. Let cool for at least 15 minutes or so before you remove it from the pan.

To make the hot chocolate, put the cream in a saucepan and bring to a boil. Add the chocolate, stirring until it is thick and smooth and the chocolate has completely melted. Pour into espresso cups and serve with little wedges of cake.

Serves 10

1/2 POUND SEMISWEET CHOCOLATE
1/2 POUND PLUS 2 TABLESPOONS BUTTER
1/2 CUP SUPERFINE SUGAR
5 EGGS
SCANT 1/2 CUP BRANDY
1 1/4 CUP ALL-PURPOSE FLOUR
1 TABLESPOON BAKING POWDER

syrup
1 CUP GRANULATED SUGAR

MOIST
CHOCOLATE
CAKE

This can be served all on its own with a cup of coffee, or more dressed up as a Black Forest type of dessert with a pile of fresh fruit such as cherries, raspberries, or clementines and a dollop of whipped cream or crème fraîche.

Preheat your oven to 350°F. Butter and flour a 10 1/2-inch cake pan. Melt the chocolate with the butter and sugar in a heatproof bowl set over a saucepan of barely simmering water, making sure that the bowl isn't touching the water. Stir until the chocolate has melted and then remove from the heat to cool a little.

Whip the eggs in a large bowl until they have fluffed up well. Slowly pour in the melted chocolate mixture, whisking until it is all incorporated. Whisk in the brandy. Sift in the flour, baking powder, and a pinch of salt, and then whisk in well until there are no lumps of flour. Scrape out the mixture into the cake pan and bake for about 45 minutes, until a skewer inserted into the center comes out clean and the top is firm and a bit crusty. Remove from the oven and make a few holes in the top with a skewer.

While the cake is baking, make a syrup by boiling the sugar with 1 1/4 cups of water for about 5 minutes, until it has thickened. Set aside to cool. Pour the cooled syrup evenly over the cooled cake (don't miss out the dome of the cake if it is slightly rounded from baking). The cake will absorb the syrup and remain soft and moist. Invert the cake onto a flat plate before serving.

Serves 8 to 10

2¼ POUNDS (8 CUPS) BERRIES
1 CUP SUPERFINE SUGAR
1 (16-OUNCE) DAY OLD WHITE LOAF
1 CUP HEAVY WHIPPING CREAM
2 TABLESPOONS CONFECTIONERS' SUGAR
1 TEASPOON VANILLA EXTRACT
1¼ CUPS MASCARPONE

SUMMER PUDDING

You can use one single type of berries — raspberries, blackberries, black currants, red currants — depending on what you like and what's in season. If you use frozen berries, leave them out for a while to thaw before you start. I like this with a mascarpone cream, but you could also serve it with crème fraîche, vanilla ice cream, or ordinary whipped cream.

Put the berries and superfine sugar in a large saucepan with ½ cup of water and heat gently for 2 minutes. Remove from the heat. Pour off the juice and set aside. (Taste for sweetness and, if you prefer your berries a bit sweeter, add a little more sugar.)

Cut the crusts from the bread and cut the bread horizontally into slices about ¼ inch thick. Dip the bread in the berry juice and then line the base and side of an 8-cup straight-sided bowl. You can patch here and there with the bread, so there are no spaces anywhere. Leave the bread tops sticking up for now. You should have a few slices of bread left over.

Spoon the berries into the bread-lined bowl and cover with the remaining bread to form a lid (make sure there are no gaps as this will be the bottom of your pudding). Drizzle more berry juice over the top so that there is no white bread anywhere to be seen, and trim away any bits of bread that are sticking up. Then find a plate that fits perfectly inside the rim of your bowl and sit it firmly on the bread lid. Find something fairly heavy (like a can of tomatoes) to put on top of the plate and then refrigerate overnight.

Just before serving, make the mascarpone cream. Whip the cream in a bowl with the confectioners' sugar and vanilla until it just starts to thicken. Whisk in the mascarpone to make a nice thick cream. Turn the pudding out onto a serving plate (if it won't come out easily, dip the base briefly in hot water) and serve in wedges with a dollop of cream. If you have any berry juice left over, drizzle it over the top.

Serves 8

2 CUPS ALL-PURPOSE FLOUR, *plus extra for dusting*
1/2 CUP GRANULATED SUGAR
2 TEASPOONS BAKING POWDER
1 STICK BUTTER, *softened, plus extra for greasing*
1 EGG
3/4 CUP MILK
1 TEASPOON VANILLA EXTRACT
1^1/2 CUPS HEAVY WHIPPING CREAM
2/3 CUP HOMEMADE JAM (*not too sweet*)
CONFECTIONERS' SUGAR, *to serve*

JAM
AND CREAM
SHORTCAKE

This is another cake that my mother makes often. It is delicious, honest, and quick and easy to make. It doesn't keep very well once it is filled so, if you won't be serving it immediately, keep the cake covered in plastic wrap once it has cooled and just cut it and spread with the jam and cream before serving. Use any flavor jam you like — just not too sweet. I love this with homemade quince and grape jam. If you don't have any jam, you could use fresh berries.

Preheat the oven to 375°F. Grease and flour a 9^1/2-inch springform cake pan.

Sift the flour into a bowl with the sugar, baking powder, and a pinch of salt. Add the butter and use an electric mixer or wooden spoon to quickly mix it together. Whisk the egg and milk together in a small bowl and add to the batter. Mix in quickly to incorporate it. You should have a soft, thick batter.

Pour the batter into the cake pan and bake for about 30 minutes, or until the cake is lightly golden. Remove from the oven and cool slightly, then remove from the cake pan and let cool completely.

Slice the cake in half horizontally. Slide the bottom half onto a serving plate. Whisk the vanilla into the cream so that it is quite stiff. Spread the jam over the bottom layer of cake and then carefully spread the cream over the jam. Cover with the top layer of the cake and dust with confectioners' sugar.

Serves 4 to 6

4 EGG YOLKS
1 TEASPOON VANILLA EXTRACT
1 CUP SWEETENED CONDENSED MILK
2 CUPS HEAVY WHIPPING CREAM

VANILLA ICE CREAM

This is not one of those nouvelle vanilla ice creams — it is dense, rich, and very country style, and is delicious alongside a buttery apple tart. I can always find a place for ice cream; I have even found that an ice cream actually makes me feel better after a heavy meal. Serve this on its own, with chocolate sauce or next to a piece of cake.

Whip the egg yolks with the vanilla until they are well fluffed up. Add the condensed milk and continue whisking until it is well incorporated.

Whip the cream in a separate bowl until it thickens and holds soft peaks. Scrape the yolk mix into the cream, whisking until it is well incorporated, and then cover and put the bowl in the freezer. After an hour, remove the bowl from the freezer, give an energetic whisk with a whisk or an electric mixer, and return to the freezer. Whisk again after another couple of hours. When it is nearly firm, give one last whisk, transfer to a suitable freezing container with a lid, and let it set in the freezer until it is firm.

Alternatively, pour the mixture into your ice-cream machine and freeze, following the manufacturer's instructions.

Remove the ice cream from the freezer 10 minutes or so before serving so that it is not too hard.

Makes 2 ¹/₂ cups

2 CUPS HEAVY WHIPPING CREAM
¹/₂ CUP BUTTERMILK
1 TABLESPOON LEMON JUICE

CRÈME
FRAÎCHE

Put all the ingredients in a saucepan and heat to 86°F. Leave in a warm place for 12 to 24 hours, loosely covered with a cloth, until it thickens. Refrigerate for at least 4 hours to chill and complete the thickening. Store in the fridge in an airtight container.

Serves 6

1 CUP MILK
1 CUP SUPERFINE SUGAR
1 TEASPOON VANILLA EXTRACT
1 TABLESPOON BRANDY *or* VIN SANTO
2¹/₂ CUPS CRÈME FRAÎCHE (SEE ABOVE)

CRÈME FRAÎCHE
ICE CREAM

This is beautiful on its own, with an apple tart or served alongside a chocolate cake or any fruit tart.

Put the milk in a small saucepan with the sugar. Heat until the sugar has completely dissolved and then remove from the heat. Transfer to a bowl and let cool completely. Stir in the vanilla and brandy and whisk in the crème fraîche. Cover and put the bowl in the freezer.

After an hour, remove the bowl from the freezer, give an energetic whisk with a whisk or an electric mixer, and return to the freezer. Whisk again after another couple of hours. When it is nearly firm, give one last whisk, transfer to a suitable freezing container with a lid, and let it set in the freezer until firm.

Alternatively, pour the mixture into your ice-cream machine and freeze, following the manufacturer's instructions.

Serves 6

2³⁄4 CUPS MILK
1¹⁄2 CUPS HEAVY WHIPPING CREAM
1 LEVEL TEASPOON GROUND CINNAMON
³⁄4 CUP THIN HONEY

MILK, HONEY, AND CINNAMON ICE CREAM

You could use a honey lightly flavored with lavender or eucalyptus that will show up in the taste of your ice cream, but just a plain thin honey will do. You might like to add a couple of egg yolks to the cream for some extra richness, but I love this wholesome and simple. Your ice cream may not freeze completely firm, depending on your choice of honey — instead it might have a lovely creamy texture.

Put the milk, cream, and cinnamon in a saucepan over low heat so that the flavors mingle. Stir in the honey and increase the heat until just coming to a boil. Remove from the heat and let cool. Transfer to a bowl, cover, and put in the freezer.

After an hour, remove the bowl from the freezer, give an energetic whisk with a whisk or an electric mixer, and return to the freezer. Whisk again after another couple of hours. When it is nearly firm, give one last whisk, transfer to a suitable freezing container with a lid, and let it set in the freezer until it is firm (depending on the type of honey you use, your ice cream may not freeze completely solid).

Alternatively, pour the mixture into your ice-cream machine and freeze, following the manufacturer's instructions.

Serves 4

1 CUP HEAVY WHIPPING CREAM
1 CUP MILK
1^1/$_4$ CUPS SUPERFINE SUGAR
GRATED ZEST OF 1 LEMON
JUICE OF 2 SMALL LEMONS
PULP OF 6 FRESH PASSION FRUIT

PASSION FRUIT
ICE CREAM

This is my friend Carl's recipe. He is an excellent cook and likes to serve this with crisp, deep-fried, sugar-dusted pastry ribbons. This is one of my favorite favorites.

Put the cream, milk, and sugar in a bowl and stir until dissolved. Cover and put the bowl in the freezer. After an hour, remove the bowl from the freezer and give an energetic whisk with a whisk or an electric mixer, then return it to the freezer. Whisk again after another couple of hours, this time whisking in the lemon zest, juice, and passion fruit pulp. Return it to the freezer. When it is nearly firm, give one last whisk, transfer to a suitable freezing container with a lid, and let it set in the freezer until it is firm.

Alternatively, pour the mixture into your ice-cream machine and freeze, following the manufacturer's instructions.

My parents are like perfume and meatballs. In their looks they are equally striking, each clearly representing their own nation.

Serves 4

3/4 CUP SUPERFINE SUGAR
2 CUPS WARM MILK
1 CUP HEAVY WHIPPING CREAM
4 EGG YOLKS

CARAMEL
ICE CREAM

This is a beautiful, buttery toffee-brown that looks wonderful sitting alongside a scoop of banana sorbet. Serve it with some dark chocolate sticks for a rich and complete dessert.

Put the sugar in a saucepan over medium heat and let it melt slowly and turn to caramel. Don't stir the sugar, just tilt the pan occasionally so that it melts evenly and turns a deep gold. Slowly and very carefully add the warm milk, standing back as it will splash up. Add the cream and mix well.

Whip the egg yolks with an electric mixer until they are fluffy. Add a ladleful of the caramel mixture, whisking constantly so that you don't scramble the eggs. Gradually add the rest of the caramel mixture. Return the whole lot to a saucepan over very low heat and cook, stirring constantly with a wooden spoon, until the mixture thickens slightly.

Remove from the heat and leave to cool, stirring from time to time. When completely cool, transfer to a bowl, cover, and put in the freezer.

After an hour, remove the bowl from the freezer, give an energetic whisk with a whisk or an electric mixer, and return to the freezer. Whisk again after another couple of hours. When it is nearly firm, give one last whisk, transfer to a suitable container with a lid, and let it set in the freezer until it is solid.

Alternatively, pour the mixture into your ice-cream machine and freeze, following the manufacturer's instructions.

Serves 4

4$\frac{1}{2}$ TABLESPOONS BUTTER
1 CUP SUPERFINE SUGAR
1$\frac{1}{2}$ CUPS HEAVY WHIPPING CREAM,
 PLUS 1 TABLESPOON
2 JUICY PEARS (ABOUT 1 POUND ALL UP), *peeled, quartered*
 and cored
$\frac{1}{2}$ CUP MILK
1 TEASPOON VANILLA EXTRACT

PEAR
CARAMEL
ICE CREAM

I love fruit caramel ice creams. You can try this with apples, plums, peaches, and maybe bananas. Serve with a buttery shortbread-type cookie.

Put the butter and sugar in a saucepan over medium heat for about 10 minutes, until liquid and caramelized. Carefully add the 1 tablespoon of cream and simmer for a minute before adding the pear quarters. Turn them around in the caramel and simmer for 5 minutes. Lift out the pears with a slotted spoon, allowing any caramel to drip back into the pan. Purée the pears in a blender and set aside.

Put the cream, milk, and vanilla in a bowl and whip for a few minutes, until the mixture thickens and you notice an increase in volume. Whisk in the puréed pears and $\frac{1}{2}$ cup of the slightly cooled caramel (save the rest for later). Cover the bowl and put in the freezer.

After an hour, remove the bowl from the freezer, give an energetic whisk with a whisk or an electric mixer and return to the freezer. Whisk again after another couple of hours. When it is nearly firm, give one last whisk, swirl in the remaining caramel, and make a few loops through the ice cream with a spoon. Transfer to a suitable freezing container with a lid and let it set in the freezer until it is firm.

Alternatively, pour the mixture into your ice-cream machine and freeze, following the manufacturer's instructions. Remove the ice cream from the freezer 5 or 10 minutes before serving to let it soften a little.

There are some things that don't change much. I find the smell of a dish, or the way a certain spice is crushed, or just a quick look at the way something has been put on a plate, can pull me back to another place and time. I love those memories that seem so far away, yet you can hold them and carry them with you, even forget them, and then, with a single taste or hint of a smell, be chaperoned back to a beautiful moment.

from Tessa...

This is my chance to thank all of you who, knowingly or unknowingly, helped me to make this book by showering me with inspiration, courage, and recipes. To Giovanni and my mice, Yasmine and Cassia, for always filling me with new hope and ideas. To George, Sipi, Tanja, and Nicholas for their unwavering support and friendship. To my perfect Italian "grandparent" cooks (the type that I always search for along my trails), Mario and Wilma Neri, who still amaze me with their readiness to help, no matter what nationality is cooking.

Thank you to dear Kay and everyone at Murdoch for their encouragement and trust: Katy for her courage on her mammoth task; Diana and Jane for their enthusiasm to dance; and Amanda and Juliet, just for saying yes.

Thank you all: Anette, Evelyn, Ana, Artemis, Niki, Maria, Adam, Jem, Stephen, Carl, Jason, Allan and his mum Sue, Silvana, Herve, Ritva Dahl, Ritva Tunaainen, Harriet, Iria, Vania, Yiota, Jenny, Stamos, Natasha, Julia, Fabio, Massimiliano, Mikela, Julietta and Aureliano, Giacomo and Angela, Luisa and Luca, Marco and Lorella, Massimo, Sergio, Beppe, Toni, Daniele, Franco, Andrea and Barbara, Nicci and Brenda, Serena, Gianluca, Bernard, and Lisa's gran.

To my always-inspiration: Angela Dwyer, Albert Clarke, Corinne Young, Liz Benatar, Ketty Koufonicola-Touros, Jo Capell, and Vivian.

And a big, big acknowledgment to Michail Touros, Manos Chatzikonstantis, and Lisa Greenberg for skipping all the way with me.